Radical Ecstasy

SM Journeys to Transcendence

Dossie Easton and Janet W. Hardy

greenery press

Cover art by Mary Neack.

Cover design by Johnny Ink.

Published in the United States by Greenery Press, 4200 Park Blvd. pmb 240, Oakland, CA 94602, *www.greenerypress.com.*

ISBN 1-890159-62-X.

Contents

Mind Journeys 163

Open Heart, Open Skin, Open Everything 199

Acknowledgments

Ben Teller, M.D.

Chester Valentine Anderson

Cléo Dubois

Daddy Drew

Doc Tsai

Fakir Musafar

Goddess Lakshimi

Huckleberry

Jay Wiseman

Joi Wolfwomyn

Lin Allen

Lin Hill

Lizzard Henry

Lynn Sockermom

Mic Bergen

Paul Romano

Raelyn Gallina

"Squeeze" Edward

Thomas Alva Waters

and all the other wonderful players, partners and friends who have traveled into ecstasy and back with us.

Very special thanks to our dauntless editor, Carol Carmick, whose patience and judgment were an integral part of making this book what it is.

Introducing Us... And Our Book

Dossie, on Janet

We met ten years ago, as some of our faithful readers will remember, when Janet volunteered to be my demo bottom for a seminar on receiving the cane. We got together before the seminar to establish limits, communication and so forth, and again afterward for lunch, to debrief. Janet said, "I think you should write a book — I've got a great title, call it *The Bottoming Book.*" I said, "I'm too neurotic to write a book by myself, I get anxious and panicky, you'd have to write it with me," and Janet said "Sure." That's how we started. It's ten years, five books and two revisions later, and more scenes than I can recall.

During these ten years we have become best friends, lovers, collaborators, co-authors and SM explorers together. Much of this book is about our explorations. And we are not primary partners. During most of the time we have worked together, one or both of us was partnered to somebody else.

For me, one of the most remarkable things about our relationship is the way our writing and thinking flows along with our

play. For instance, we might be stuck trying to describe something that seems undescribable, and then we'll play a scene. The scene will go wherever it goes, and next morning one of us might wake up with a good answer: the story of the scene becomes the teaching parable.

We fit together. We fit together very well. We like to cook together, hike, go to movies, hang out with our kids and all those other good things. We both sew and knit, we are both crafty — Janet wrote her delightful book *Kinkycrafts*, and I was a cottage industry leather crafter throughout most of the '80s. We like to make things.

We also fit together in our differences. Janet is an older sister, I'm a younger sister — even though I'm eleven years older than Janet, you can see the dynamic. Janet describes herself as a reformed caretaker, I as a reformed clinging vine — if we hadn't reformed before we met each other, we'd be impossible. But somehow we avoid codependence and keep on doing what we're doing.

We both write and think and edit. Janet tends to do the big editing, has a vision for the overall structure of a book, while I'm the detail freak, doing tons of copy-editing and smoothing and clarifying the language. Nobody is anybody's ghost writer here — we both write and think. And edit. Each other.

We have never had a quarrel about our writing. We are, actually, both conflict-avoidant to a fault, but since it's both of us, we're on equal ground here, so it pretty much works. The few times there have been conflicts that we needed to talk about, we were pitifully polite about it. When one of us says "I hate to bring this up," it's always true. Our disagreements are usually resolved easily, possibly because we both give in too easily, but then neither one of us is very pushy, so we're not in danger of overwhelming each other.

We love each other. This is not romance: violins don't often play (although there are moments when we hear a note or two).

Janet mostly tops, I mostly bottom, although we do switch from time to time, and our play involves many different roles for both of us. She's bisexual and gender-bent and I'm a femme dyke. I'm a therapist and she's a publisher. I'm a pagan who has been exploring spiritual practice for forty-two years, she is stubbornly secular and puts a lot more faith in science than I do. And sometimes our differences make friction, but mostly they make wisdom and fun.

We are both really, really smart. And serious about our work.

Janet, on Dossie

In the movies, the lyricist stands by the piano and says a few words, and the composer plinks out a phrase on the keyboard, and they look at each other with a dawning recognition, and suddenly burst into song: and a song is born.

They hardly ever retire into the bedroom to torture and fuck each other as preparation.

Dossie and I have been friends, play partners, collaborators, lovers, co-conspirators and confidantes for more than a decade now. We've seen each other into and out of one primary relationship and several hot flings each; we've written five books, moved each other into seven houses, had several miserable weeping arguments over money, and collectively gained and lost easily a couple of hundred pounds.

We are not romantically in love with each other, probably never will be — that's a role that just doesn't fit, although in some ways I think we'd both like it to. I usually fall in love with men. She falls in love with women, but the women she falls in love with are a particular flavor of crazy that doesn't match up with mine. Yet our sex is blazing hot, and we know more of each other's secrets than anybody else, and we sleep peacefully and blissfully in the same bed, and we cook fabulous meals in the same kitchen without tripping over each other.

She lived communally with drag queens while I commuted through suburbia in a station wagon; she was taught violence by men, I benevolence; she floats easily in realms of spirit and ritual that cause me profound discomfort. Yet when we sit eye to eye and join our breath, we fly together; and later, when we talk about what we felt, it is the same — only the words are different.

We've role-played everything from Little Red Riding Hood and the Big Bad Wolf to kids at a birthday party to inner-city pimp and whore, then gone out to the kitchen in our robes and slippers for fruit and cheese and chocolate and arguments over philosophy, and then back to the bedroom to get out the vibrator and finish the evening properly.

So what we have is this odd, puzzle-piece of a relationship that's defined by what it's not: we're not spouses in the way most people are spouses, not best friends in the way most people are best friends, not lovers in the way most people are lovers, not fuck buddies in the way most people are fuck buddies, not co-authors in the way most people are co-authors. No word for it at all, I guess. Just us.

Both of us, on the book

This book is radically different from our previous work. Until now, we have always written "how-to" books, with lots of explication and direction spiced up and illustrated with teaching stories derived from our play. This book is lots of stories with bits of explication tossed in to give you some of our ideas about why and how things happened the way they did, and a few suggestions about how to follow your own pathway.

When we first decided to write this book, we started out, as we often do, by leading some workshops at conferences on the subject of transcendent SM, to test out our ideas and to hear from people all around the country what was important to them. A sweet man

in one workshop raised his hand and told us that he had a vision of this book as a journey, kind of like *Zen and the Art of Motorcycle Maintenance*. We liked that idea a lot (once we got over being intimidated by comparison with Robert Pirsig).

So for two years we sought out ecstatic experience, together and individually, and wrote about what we did, how it felt and the thoughts we found in our brains the morning after. Then we drove ourselves nuts for six months patching all the pieces together into what you are holding in your hands.

This process has been amazing for us: terrifically intimate, personal and vulnerable. We have kept a lot of our individual writings intact in the voice of each of us, and written the explication parts in the more familiar authorial "we." We created some visual distinctions so you can easily tell who's speaking:

Dossie loves you.

Janet loves you.

And we, your faithful authors, love you.

What we're not going to do

We already wrote *The New Bottoming Book* and *The New Topping Book*, which cover the emotional basics of SM — and several other authors have written excellent books that cover basic techniques, negotiation, safety information and so on. We didn't write this book as a how-to; it's a description of our own journeys into transcendent sex and SM, with some thoughts about why it's worked for us and some ideas about how to make it work for you.

If this is your first book about BDSM, we'd like to request quite firmly that you read at least a couple of those other books,

or attend some good workshops, or learn from some experienced players, before you actually try any of the activities we describe here. In other words, please play sensibly, with the most complete knowledge you can get — ecstasy carries responsibility. If SM is completely unfamiliar territory, you might be quite startled at what we include in our normal sexual practice. If you would like to learn more about SM, we'd like to recommend our book *When Someone You Love Is Kinky*.

Authors and authority

Dossie remembers:

When I was 19 years old, and trying to figure out how to have orgasms with a partner, I read a book called *Sexual Surrender in Women* by Dr. Benjamin Morse. Here are some of the chapter headings:

The Terrified Virgin

The Insecure Mistress

The Nymphomaniac

The Dominant Female

The Masturbator

The Latent Lesbian

The Guilt-Ridden Girl

The text was based on case histories of women with each of these so-called pathologies, and, not surprisingly for 1962, they all got better by getting married. It took me a few years to come to terms with the reality that marriage was not my path, and a few more to figure out how I wanted my relationships and my sexuality to be. And there was a time when I agonized over the ideas that were presented in books like these, basically that who I wanted to be and how I wanted my sexuality to be

was sick, sick, sick, and that I would only be happy when I gave up being myself in order to become somebody's wife.

A few years beyond that and a lot more experienced, I was sitting in a Greenwich Village coffeehouse with some friends who were professional writers, from science fiction to hack, when one of them started telling a story about how he had written this book called *Sexual Surrender in Women* under a doctor pseudonym, and even got invited to speak at some universities, har, har, har. I was very good, I didn't throw my coffee cup at him, even though I was tempted. I did shriek: "I know you. You don't live anything like what you wrote in that book."

He was obviously astonished that I was so upset. "You got to tell them what they want to hear."

We include this story here as an object lesson in evaluating the voice of "authority" — including what you're reading in this book — by matching it against your own experience, and deciding for yourself if this fits for you.

A legion of individuals and institutions claim authority, in most cases exclusive authority, in matters spiritual. Religion teaches us to defer to the wisdom of a higher authority — Jehovah, the priest, the guru, the ten commandments, the twelve steps. Academia teaches footnotes: what we say must always be based on somebody else's authority.

It is with a considerable sense of risk that we decided to write this book on our own authority. We decided to report to you our experiences on a journey we made while we wrote it, to share with you our thoughts, our play, our sex, our arguments, our discussions, our journeying, our journaling about what we did and how we felt and what we thought about it. All of this book comes directly from our own experience: what we felt and saw and heard

and tasted and struggled to find words for. We have chosen our-selves as the authors of our experience.

Sometimes we found it hard to stay with our own authority. Surely we should be spending hours in the library, reading what everyone else has said. Or looking to scientific authority, as if spiritual or sexual experience could be condensed into a multiple-choice questionnaire and turned into numbers, where only the average counts as truth.

We have felt a little giddy, unanchored, a trifle terrified, maybe a little miraculous — could it possibly be that our own insights and experiences could be enough? Fifty years between us of SM play, sixty-five years of sluttery, could that be enough? Enough to write a book, enough to be useful to you?

We decided, for better or for worse, to write this book on our own authority. We hope it encourages you to discover and rely upon your own.

Radical *What?*

You picked up this book in the bookstore or ordered it off the website for a reason. Maybe you've read our previous books, or you liked the gorgeous picture on the cover, or you were attracted by the odd title, or something in the jacket copy interested you. But we bet you're still not quite sure exactly what this book is about — because it's a difficult topic to talk about: a lot of the words we use mean different things to different people. So we want to spend this chapter talking about what we're trying to do in this book, and some of the pathways that led us to write about such a jungly, resistant, hard-to-write-about topic.

Between us, we've been doing SM, or BDSM, or kink, or leathersex, or whatever-you-like-to-call-it, for a bit upwards of half a century (Dossie started in the early '70s and Janet in the mid-'80s). For each of us there came a time when we realized that we were having experiences that went beyond the kind of generally wonderful times we'd come to associate with genital sex, and beyond those we'd experienced during our ordinary SM. These experiences were hard to talk about — they had

some features in common with psychedelic experiences, some with trance states, some with what we'd heard about tantric practices, some with the writings we'd read from ecstatic mystics of other millennia.

We began to hear from, and talk with, other pioneers of our own communities who were exploring similar avenues during solo practice, partnered play and in groups. We started exploring other embodied spiritual practices like tantra and trance dancing, investigating other sacred sex communities, reading scientific studies on the neurophysiology of spiritual experience and the anthropological background of the uses of pain as a transcendent and spiritual practice, and poking around in writings by various Western and Eastern philosophers about ecstasy and interpersonal connection, wisdom and magic.

In other words, we started getting serious about this stuff. And, of course, we got seriously into our favorite form of research: we started playing with each other and with our friends — a whole lot — to see what we could learn from it. (Hey, it's a filthy job, but someone has to do it.)

So here we are — nearly three years later, considerably better read, with a lot of very hot scenes under our belts (and between our eyes, and up and down our spines, and at the center of our chests) — and still having a hard time putting into words exactly what this book is about. But we'll do our best.

Words fail us

Transcendence is, pretty much by definition, a state of being beyond words. Books are, pretty much by definition, made of words. You could say that this situation created some difficulties in writing this book — if you were prone to vast understatements.

To make matters even more complicated, Janet and Dossie use different words to talk about radical ecstasy. Janet prefers words

that don't have historical connections to religion and that at least sound rational; Dossie prefers to redefine, or in many cases undefine, words that have been in use for centuries, and is fond of the language of poetry.

And each and every one of you reading this has your own history and experience and prejudices about words, perhaps especially about words that have to do with spiritual or exalted or transcendent experience. Some words may feel right to you, others may push your buttons; and it's almost certain that those sets of words aren't going to match up to the next guy's sets of words, and probably not to ours.

Here's what some of the philosophers and authors whose thinking we like have had to say about words:

> *The Tao that can be named is not the Tao.*[1]
>
> — Lao Tzu

> *If we threaten the word, we threaten ourselves. Until now, it is through verbal language that we have learned to understand the world. And we understand it badly. By assassinating verbal language, we are killing the father of all our confusion. Finally we shall be free. This is not only true of theatre. We will be free men in every aspect of our lives.*[2]
>
> — Antonin Artaud

> *All the things you can talk about in anyone's work are the things that are least important. It's like the ballet. You can describe all the externals of a performance — everything, in fact, but what really constitutes its core. Explaining something makes it go away, so to speak;*

1 Lao Tsu, Tao Te Ching, trans. Gia-Fu Feng and Jane English, Vintage Books, New York, 1972.

2 Antonin Artaud, in a letter to J. Paulhan, 1932.

what's important is what's left over after you've explained
everything else.[3]

— Edward Gorey

drive dumb mankind dizzy with haranguing
— you are deafened every mother's son —
all is merely talk which isn't singing
and all talking's to oneself alone.[4]

— e.e. cummings

Now, we make our living writing about BDSM and sex. It's pretty easy to describe the difference between the part of the butt that it's OK to hit with a heavy wooden paddle and the part you can only hit with a slim rattan cane. But we've never been able to write about the time that the shape of the inside of Janet's mouth turned into a giant bubble, and every stroke of the flogger turned it into a different shape — one stroke huger than the whole house, another stroke the size and shape of a toothpick — and reading this sentence makes us realize there's a very good reason for that. In this book, we will often attempt to convey how a sex/SM/ecstatic experience feels (or tastes or smells), in an attempt to write around things that can't, and possibly shouldn't, be completely or adequately described in words.

We asked the participants in one of our workshops to list all the words they could think of that meant transcendent states to them, and in just a couple of minutes they came up with this list:

God/Goddess	source	self-connection
spirituality	power	connection
juju	magic	communion
juice	magick	unity
mojo	body's electric field	oneness

3 Edward Gorey, quoted in The Strange Case of Edward Gorey, *Alexander Theroux,*
Fantagraphics Books, 2000.
4 e.e. cummings, 73 poems, *Harcourt Brace, New York, 1961.*

Radical Ecstasy

transcendence	subspace	eye-opening
vision	topspace	mind-expanding
ecstasy	the Force	magnetism
bliss	energy	the universe
kundalini	high	cosmic
life force	stoned	infinity
energy	aura	eternity
altered state	exaltation	boundless
illumination	imaginative	beyond words
love		

And that's just scratching the surface — we bet you could come up with a dozen or two more if you thought about it for a while. (It might be an interesting exercise to write your own list, and it might come in handy later on if you find yourself having trouble with some of the language that we use in the book. Feel free to substitute your favorite words for ours anywhere you like.)

We've kicked around all of these words and more. And those are just the names of the main topic we're writing about — that's not even getting into words for what we want to say about it, or how we do it, or how it feels once we do it, or the even more difficult question of who we are while we're doing it.

All of the words are partly right, but none of them is completely right, and every single one is going to shut down or turn off or annoy some percentage of the people we're trying to reach with this book.

Even words we like may not mean to us what they may mean to you. "Spirituality" doesn't mean the same thing to Dossie that it does to Janet, who keeps saying she's not into spirituality — but when she describes what she is into, Dossie cries, "But that *is* spirituality!" "Energy" can mean anything from what the copywriters say you'll get from their latest breakfast cereal to the force that sets your body afire at your lover's touch. All in all, we'd much rather

come to your house and show you what we're talking about — but we can't figure out a way to do that for seventeen bucks.

So, frustrating as it is, we've reconciled ourselves to the reality that we're stuck with the written word for now, and we ask your patience as we slog our way through the difficult task of trying to figure out terminology that we (and you) can live with. You'll notice that we don't always use the same words to describe our experiences — we want there to be plenty of different ways to talk about radical ecstasy so that plenty of different people can find some language that fits for their own experiences.

Given that this is a relatively new area of discussion within the BDSM and sexuality communities, its vocabulary is still brand-new. New language will evolve, and someday this volume, and our struggles to find the words for what we've experienced, may seem primitive — and we suspect that the cosmos will continue to defy definition in twenty-five words or less.

Get ready for a lot of "I don't know"

One of the problems we have with many of the world's religions (and their secular friends, sciences and philosophies), is that they too often leave no room for mystery. In professing to have a monopoly on the truth, especially about phenomena that cannot be seen or heard, they lose tolerance for ambiguity and fail to honor the unknown — those things that cannot be fully comprehended with human minds or brains.

We humans have trouble tolerating blank spaces. We feel anxious, insecure. We want to fill in the blanks — like when your friend, driving (you think) to meet you, is seriously late, and you call the Highway Patrol because you are sure that they have crashed and are in a hospital somewhere broken and bleeding. That's a story you made up, a myth. So because these religions/sciences/philosophies are supposed to tell us what is true about the unseen universe, the

pundits, not wishing to appear ignorant, have a terrible history of making up stories to fill in the gaps.

A lot of people seem to want answers; we wish to stay with the questions. We treasure the adventure that mystery offers, and answers would cut short the exploration.

So, a word of warning in advance. If you bought this book expecting to be given Answers, now would be a good time to return it to the bookstore before you've bent any of the pages or cracked the spine: you're not going to find them here. However, we hope to offer you some pretty interesting questions.

About bliss

What does that experience — the one that seems like "more than" orgasm, "more than" SM — feel like? When it happens to us, or to the people we know, the words they use to describe their experiences include "bliss," "transcendence," "exaltation," "spirituality," "out-of-body," "out-of-this-world," "floating," and a lot more, including the one you see on the cover of this book — "ecstasy."

The question of what role ecstasy plays in the human organism, and why we're obviously hard-wired to feel it, is an enormous one. It's a very, very big feeling, probably the biggest feeling our brains are able to experience. It's also worth noting that ecstasy is not necessarily a "good" feeling — the dictionary definition of ecstasy is "a state of being beyond reason and self-control,"[5] so you can be in an ecstasy of fear, an ecstasy of anger, an ecstasy of pain, or, of course, an ecstasy of pleasure.

In the fascinating book *Why God Won't Go Away: Brain Science & The Biology of Belief*[6], the authors come to this conclusion from their research:

5 *Merriam-Webster.*
6 *Newberg, D'Aquill & Rause, Ballantine Books, NY*

We believe... that the neurological machinery of transcendence may have arisen from the neural circuitry that evolved for mating and sexual experience. The language of mysticism hints at this connection: Mystics of all times and cultures have used the same expressive terms to describe their ineffable experiences: bliss, rapture, ecstasy, and exaltation. They speak of losing themselves in a sublime sense of union, of melting into elation, and of the total satisfaction of desires.

We believe it is no coincidence that this is also the language of sexual pleasure. Nor is it surprising, because the very neurological structures and pathways involved in transcendent experience — including the arousal, quiescent, and limbic systems — evolved primarily to link sexual climax to the powerful sensations of orgasm.

All well and good — and, we think, absolutely fascinating. Yet the information that we have neural pathways that are capable of perceiving ecstasy, and that those pathways may have evolved from an experience as everyday, clearly understood, and easily accessible as the vibrator on our nightstands, doesn't change the fact that our knowledge of that ecstasy, and what it might mean, is entirely subjective.

We do not wish to diminish the great mysteries that we travel in when we seek ecstasy. To do so, we feel, would be less than honest, and disrespectful of things that are too great to encompass. Dossie's favorite prayer is, "Lady, protect me from hubris." We would rather honor our ignorance, which opens our minds to new revelations.

Radical ecstasy, by the way, is not a particular brand of ecstasy, or a goal of some quest for some form of ecstasy that is better than whatever ecstasy you are currently familiar with. Radical ecstasy is nothing more than an expression that makes a good title for our book, maybe because it starts people thinking about ecstasy and

about what the roots of ecstasy might be. That's what radical means, you know — it's about the roots of things. (It comes from the same origin as "radish.")

So we can only tell you what radical ecstasy feels like to us — and that's what we will do in this book. We can't define it, we can't encompass it, we can only describe it from our limited perspective, tell you a little bit about what has worked for us, and hope that some parts of your experience hook up to some parts of ours, maybe down there at the roots.

What's all this stuff about tantra?

When we started to work on this book, we decided to find out a little bit more about tantra. This wasn't the first time we'd thought about this practice — when Dossie was a wide-eyed eighteen-year-old, someone taught her to imagine the kundalini snake and open the chakras while she was tripping — excuse us, meditating. She's been using those images during her meditations ever since. Tantra looks to us like another form, along with SM, of graduate school sex. The tantra that you find in California is a westernized form of some ancient spiritual practices that originated in the Himalayas. It employs intense breathing, body movement and intimate connection with another person to raise sexual energy into our genitals, up through the body and out the top of the head.

Why? you may ask. What does tantra have to do with BDSM? The answer, we discovered, is everything. What we found was that the people in the tantra workshops were traveling to ecstasies that felt just like our SM ecstasies, only using different techniques. They were climbing the same mountain up a different side.

The tantrikas we played with were amazed at how fast we "learned." We told them we'd been practicing for decades, only with whips and chains. And once we were satisfied that tantra was basically the same stuff we were researching, we kept going back

because it really works! We've added a lot that we learned in tantra to our SM practice — you'll read more about this soon.

Zooming through Nirvana

Another fascinating finding in *Why God Won't Go Away* has to do with the goings-on of the human nervous system during spiritual and ecstatic experience. Normally, the researchers explain, either the sympathetic (aroused) or parasympathetic (relaxed) nervous system controls the way the body is responding at any given time, depending on the environment and circumstances. However, they can occasionally function together; when this happens, their collaborative effort is called the "autonomic nervous system":

> *There is evidence... of cases in which both systems function at the same time when pushed to maximal levels of activity and this has been associated with extraordinary alternative states of consciousness. These unusual, altered states can by triggered by various kinds of intense physical or mental activity, including dancing, running, or prolonged concentration. These states can also be intentionally triggered by specific activities that are overtly religious in nature, such as ceremonial rituals or meditation. The similarities between these intentionally and unintentionally triggered states point to a clear link between the autonomic nervous system and the brain's potential for spiritual experience.*

This feels to us like a very clear description of the relaxed-but-revved-up way we feel during our ecstatic BDSM experiences. As we move on in this book to describe some of these experiences, perhaps you'll recognize it as well.

The walls come tumbling down

When Dossie's daughter was newborn, Dossie used to call her "Baby Buddha" because she had not yet completed the first task we learn when we leave our mothers' bodies — she had not yet learned to tell the difference between herself and the rest of the world. She was still "one with everything."

All of us spend the first few weeks of our lives working on this problem when we're not nursing or sleeping, until we get a firm grasp of where we end and the rest of the world begins. And then many of us spend a great deal of the rest of our lives in a frantic scramble to dissolve those walls again, at least for a little while. We may wish to lose track of where we are in space and time. We may want to achieve transcendent oneness with the world and/or with someone we love. We may desire to feel a sense of perfect godlike unity with others, with the world around us, with the universe.

Your authors believe that one of the things that feels so very good about orgasm is that it's most people's easiest pathway to something that feels like oneness-with-the-universe: when you're busy coming, you're too damn busy to worry about where you end and everything else begins, so for just those few seconds or minutes you get to float (or shimmy, or tremble, or convulse, or scream, or bellow) in a place outside space and time and boundaries. Extremes of sensation or emotion or loss of control that we experience during peak BDSM moments carry us into those same transcendent spaces — this is one of the reasons why scenes that look violent and offputting to outsiders can in fact connect us in a loving and profound way. When we drop our boundaries, we flow into each other.

Similarly, those who practice tantra learn to use their breath, their gaze, their movements and the energies that run through their bodies to carry them into the same boundary-dissolving experiences, into orgasms-that-are-not-genital — experiences that seem

to have much in common with our experiences in the dungeon. We've both observed that seasoned kinksters who try tantra seem to take to it like ducks to water.

We think most people feel pretty trapped behind their walls and are pretty desperate to escape from them at least some of the time — we certainly are. We've found that our experiences in getting rid of our walls have left us feeling happier, sexier, stronger, freer and much much more loving. (And, yes, occasionally kind of scared too, although usually a good kind of scared.)

Once again, we turn to the fascinating research in *Why God Won't Go Away*. Brain scans of people having ecstatic experiences during meditation or prayer show that brain activity in the part of the brain that tells us where we end and everything else begins, a section the authors have dubbed the Orientation Association Area, slows to almost nothing — the sense of becoming "one with everything" is reflected in the actual activity in the brain. When we read this, Janet instantly wondered if her lifelong tendency to get lost along the simplest of routes might in fact be one of the reasons she reaches ecstatic states so readily; Dossie had similar thoughts about her severe left/right confusion.

We think that radical ecstasy, as we've experienced it, is a way to pull down the walls that keep people apart from each other and from the rest of the universe — just as much as they want them down, and with the people they want to connect with, for as long as they want them down, and for as long as it feels safe. This can lead from anything to fabulous sex — a pretty great goal in itself — to a kinder and more welcoming universe.

Why ecstasy?

A friend of ours once pointed out a fascinating truth: we have no word in English, like "hungry" or "thirsty" or "horny," for the desire for ecstasy. Let's take a look at why we, and a whole bunch of

other enthusiastic players, are looking for paths to transcendence at all. What is it good for?

For starters, it is good because it feels good. Just that. Bliss, divine communion, whatever you call it, feels extraordinary. Even when it feels overwhelming or intense or difficult, which it certainly sometimes can, it still feels different than mundane experience in a way that we often choose to seek out, simply because it *is* more intense, bigger, more life-affirming.

This amazing feeling is the intrinsic value of the experience. We live in a culture that does not value pleasure or ecstasy — our predominant religions insist that we renounce pleasure in this life and obey religious law in order to be rewarded after we die. We aren't much taught that we can have divine ecstasy as part of our daily lives. And we are just about never taught that the pursuit of what feels good is a positive force in our lives — most western culture has pleasure as a sin, a distraction, an escape from the terribly serious work of getting to your death in the way that the priests will approve of.

The experience of ecstasy just about always coincides with an expansive feeling of self-worth, of loving the entire universe and ourselves as a part of it, along with a lovely sense of life being validated as a way to participate in something larger, some energy that is larger than each of us. Through that participation, we also get to discover how deeply and lovingly we are connected with each other.

Ultimately, in transcendence we rise above our everyday hassles and frets, get bigger than our judgments (including the harsh judgments we so often apply to ourselves), and experience a sense of wholeness, integrity and just plain rightness which is rewarding in and of itself.

Compared to that extraordinary bliss, any external rewards of transcendent states are almost the icing on the cake — but there are consequences of transcendence that can make our lives work

better after our journeys are over for the moment, when we return to more mundane pursuits.

The dissolution of boundaries involved in ecstatic experience means that we can, for a while, expand our vision beyond our everyday paradigms and the limits of our current worldview. When traveling in ecstasy temporarily dissolves our templates, maps, patterns, personal mythologies or belief systems, we can make new associations, incorporate new ideas, see with a vision unclouded by our history. This can lead to new solutions for problems — in much the same way we might search for a solution by "sleeping on it" or dreaming about it.

For instance, as is described later in this book, it was an ecstatic journey that first led Dossie, back in 1969, to look into feminism. In the bright light of transcendent vision, she saw how society's expectations of her as a woman didn't fit her. Through the temporary clarity of an ecstatic state, she created a plan to change her life and grasp her power in ways that she had not previously thought possible. Thirty-five years later, as a therapist, an author and an outrageous free spirit, she can report with assurance that it all worked very well.

Sometimes the rewards are smaller and more secular. Janet has had numerous experiences of returning to her mundane existence the day after an extreme and blissful scene, and suddenly finding herself able to solve creative problems on which she's been stuck for months — a friend calls this "defragging her brain" (after the process of defragmenting the data on a computer hard drive), for the sudden cognitive and emotional clarity it gives her.

Our experience of transcendent states is that they open up our own power in the form of tremendous energy that becomes available to us for whatever purpose we might choose.

So, with all these goals in mind, we set forth to discover the hows and whys of the astonishing experience that we have dubbed radical ecstasy. Welcome to the journey.

How We Believe

One of the things your authors have in common is our over-active intellects. We both grew up in environments that placed a lot of value on academic achievement, on succeeding in a world where the right answers got you a reward and the wrong ones got you an F. But we've also both come to learn that while the human intellect works very well for building bridges and discovering cures for diseases, and is indispensable for keeping food on the table and a roof over our heads, it isn't very helpful for traveling in bliss.

Releasing the traps that your brain can set for you isn't the only way to achieve transcendence, but it's an important step — and that's why we're taking this chapter to talk about our ways of believing, and how they've worked for us. And, as the chapter title indicates, we find it easier and more relevant to talk about the process that we use for believing things than it is for us to talk about what those beliefs might or might not actually be.

Letting go of either/or

Obviously, not believing in anything at all would not be a very functional way to move through life. We believe, for example, that you exist, otherwise we'd turn off our computers now and go to dinner and a movie. We guess we must believe that the restaurant and the movie theater exist, too. However, we often have trouble with more traditional belief systems, which are based on, well, belief systems — belief that God or Goddess exists, or doesn't exist, for example.

One of the ways we believe is that we're very suspicious of dualism. Dualism in philosophy is the theory that there are two basic principles or things, such as mind and body, and that by separating them we are expressing some truth. (As the saying goes, there are two kinds of people in the world: the kind who believe that there are two kinds of people in the world, and the kind who don't.)

In theology, dualism is the doctrine that the world is ruled by antagonistic forces of good and evil, or the concept that man has two basic natures, the physical and the spiritual.[1] We are particularly suspicious of doctrines that split spirit and body, as if they were at war, as if the body were inferior and the goal of life to escape from it. We like what we get to do with these bodies — that's why we're writing this book.

A lover of Dossie's, in an argument-fueled moment of frustration, once cried, "Either you're wrong or I'm crazy!" At the time, that seemed to make sense to her, but of course it really doesn't — both of them could have been wrong or crazy, or both right and simply disagreeing with one another. Dossie's response: "Can you think of a third option?" The next time you get stuck in an either/or dilemma, try thinking of a third option, and a fourth — the

1 Adapted from *Random House Dictionary of the English Language, Unabridged,* Ed. Jess Stein, Random House, New York, 1971, and from *The American Heritage Dictionary of the English Language,* Wm. Morris, Ed., Houghton-Mifflin Co., Boston, 1981.)

answer to dualism is pluralism, a much more suitable philosophy for sluts like us.

Some fallacies of dualism are pretty easy to perceive. Others seem incontrovertible: a thing must be either X or not-X. But we invite you to stretch your brain, to embrace a way of believing — or not-believing — in which it is possible for neither of these to be true, or perhaps both. There may come a time when it will work better for you not to make such a division — like when you want to be more connected than separate.

What do these philosophical/logical calisthenics have to do with sex or SM? Well, more than you might expect. Transcendent play is a way that we dissolve the boundaries of space and time, and the walls that seem to keep us apart form the people we care about. Where do those boundaries, those barriers, come from? Sometimes, we think, they come from patterns we learn when we decide that a thing must be either one way or another. If the divine is in everything, the divine is both one way *and* another: as simple, and infinitely complex, as that.

When you start out by cultivating your tolerance for ambiguity and paradox, you are loosening the strings on your mind, giving yourself permission to feel without judging, to trust your sensations and emotions rather than your busy brain. You are practicing believing in what you feel at the moment, not reflecting the past or fretting about the future. You are practicing for ecstasy.

Letting go of knowing

Once we get better at believing several things at once, even when they seem to contradict each other, it's a short and sweet step to letting go of our need to know anything at all.

Certainty is a trap, objectivity is a trap. How do we go about knowing what we think we know? We assume that we can readily tell which of our perceptions are subjective and which objective, but

are we truly in no part subjective? We need to be willing to recognize that we can only see the world from our own point of view.

Dossie was fortunate enough to have this revelation at an early age:

Lost In the Great I-Don't-Know

In the 1960s, I was a utopian psychedelic activist. I believed that the universe, and our society, could be perfected — and somehow that possibility made me responsible for the job. In the idealistic omnipotence of my early twenties I castigated myself that I hadn't figured out a way to fix all injustice, and solve the riddle of the cosmos.

Twenty-five years old, and a member in good standing of the love generation, I had been traveling inside my psyche for seven years, accruing wisdom along the way, and questing always for that defining revelation, the vision that would unriddle the universe and start me on my path toward healing the world. I yearned for enlightenment.

My daughter was an infant. I hadn't tripped in quite a while, being first pregnant and then exhausted. But one fine sunny morning, a friend dropped by my house while the baby was taking her morning nap, bearing sugar cubes. In a totally against-character move (I was usually careful and planned trips well in advance), I spoke out: "Can I take two?" My roommates being free to care for the baby when she awoke, I sucked the sweetness and went traveling.

The rush was astonishing. I lay on my bed, no question of moving, I'd get vertigo from lifting my head. Everything was luminous: the sun pouring through the paisley bedspreads on the windows, the white sheets, the walls, my fingers. Looking at some messy paint on the

side of my black dresser, I was instantly transported to the intergalactic void. I vaulted around in outer space for a while, looking for something to connect to, but everything was way too big. The distances, the speeds, these balls of frozen rock hurtling around, blinding nuclear fusions. How long would it take to hitchhike a light-year?

I got it. The universe was bigger than me. Lots bigger. Incomprehensibly bigger. And in my wanderings between the stars, nothing responded to me. The language of the stars was too huge, too fast, for my brain to apprehend. I felt like an ant.

Lost in the cosmos, feeling lonely and abandoned, I brought myself back to my body in my bed, sun still pouring in, though at a safer distance. In front of my eyes, walking on my white cotton sheet, was a tiny, nearly transparent spider. Her progress was unbearably slow and interrupted. Every few seconds, a piece of lint from my sheet would get stuck to one of her legs, and she would stop and painstakingly rub it off. With what seemed to me infinite patience, she would then continue her journey, only to pick up another piece of lint, stop, rub, a few more steps, more lint... Intent on her mysterious purpose, she progressed across my field of vision. I wondered what awareness she had of me, this tiny mind in a body smaller than the pupil of my eye that watched her. Was I as vast to her as the galaxy was to me?

I started laughing. What a fool I had been, a child in my twenties, to take on the job of solving the mystery of the universe. My brain, whose vastness I had only begun to explore, was still overwhelmingly too small to take in the cosmos. We were into mind expansion in those days,

and I laughed like a maniac imagining stretching my brain out like a giant balloon, trying to fit it around the universe. I couldn't reach around even one galaxy, not even a solar system. Earth herself was wondrously bigger than me.

"I quit! I resign!" I cried. What a divine joke! If anybody or anything was running this operation, he, she or it was welcome to the job. Swimming around in the galaxy again, I felt lost and lonely, so I flew back down to earth. My home planet was studded with glowing campfires, and around each campfire was a circle of people; dear, sweet, lovable people, doing what they could do to create warmth and light and meaning in the enormous emptiness.

I ran downstairs to share my revelations with my fellow communards and my baby. "I quit! I resign! I figured it out! The answer to the riddle of the universe is... I don't know!"

As I came down from my grand journey, a lot of pieces about my life fell into place. I explained it all to my baby daughter, and she listened patiently, watching intently, it seemed to me, with her baby Buddha eyes. By now I wasn't high any more, hours had passed, and I was in the resolution stages of my trip.

Many things fell into place for me when I let go of the notion that something was wrong with me because I didn't know everything. I had explored my difficulties as illnesses with neo-Freudian shrinks, and been pathologized. I had sought healing from spiritual teachers who blamed my unhappiness on sin in this life or, if none could be found, I must have made some terrible error in a past life. All these attempts to make sense of my

life had been predicated on the notion that something was wrong with me.

But wasn't I, by and large, as good a human being as anyone else? I saw myself, along with the other people around the tribal fires in my vision, as a courageous pioneer, searching through the vastness, creating meaning in the sharing of love and support and warmth with other people.

I saw something else, with tremendous clarity, that I had never seen before. As I returned to a more normal state of consciousness, I realized that a lot of what I had blamed myself for added up to things that I had been taught were unwomanly: intelligence, outspokenness, overt desire for sex, valuing my own opinion, making my own decisions — not to mention my inexhaustible lust for chasing my own destiny. I had thought for so long that something was wrong with me because I didn't fit into the role of nurturing wife and second fiddle, and found in myself no delight or fulfillment in the washing of everybody else's socks.

This cosmic adventure made a feminist out of me at a time when feminism was considered pretty weird. In the aftermath of revelation, I vowed to learn to value all the parts of myself, especially those parts that I had reviled as too masculine. I vowed to grasp my life, full tilt boogie. I vowed to be androgynous. I vowed to embrace my sexuality. I vowed never to be monogamous again. I vowed to take my relationships with women, all my sisters, seriously, and to honor these connections, sexual or not. I vowed to remain unpartnered for five years so I could learn who I am when I'm not trying to be somebody's wife.

My life plan was truly formed on that day. In the afterglow of the expanded mind, I was still thinking with luminous clarity. I saw that I needed to find myself as an independent person, and that I also needed affection and connection and love, and that there was no reason I couldn't have all that at the same time. I vowed to find my security in my community, and in order to do that, to become a more affectionate and demonstrative person. To share intimacy generously, with my roommates, my friends and my lovers. I had work to do to reclaim myself, a lot of work, and what a blessing to have that glimpse of who I could be if I did the work.

It is now thirty-five years from that day; I am sixty years old; and all my visions have come true. I have been privileged to be part of a much larger movement, in feminism, in sexuality, in extended families, in queerness, in expanding definitions of self and relationships.

I notice, as I write down the early revelations that defined my life as an adult, that so much of what I needed to do was about letting go — of definitions, of roles, of tasks, of oughta-be. Letting go to open space for new ideas, new explorations — for could-be, might-be and wouldn't-it-be-wonderful.

And now I get to write a book about this journey, and share it all with you.

Letting go of causality

In some belief systems, bad things happen to bad people in the afterlife; in others, in the next lifetime; in still others, here in this lifetime. These days, it seems common to hear people attribute difficulty in their lives to "karmic lessons," implying that some

intelligence, or law of nature, possibly divine, has made a plan to offer them exactly the adverse circumstances they need to learn what they need to learn.

We are, to put it mildly, skeptical. Do all the victims of an earthquake or a war or a plague need the same karmic lesson? Have they all called their fates to them by some need? Is everything painful that happens in our lives happening for a reason?

The two of us have discussed experiences we've had in our lives that we've valued, that we definitely would not want to have missed. Many of them, somewhat to our surprise, were painful losses, errors, illnesses, disasters: adverse events in our lives that somehow set us on a path that we valued.

Between us, we have survived physical and emotional abuse, the serious illnesses of a couple of our children, poverty, business disasters, losing houses, losing lovers and a lot of very hard times. These things have stretched us, taught us new things about ourselves; while we hated them a lot when they happened, we guess that we can accept them now as part of what has made us the strong women we are.

Happy, easy times don't seem to stretch us very much. When things are going well, although we might very well be learning lots of important stuff, we don't struggle, strive, stretch, push ourselves. Seems like the times when we discover our strengths are when we are battling with some adversity.

But we feel quite sure that none of this was planned. Troubles are opportunities, and tripping over some of them is inevitable in the world, and in the bodies that we inhabit in this life.

People want answers to the questions of Why? so intensely that they are willing to make them up. Things seem to us to fit together in the world because they grow into the spaces available. Plants need the sun to grow, but the sun doesn't shine in order that the plants may grow, or that we should feel sunny, happy and safe. The sun shines because it is burning itself up in its own incalculably long lifespan.

So we believe that it is important to practice holding the blank, empty, painful space of what we don't and perhaps can never know, and to stretch our ability to tolerate ambiguity. A lot of people are looking for answers. Sometimes it is important, and more truthful, to stay with the questions.

Letting go of control

Traveling in the realms of transcendence is a goal that doesn't match up well with the need to know it all, to be on top of things, to be in control. This is a lesson that most of us get to learn over and over — at least, we both do. The addiction to control sucks us in over and over again, and it's a good thing that we have our wonderful friends, with their whips and ropes and their soft kisses, to coax us back out from the iron fingers of our control addiction from time to time. Even tops, who often become tops because they are eroticized to control, must have a clear understanding of what is theirs to control and what isn't, and of the distinction between the fantasy of control and its reality — we'll discuss this further in a later chapter.

Janet looks at boundaries and unboundedness:

Skin as a Meditation on Morality

Here's a moment I like to remember. I was kneeling on the floor, bent over the edge of a bed. There was a clothespin on my clit. It had been there for quite a while. My lover was fucking me up the ass. Just as he came, he reached around, opened the clothespin, lifted it away from my sticky flesh.

The inside of my head went white. The next thing I can remember is that somehow I seemed to be holding all the bedclothes in my hands, and there seemed to be a very loud shriek echoing off all the walls.

What I love about that moment is its purity. I had no volition, no ego, no self. I was a tiny scrap of burning white energy floating in an infinitely huge universe, contained only by the intent of my lover.

It seems to me that the experience I'm trying so hard to describe in this book, whether you want to call it ecstasy or bliss or spirituality or transcendence or whatever, is always at some level about loss of self — about having the precious opportunity to forget, for just a little while, where I end and everything else begins.

Which brings me back again to the question of skin — the membrane that defines the boundary between what's me and what's everything else. Working on this book has brought me back again and again to the question of skin, and I've realized that at least for me, it's a powerful metaphor.

For me right now, all of SM seems like an exploration of the nature of skin. When I beat you, I light up the nerves in your skin. When I put clamps on your skin, I compress its nerves and drive away the blood that feeds it, and when I take them off the blood comes back to heat up your skin and make you gasp. When I put you in bondage I have turned your skin to a rigid armor that holds you in place, and drawn your attention to the pressure of the ropes and cuffs against your skin, holding you in place when my hands can't be there. (Is this, I wonder, why leather has become so important to SM — are we at some level recognizing the importance of skin to what we do?)

But here's the real thing about skin, the important thing, the thing that's about morality. Without our skin, we'd be part of everything, and everything would be part

of us — so we'd never know what was ours to take care of, and what wasn't. That's what my skin does: it reminds me what's mine to control, and what isn't. Skin is my karmic job description.

Now, I have a friend right now who is receiving proof every hour that even inside his skin he doesn't get to control things all that much – millions of cells are dancing an arrogant square-dance inside his skin, propagating and multiplying, sticking their little cellular tongues out at radiation and chemotherapy. But at least, I think, he gets to *try* to control what's going on inside the pink membrane, the bag that we're given for carrying our groceries.

As I've mentioned elsewhere in this book, I have a tendency to try to control a lot of things. I think of myself as good at controlling things, and I'm pretty sure that the world would be a much better place if they just let me run it. I make myself pretty crazy trying to control more than I really can or should. So it's probably a very good thing that I have this soft chamois bubble around me to remind me exactly where my control stops.

Sure, there are lots of things outside my skin I get to *influence* — but anytime I get to thinking I'm in control of anything outside my epidermis, it's time for me to take a deep breath and start letting go. Letting go, letting go, letting go. Remember, goddammit, Hardy, letting go.

And then, when policing that boundary begins to feel like too much effort, I can free up my heart, open my throat to scream, maybe ask a good friend to pull a clothespin off my clit at just the right moment, and float skinless, a burning scrap of energy, boundless through the universe, for just a little while once again.

What it all adds up to

Now that we've finished explaining to you all the beliefs we don't have, all the knowledge we refuse to know, all the causes we refuse to ascribe and all the control we're struggling to let go of, it may surprise you to hear that all this non-ownership does add up to something resembling philosophies of life. Although Dossie's and Janet's philosophies sound very different; we manage to fit together very well: different metaphors, same cosmos.

Here's Dossie's description of how she sees the world.

The universe is bigger than all of us. Divinity, if that's what we can call the energy of the cosmos, is infinite, eternal, or at least so much more vast than our consciousness can comprehend that it might as well be. Longer than we will ever know, bigger than we can see or imagine. When I need a reminder, I like to hang out with redwood trees: they are also way bigger than I can really get. We operate on finite brains, and there is no way we know what God looks like.

Understanding that the universe is bigger than me offers me infinite opportunities for becoming a bigger person, possibilities for growth beyond what I can imagine today. It unbounds me. Acceptance of the ultimate unknowability of everything frees me: it releases me from feeling responsible for controlling what I can't.

I feel from my experiences that the divine energy of the cosmos, God if you will, or the tao, or kundalini, or eros, or the force — whatever you like to call it — flows through each of us all the time. That's why I like names like "life force" or "the Way" to describe that mysterious energy that makes us living beings rather than hunks of meat. So if this animating energy flows

through all of us all the time, and if that is what divinity is, then the only question becomes, why are we so seldom aware of this?

For most of us, everyday consciousness is focused on the tasks of life: working, walking, eating, communicating. Divinity is flowing through us, yes, but we aren't paying attention. Spiritual practice and religious participation are among the huge number of ways that we set ourselves up to pay attention to the divine.

In 1962, when I was first living on my own at the age of eighteen, I heard something that changed my life, from a guy I met in a Greenwich Village coffeehouse. Listening to my struggles to find a spiritual belief I could live with, he said: "Everything changes if you see God as a woman." Here I was struggling with a god of wrath when I could relate to a goddess of compassion, of flowering and fruitful earth, of unconditional love. Something like a huge array of dominos went down, and everything, indeed, changed.

Because I got to choose. God, like the redwood tree, like the universe, obviously must be way much more than some grandfatherly guy with superpowers. So I don't really know at all what God looks like. If you like to anthropomorphize the divine, if it works for you to focus on the ineffable by personifying it, then remember that you get to choose the form. I get to envision God or Goddess however it works for me at any given moment in time. Mother, crone, warrior, dancer, healer: the pantheons supply us with imagery, mental pictures we can imagine when we want to connect to any aspect of the divine, something we can talk with,

ask questions of, pray to. Many of the world's religions have a concept of an unknowable god, eternal, infinite, too big for us to grasp, and then a pantheon of lesser deities, envisioned as more or less human: saints, angels, elves, fairies, orishas, ancestor spirits, nature sprites, divinity on a human scale.

So to my mind, all religions are valid insofar as they supply ways for their members to experience and realize the divinity that flows through all of us. And it doesn't matter if you imagine divine force flooding up from inside you, or pouring into you from above or below. It's really all the same thing. Spiritual practice, religious ritual, high-consciousness sex: all ways of paying attention.

I have always been drawn to embodied spiritual practices, and indeed, that's what this book is about. Embodied means occurring in the body, felt in the body, enacted with the body. Practices that move our attention through our bodies on a path to open our awareness to the divine.

Examples of embodied spiritual practice include gospel churches, where the devout sing and dance quite vigorously to raise the spirit. Hatha yoga stretches the body to open a clear relaxed channel. Sufi dancers spin and twirl, using the disorientation of turning and the focus required to remain upright, as the path they follow to wake up to the life force within. Prana, following the breath that flows in and out of each of us in turn, chanting and devotional singing, are yet more ways of moving energy in the body. Medieval flagellants, Hindu saddhus, modern flagellants in the Phil-

ippines, Native American piercing rites, ancient and modern practices of scarification: yet more embodied spiritual practices, these last involving sensations of pain designed to alter our states of consciousness and wake us up to the glorious flow of the life force inside us.

We perverts are not without precedents.

And Janet's:

> Yesterday I spent the day having astonishing sex. It's only been hours, but the memory of sex is ephemeral, so all I remember now is flashes: clamping my hand across a mouth so I could feel the scream against my palm; pushing my left fist up against a perineum and my right hand flat against a belly, and feeling the bolt of electricity that threw my head back and rattled my teeth like an old-time preacher baptizing a child; the trembling of my knees as I fought to keep my legs open for whatever might happen between them next.
>
> Today I am in an airplane, somewhere over Nebraska, I think. I have spent the day showing my passport to strangers, buying expensive snacks in airport gift shops, wrestling my overweight suitcase onto conveyor belts, reading glossy magazines with far more attention than they deserve.
>
> Ever since Dossie and I started this book, I've been arm-wrestling with the question of spirituality, and the back of my hand seems to be nearing the table. The things that other people describe as spiritual experiences are things that I've experienced too: the still majesty of nature, the heart-stopping love that is parenthood, the miracle of seeing my own muscles and tendons rise and fall under my

skin as I wiggle my fingers — my god, all I have to do is think about moving my body and it *moves*, just like that.

So I guess it was spirituality — the magic that vibrated my palm, that threw my head back, that shook my waiting knees. It was *something*, anyway. It felt to me like any other kind of energy — like electricity, or light, or heat: physical, concrete, measurable. It's hard to talk about it much because everything I say sounds so vague and woo-woo — even the word "energy" sounds ridiculously inadequate, a groovy holdover from a less left-brained era. But if I'd been around in the 14th century, and I'd been able to perceive radio waves with my own body and had tried to describe what I was feeling, I'm sure it would have sounded equally ridiculous. Given a choice between sounding stupid and denying my own perceptions, I guess I have to choose the former.

But what I don't get, can't get, is what's so especially spiritual about that particular energy. It's certainly one of the great mysteries that holds the universe together, that connects me with friends and strangers and animals and plants and rocks. But so is the $5 I handed across the counter for a copy of *Premiere* a couple of hours ago. So is the bag of pretzels I ate, and so are the crystals of salt at the bottom I moisten my finger to pick up and lick off. I can't understand why my hands dancing across this keyboard can be a spiritual experience and the silicon and plastic and metal they're tapping can't.

The phrase "sacred sex" makes a certain amount of sense to me, and heaven knows we need it after a couple of millennia of being told that sex is a dirty hellbound sin. But I just can't work out a schema in which sex is sacred and choosing new tires for my car isn't.

What is sacred, I think, is *attention*. If I'd had my mind totally focused on my clit yesterday, I'd have missed the moment when the power ripped up from my friend's asshole into my right arm, across my chest, back down my left arm, into her belly, and round and round like a dazzling pinwheel of light. If all I can think about is how much money there is in my checking account and whether the $200 tire will last twice as long as the $100 one, I miss the astonishing realization that the tread under my hand passed through the rain forest and the steel mill and the conference room of a Madison Avenue ad agency and the shipping department of Costco; and that handing my credit card to the clerk has connected me with hundreds of people I'll never meet, with trees I can't climb and a factory whose workings I don't begin to understand; and that I breathed in molecules from those people's skin and oxygen exhaled by those trees and pollution floating in the air from that factory before I ever considered buying the tires.

It is with some reluctance — well, kicking and screaming, honestly — that I've come to conclude that the energy, or kundalini, or life force, or whatever it is we are writing about in this book, is absolutely real: when something lifts me off the floor and slams me against a wall, that's evidence enough for me. But nothing about it strikes me as particularly "spiritual." To me, it's a physical energy, just like electricity: a form of energy that we don't have the right instruments to measure yet.

Now if that's spiritual, then *everything* is spiritual. And, yeah, of course everything is spiritual, but used that way the word has no meaning — when I look up a word in the dictionary, I like to find a more precise definition

than "*See also:* all the other words in the dictionary" —
so we're back to the beginning.

Sex, because it feels so very good, is easier to pay
attention to than hooking the back of my bra every morn-
ing: maybe that's why we call it sacred. But I think sacred
sex is simply practice — a way of practicing to notice
sacred *everything*.

Morality Play

Stolen pleasures

What happens when we look at pleasure as our birthright? And when we give ourselves permission to enjoy pleasure fully and easily?

Most of us grew up with values that didn't really allow us to deserve much in the way of pleasure, particularly sexual delights. Everything was either forbidden or you hadn't worked hard enough for it. And there were enormous proscriptions against enjoying sex, which was seen as somehow anti-spiritual or overly devoted to the flesh.

So we wonder if we are acculturated to believe that stolen pleasure is the only kind we are allowed. Some folks have a lot of fun being naughty and don't mind, indeed delight in, the sense of the forbidden they get from dirty, raunchy, definitely transgressive SM and sex — an act of rebellion against the established order. Others, like us, find guilt distinctly un-sexy, and want to feel radiant and powerful and free. However, those who enjoy transgressing

in play but don't want the crushing burden of real-world guilt, as well those who dislike and distrust guilt inside or outside the bedroom, have one thing in common: we're still stuck with the values that pervade our culture, the values that love to steal our pleasure by making us feel that we don't deserve it. Why *do* we call it "Devil's Food Cake"?

We are never good enough. A supreme example of this insidious belief is our national obsession with body image — with size, weight and an increasingly unrealistic standard of physical beauty. A perfect work ethic issue — we can work and work and work, and work out, have surgery, diet till we drop, and still not feel good enough. So we strive and struggle to work harder, spend more money, look better, to earn love and pleasure.

And we can never work hard enough to deserve love and sex and pleasure... because that's not how we get them. The basic pleasures of human existence are free for the taking.

Ask yourself a few questions. What would it be like to take the day off to go to the beach without fretting that you should be using the time to get started on your taxes? What would life be like without that constant nagging voice of authority at the back of your brain?

What would pleasure be like if we valued it properly?

What would any form of delight feel like without that background drone of shame?

What would sex be like with no guilty thrill?

Do we even know?

About ethics

We, your authors, make no claim to be perfect, but we are ethical people who care a lot about the well-being of those around us, and of those we may never meet as well. In all the books we have written about sexual practices, it has been very important to us to teach and value ethics.

We are constantly learning and teaching about ethical intimacy: how to find our own boundaries, how to respect the boundaries of others. How to say no and to hear no, how to demonstrate caring for the well-being of each of us. Playspace, in the bedroom or the temple, where we make a special commitment to be our very best selves, needs to be a safe container for us to open our hearts and explore the unbounded love that ecstasy opens up. In sex and SM, the play party or scene space is often the special bounded space that we hold sacred, where we show our most vulnerable insides in order to travel together into ecstasy, where we make and keep a special commitment to mutual safety and respect for everybody.

Especially when we're exploring our darker and more challenging fantasies, as Janet has found:

Sadist

Today I beat someone as hard as I could.

I broke one toy over his ass and bloodied several more. I beat him until his cries were high as a child's — if you heard an animal making a sound like that, you'd put it out of its misery.

And afterwards, he hugged me, and thanked me, and made me a cup of tea, and helped me put away all my toys.

When I try to think about the "me" that was breathing hard and getting wet as I whipped the cane down again and again, the first thing I think of is a Victorian schoolmaster, a figure out of Dickens: solid in my sense of righteousness, implacably, impossibly cruel, letting a lifetime of repression and anger pour its strength into my clenched jaw and my descending arm. How am I going to sleep tonight, thinking of that?

Yeah, yeah, I know the standard line: it was all consensual, we both wanted it, consenting adults in private, blah blah blah. But the hell with that: it was a vicious, savage beating. And I'm still shocked and a bit scared. And I wish I could do it all again right this very minute.

Because somehow, as the blood rose up under his skin and his ass got redder and harder and darker, it was as if he, his essential self, was what was rising up to the surface, pushing up to greet the cane, reaching for my cruelty like a delicious treat.

All his layers disappearing, melting into the rising tide: the clever writer, the respected academician, the family man, the athlete, each melting into the surging heated blood so that nothing remained between him and me but a thin layer of skin...

... and when the first spot of blood appeared, I felt an exultation, a triumph: the last layer dissolving, perfect connection. His wails transported me like music. I was nothing but the arm that beat him and the ear that heard him and the cunt that oozed and the heart that pounded with exertion and bliss and love and, yes, cruelty.

A kind of perfection, really: a being that gives hurt, and a being that gets hurt, and nobody and nothing else. Where else could I ever find that kind of purity, that clear untainted sweetness?

Tonight I am surfeited with that sweetness, a child on Halloween night, and I will sleep badly, dreaming of schoolmasters. But soon I'll crave more; I always do. Because, you know, I've always had a terrible sweet tooth.

When we're playing with such dark fantasies, how can we know that we're ethical people? The ethics of SM are often ex-

pressed as "Safe, Sane and Consensual." What that means is respect for physical safety, respect for emotional safety, and tremendous honoring and respect for each person's autonomy, for every person's right to choose their experience.

Our ethics are internal, subjective, based on how we feel, because we want to feel good about who we are and what we do. We want to live in a world where people treat each other well. We want to like who we see when we look in the mirror every morning.

Making space for difference

Honoring vulnerability becomes even more important as we explore our differences. Sacred space in conventional temples has often been a problem for leather perverts and other sex radicals. Most places where we go to learn spiritual practices that don't involve sex pretty much expect that our sexual differences will be left outside. Leatherpeople have too often had to attend their spiritual practice in the closet.

Sacred space is intimate space: our temples, our playrooms, our dungeons, everywhere we gather together to practice. So we must put serious attention into how our playspaces are going to be safe spaces for everyone who comes to play.

We are all perverts, and we all arrive in the dungeon fearful of judgment as we contemplate baring our most intimate kinks and our juicy (and often wounded) selves to all who are present. It is a gross violation to be anything short of totally respectful to anyone who opens themselves up in our rituals.

The wide-ranging sexual diversity of our community can create tensions. Gay men, transmen, transwomen, drag queens, hyperfemmes, straights, gays, bis, genderqueers, people covered with tattoos and piercings and inhuman colored hair in dreads, people who look like the folks who live next door to your mom and dad. We come from a huge diversity of backgrounds: class difference,

racial difference, cultural difference. Tops and bottoms and switches, doms and subs, those who follow protocols and those who are extremely loose — we have a lot of difference. Our entire society deals very poorly with difference. Our differences rub together when we gather in a playspace, and we get to discover the fears that we still carry around, and the myths and stereotypes about "those other people" that still infest our thinking and our feeling.

We maintain that we are enriched by all this difference. We have a whole lot to gain from connecting with people who are different from us — who look different, whose experience is different, whose expertise is different, who have different wisdom. Wisdom that might make us wiser, if we listen carefully.

The difficulty is that difference has so often been persecuted. Many of us have serious reasons to fear assault, battery, bashing, rape, even murder. Those who come from cultural or sexual minorities have generations of history of oppression and enslavement, lynching and genocide, entire societies attacking them not for their individual differences, but because they are a member of a group that the culture in power hates or fears: people of color, people of ambiguous gender, women, people from other countries, people from other cultures...

At a panel at a recent Leather Leadership Conference presented by people of color within the leather community, each panelist responded to the question, "How would a person be polite to me?" This can be the first step in understanding another person's experience — asking, respectfully, how they wish to be addressed, asking what works for them, what they need to feel safe.

Think of how you have felt anywhere where your kind was the minority. (If you are heterosexual and of European ancestry, and have never been anywhere where you constituted a minority, let us recommend the experience to you.) Did you feel awkward? Self-conscious? Was it hard to be understood? How did you fit yourself into somebody else's milieu? What were the culture gaps, the

unfamiliar forms of communication? They say a fish can't see the water, and we can't see the air, but maybe, when we try an excursion out of our own familiar atmosphere and struggle to understand communications from elsewhere, we can start to see beyond the paradigms of our own culture that constitute our assumptions. Maybe we'll learn something new. Maybe we'll take a few steps outside our box. Maybe we'll feel freer.

If you are a member of a group that has been oppressed, for whatever reasons, how do you feel among people who look and act like the people who oppressed your ancestors? Are they stereotyping you, assuming they know who you are and where you come from by how you look? Do you feel on edge? Poised to defend yourself? Angry? Fearful of being treated as anything other than the beautiful wise proud sexy individual that you are? What do you need to feel safe here?

As we contemplate sharing intimate space with people who are very different from us, let us also remember that those of us who explore the world's religions to extract practices that fit into our SM spirituality are borrowing from cultures that we probably don't understand very well. Reading about a culture is not the same as growing up in it.

We perverts borrow ritual technologies from a lot of cultures and redesign them to our own purposes. Who do we borrow from? Native American sun dance, African polyrhythms and possession, Hindu *kavadi*, Malaysian *tai pu san*, Maori tribal tattoos, piercings from Irian Jaya. We don't think of this as stealing, since nothing is lost from the original; on the other hand, we don't really have any way to return what we have borrowed. Many of the people who have preserved traditions from old roots — shamanic practices, initiation rituals — are native peoples who are mightily oppressed by the mainstream culture.

We need to be thoughtful about other cultures' rites. Members of these cultures are not always happy about our borrowing, and

they justifiably feel disrespected if we lightly and casually colonize their sacred traditions. Europeans have, after all, colonized just about everybody else (not to mention frequently each other). So back again to learning how to be polite: we need to value the sources of our traditions, and to respect the truth that the people who grow up in a particular tradition and have years of study and practice know more about that tradition then we do.

We have a vision of cultural pluralism. If we only play in groups restricted to people who are exactly like us, then the people we are truly restricting are ourselves. We would like to continue our explorations in communities populated by a huge diversity of people. Where there is conflict, we like to remember that friction makes heat, and heat is energy that can blast us out of our boxes and into a wider understanding of everybody else, and ultimately ourselves.

What Does It Feel Like?

The ability to achieve ecstasy is not like a black belt in karate. You don't have to study for years to get it — it's in you right now: if you doubt it, watch any six-month-old baby exploring a mound of soap bubbles.

Many of the characteristics of an ecstatic state happen to you every day. For instance, you experience an altered time sense whenever you get so involved in a task that you lose all sense of time — like when you're reading an exciting book and look up in what seems like a few minutes to find that a couple of hours have passed. You may have moments of unusual clarity when you let your attention drift: many people find that solutions to problems just "come to them" in the shower, or in the moments just before they fall asleep. And loss of boundaries between self and other are, of course, characteristic of the feeling of being in love — many of us can remember gazing into the eyes of our beloved, feeling as though we were falling into a deep well; or watching our newborn infant sleep as raptly as we would watch a Hollywood thriller.

All these experiences have two characteristics in common: *presence* and *acceptance*.

When you are present, you are completely occupying the space and time you are in. You're not thinking about the past or the future, or any place but where you are right now: a chant we like to use for this practice is "reborn every moment." (Of course, as Janet moans, by the time you notice how completely you're in the moment, you're not in the moment any more!)

When you are accepting, you are receiving each moment for exactly what it is, not wishing it were anything else or striving to make it more or less than it is. You are willing to accept yourself as you are today, perfect in this perfect moment. There may be other times for striving, such as when you set up your scene — but when you set out on the road to ecstasy, you must welcome each instant exactly as it is, then let it go to welcome the next one. Let go of attachments — they are anchors, and you want to fly. Release desire, fantasy, yearning, any lust for results: the wanting mind only gets in the way.

You can't force yourself into presence and acceptance, any more than you can pry open the petals of a flower. ("I'm not being accepting enough, goddammit!") The breathing, relaxation and movement techniques we will explain in a later chapter are all designed to help you move easily and naturally into these states of mind, so don't worry too much about them here — presence and acceptance are best recognized after the fact.

When the world is too much with us and our busy brains won't shut up, we very often need some help in getting present and open — and while it's certainly possible to get there solo, a willing and skilled partner is better yet. Here's Janet's account of a scene in which Dossie took her back into presence and acceptance from a place where she had neither:

> The trouble with being known as a painslut is the
> number of tops who think that means that you never

need warmup, scene-setting or an occasional break. I've had too many scenes like that lately, usually ending in emotional meltdowns that I didn't want, and I was beginning to wonder if my bottom space was gone for good.

So I'd asked Dossie if she could please give me a nice long slow-building session, hot and entrancing. And we'd already wanted to breathe together, so we decided to combine the two — her first time consciously combining topping and breathing, my first consciously combining bottoming and breathing.

The music she chooses is women's voices in soft, rhythmic chanting, complex and soothing. When I start to unbutton my shirt, she firmly moves my hands back down to my sides and unbuttons it herself. I feel my armor start to slide off my shoulders as the shirt falls to the floor. The bra comes off, then the slacks, then the underpants, and the first time I'm allowed to move is to step out of the garments as they puddle around my feet. A prism hangs in the window, throwing flickering rainbows around the room like confetti.

She begins to weave a harness, thick soft purple rope. Bondage usually makes me tense, worried about damage to my injured shoulders, but this is completely comfortable, constantly present against my skin but not pinching or hurting or twisting my body. Each pass of the rope across my skin is a reminder to feel, to let go of thought and to move fully into my body. All the small sensations that are normally beneath my consciousness, the pressure of feet against floor, the tiny creak as one muscle slides over another, the redness of sun from the window against my closed eyelids, all take over my brain, filling it

too full for any thinking. I become a beautiful, symmetrical purple package, a gift from her to herself.

We sink to the floor, her legs under mine, crotch to crotch and breast to breast. We begin to breathe, slowly at first. Our faces are so close together that she has one big eye, and I sink into it like blue quicksand. I let her set the pace for the breathing — she's more experienced than I, and besides she's the top. I am consciously working to be receptive, to let her energy pour into me instead of forcing mine into her as I often do. I swim along the currents of our breaths, feeling the column of light sucked upward into my body on each inhalation and letting the top of my head open so the beam can go all the way to the sun, then letting it fall back into the earth on each exhalation.

She picks up the pace and I follow. A tremor of energy shakes her from her hips up through her torso, and she giggles with pleasure. My receptive state is so soft that I have no corresponding tremor, but I don't miss it; I'm floating. We switch to alternate breathing — I suck in her exhalation and pull her essence into my lungs, then blow my own into her mouth, an act of astonishing intimacy, like an infant and mother.

She takes our breathing up to one last crescendo, both of our voices sounding like sobs, like orgasms as we let ourselves open flowerlike to one another. Then we hold each other and giggle together a bit as the intensity ebbs.

We stand. We breathe together a bit more, building a bridge from tantra to SM. She attaches my wrists to overhead chains. She fusses for a few minutes to lower the chains and take the strain off my shoulders; I am swaying gently to the music, barely noticing as she adjusts links and connections.

The first caress of the flogger, nothing but a whisper across my ass, makes me sigh with longing. So slow, so gentle, nothing that pushes or startles. I go on swaying, my entire being focused on the sensation. Exquisitely it builds, from a whisper to a murmur, to an audible whap! as the skin of the flogger meets the skin of my backside. I breathe it in and wait expectantly for more. There is more.

"Take it in, green lady," she murmurs in my ear. "Look at that green rising up in you." And suddenly I am emerald, a woman of emerald, clear and shimmering in the sunshine, the green flaring up like flame with every stroke of the flogger. I have a sudden vision of myself as a superhero, a magical being of green light. I am entranced by my own beauty.

Then the bite of a paddle. I flinch away from it at first, and wonder if this is really such a good idea. Then I remember my pain-play mantra: Don't judge it, just feel it; and I breathe, and the next stroke is all heat and light and it rings me like a chime, and I push my ass out for more.

I won't bore you with a toy-by-toy account of the rest, from paddles to crops to canes. Every time she strikes me with a new toy I freeze for a moment, frightened by the sting and unsure of myself, then I remember to let myself feel and a new layer falls away from me. And at the end I hear the whir of the cane and some distant part of me thinks, Wow, she's hitting me pretty hard, and my skin soaks the pain up like dry earth absorbing the rain. And at one magical moment, the cane slices into me exactly as the prism in the window flashes a beam of pure clear red into my eye, and all my senses explode in perfect unison.

And then it's over. She takes me down and we move onward to sex. And I'm sorry to disappoint you but I'm not going to write about that now, because I've experienced the magic of sex a thousand times and so have you, but the magic of the breathing and the bondage and the flogging and the music was a journey into a whole different world, a world that I must write about now before I plunge back into quotidian life and forget how to hold onto it.

What is this bliss?

So what is this bliss, this ecstasy, that we seek — through religion, through meditation, through sex, through SM? Definitions are always too small to fit the amazing reality we experience in ecstatic states. This ecstasy, as we and many others who write about it experience it, adds up to experiential proof that the universe is bigger than us — *lots* bigger. And if some people want to call the universe God or Goddess, there's nothing wrong with that, as long as we understand that God or Goddess is a name for something so immense that we cannot in any way begin to describe it with a name.

So we can only describe ecstasy by how we relate to it. That part we know: we know how we feel and how we travel in mind and body from everyday states of consciousness to what we think of as divine ecstasy.

Dossie writes:

> I can only describe to you what it feels like to me. First and foremost, it feels undeniably real. When I am dancing in the storm of a flogging, to the song of the whip; when I am writhing in the throes of orgasm; when I am undulating to the breath of tantra; when Kundalini the

great snake is awake all through my body and beyond and I am thrashing and bellowing on my meditation mat, I know that the divine is real. I can feel it rushing through me, like sap flooding up a great tree, like swarms of sparks, like an iridescent fountain showering over me, like a river coming up from the center of the planet and driving through me, from my root out through my crown and thence up to the stars and galaxies. I feel all this, as surely as I can feel my feet on the floor, my butt on the chair, as certainly as I can feel when I'm hungry or tired or angry or sad or joyous.

This is not science here, but it is knowing. An active, live knowing of a vast truth. I can't tell you what it is, I can only tell you what it is like.

The Tao that can be named is not the Tao.

So this weekend, in my tantra workshop, I was in and out of states of ecstasy for two days, living in a temple and practicing with other tantrikas for our monthly weekend of exploring bliss. A new image came to me this time: during a meditation on heart opening, I felt water running up from the earth in a bright opal fountain, shaped almost like lightning. It came up my body to my heart, meeting scarlet energy pouring down through the top of my head. They met in my heart, the red and the white streams of light, and spread out to cleanse and warm my entire being.

Imagery can be a big help in attaining ecstasy. It can help to imagine pictures, colors, sounds, plants, flowers, animals (Dossie's personal snake is the humble San Francisco garter snake, a jet black beauty with red and yellow racing stripes).

Leonard Shlain does a good job explaining the value of imagery in his excellent book, *The Alphabet Versus the Goddess.*[1] There he explains most beautifully how our technological culture has valued the left brain's ability to generate and work with abstractions, like numbers and equations, like phonetic symbols for sounds. Abstraction has been tremendously valuable for ensuring our survival and well-being, and allowing us to adapt nature to us rather than us adapting to nature. This has made us a very successful species — however, as we well know, we are in danger of destroying our ecological niche by continuing to try to adapt nature beyond what nature will tolerate. Shlain suggests that we have neglected our right brain, our image-making capacity. We ignore our feelings, stating that we are "imagining things," as if there were no truth or value in the discoveries we make through imagining.

We think of "imagining" as if it were a child's game: making believe, making things up, fantasies suitable for comic books. But look at the root of the word. To imagine is to make an metaphor in the mind, an image in pictures or sounds or sensations of something we can perceive internally — an image that may be better able than language to convey a complex truth: not precisely, as a scientist would like it, but accurately enough to communicate the gestalt. This is why some forms of truth are better expressed in poetry, and why in our culture we have to work to find language with which we can communicate our emotions.

So perhaps imagining is a valid form of perceiving and a truthful way to explore the universe — particularly when traveling in the open realms of ecstasy, where precision may be inimical and boundlessness our best friend.

Imagination may speak to you in many ways: auditory, musical, tactile, kinesthetic, emotional. Colors and shapes may be more

1 *Viking Books, 1998*

important than objects or beings. We are suggesting here the power of following your imagination, rather than leading it.

Visions may tell a story, or they may just flow, like a dream. Here is a vision of Dossie's that turned into a poem:

Kali Dasi

Black skin, Scarlet tongue,
hard feet horny trample me,
Beloved, Destroyer, my Mother.
Your skin eats light
utterly round Your hips.
I sink in Your breasts, infinite softness
hanging beneath the skulls of men
Your arms trap me implacable
in the language of crows You
open me up You
 tear me down

Tigress sweaty over me, Your fur scours.
You turn me over, buffet me,
spread my legs with Your great paws.
Your claws, sheathing and unsheathing,
knead my flesh, spilling little streams.
Scarlet Your tongue, bright like persimmons
You lick salt in my wounds.

Your huge tongue
in the language of frogs
Rough like starfish
licks my cunt, sucks me dry:
I am not ready.
I try to offer myself but You allow
 no will, no reason:

I am not ready.
I am Yours because You take me.

Tails of snakes enfold me, muscles
Wrap my limbs, crush my chest, I cannot breathe:
Your rattling in my ear is all the sound of the universe,
 deafening me.

Where Your rocks meet Your waters in thunder
Your cliffs are dangerous, my Lady
Your tides turn stones back and forth, clicking.
Shaman's rattle, diamond back,
Demon Mother, Killing Moon,
eclipse me in Your infinite darkness.

With shining steel nails on fingers and toes
You lift me, shake me, split my skin
spill my life in sticky red streams and then
 You let go.

I land empty
dry and rattling:
I have forgotten that I am.
I must be
Yours.

Not always what you expect

Ecstatic states are not always predictable or reliable — they some-times appear when you're not expecting them, or fail to appear when you want them desperately, or zoom off in a direction you're not expecting — they're not like cars with accelerators and steering wheels that you can control and manipulate. Although certainly you can get better at managing them with time and practice, it is best to remain humble in the face of ecstasy, and to recognize that

ecstatic states have their own will and desire that is beyond our will, as Janet learned here:

Getting Lost

I spend a lot of my time lost. It's kind of a state of being for me, and I don't fight it much any more — I'm on my way somewhere, and I think I know where I'm going, everything looks pretty familiar; and then all of a sudden it doesn't, and there I am again, lost. And I don't mind when my friends tease me about it, and I don't even get too frustrated when it makes me late to things — sometimes I find something cool while I'm wandering around looking for a landmark. The main thing to remember is that I always find my way home eventually — I'm sitting here writing this right now, right?

Once in a while, though, it's late at night, and I'm by myself in the car, and the terrain outside looks frightening, and the gas gauge is ominously low (I habitually drive until the little gas tank on the dashboard flashes danger red), and I snap down the door locks and I'm lost lost lost and I utterly forget the part about somehow always getting home OK.

Which brings me somehow to a big room in a rural retreat in Sonoma County filled with pairs of women breathing hard. There's a boom box playing New Age music somewhere in a corner. I've spent the whole day doing tantra exercises, some with Dossie, some with other women, and I'm running enough sexual energy to light up a small city. Dossie and I have met for the final practice of the day; we are both tousled, sweaty, tired, exultant, aroused and ready (we think) for whatever will happen next....

She plops onto my lap, breast to breast, crotch to crotch, and wraps her arms around me; we press our mouths together, leaving a little room at the sides for oxygen, and begin to share breath — my exhalation becoming her inhalation, back again, deeper and stronger, the breaths becoming groans as our pelvises begin to move back and forth and we press closer together.

My energy penis twines up into her cunt, locking us together in exaltation. I am distantly aware that there is a storm rising in me, a big one, bigger than I have yet experienced; it pervades and then engulfs me. My cock begins to pull me up into Dossie, lifting my hips up from the floor, and a flood of heat opens my mouth, and noise begins to come out of me, high-pitched, tearing my throat open; she is riding me like a bronco. "EEEAAAAAAA..." Some part of me is aware of the sound, cannot believe it is coming out of me, is frightened by it. My body is arched like a bow, lifting Dossie's weight and mine high off the ground. My face is stretched wide open and still the sound comes. I suck in another breath and go on screaming as the energy arcs up my body in wave after wave. My fists are slamming into the floor and I cannot find my way out of the breath. The distant part of me thinks of seizures, of strokes, of torn muscles — can my body sustain this ecstasy?

But, apparently, it can, and it knows its own way out, knows its landmarks. Soon enough — Dossie tells me later she thinks it was about a minute and a half — the tidal wave begins to recede into smaller waves, then into ripples, then into a calm, if considerably sweaty and disconcerted, peace. I open my eyes and Dossie is peering into them, looking half delighted, half

concerned. I giggle. "What the fuck was *that?* Jeezus!" And then, like the child who gets off the roller coaster and walks halfway down the midway before the scaredness hits, I fall apart. "That... that was *scary*... I didn't know if I could *stop*." And I burst into tears, cry my way through everybody else joining hands and singing, cry in Dossie's lap until it's time to pull myself together and go home. I talk to the instructor and tell her what happened, and she gives me some ideas about what might have happened, how to take care of myself, how to prevent such a frightening thing from happening again if I didn't want it to.

The next day, though, I decide to take it very easy, to spend most of the day soloing, to keep things low-key. I keep my energy very contained, have a few quiet small waves all to myself — and discover they feel pretty much like the previous night's tsunami, just smaller, and that my body knows its way into this process and back again quite well. And I realize that all I've done is found a new way to get lost, and that getting lost is part of who I am.

I am never going to be someone who follows an exact path or who knows where I am all the time, and that means that often I'll be disoriented, and sometimes I'll be frightened. And it may mean that sometimes I'll get hurt. But for me, the path to ecstasy is not the path from Here to There — it's the random streets I wander when I let myself get lost.

Catharsis and purgation

It's important to remember that not all ecstasy is about happiness ("a state of being beyond reason or self-control," remember?).

Ecstatic states may serve an important purpose by awakening catharsis for grief, rage or other difficult emotions. While these may not look like as much fun as energy orgasms, they are often, in our experience, at least as profound, and in an odd way as joyous, as their more lighthearted counterparts.

During much of the time that we were writing this book, Janet was mourning the loss of a long-term relationship. At one point she wrote:

There's very rarely a day lately in which I don't cry.

I didn't used to be like this. I can remember when tears were a very unusual event for me, something that happened only in moments of great stress or crisis, often months apart. These days, I'm talking on the phone with someone and I start to cry, or I'm sitting here in bed writing and I start to cry, or I'm playing with someone in a nice scene that I thought was going to be hot and erotic and fun and pow, there I am crying again.

I don't like it. I feel leaky — like the membrane that holds me together has suddenly developed little holes, and if the force behind it gets big enough those holes will tear and I'll just dissolve, just a big messy puddle of Janet that can't be stuck back together. And besides, it's boring to cry and cry and cry, and I just can't believe that one nose can produce that much snot, but apparently mine can.

Today I was playing with a friend. He was spanking me, a nice long warmup with his hand and then with a little leather paddle. And I just couldn't stay there with him. My mind was straying backward into the past and then rocketing forward into the future, and the thighs that I felt under my hips were the thighs of every man I've ever played with except him. And I told him I needed to stop,

and I cried for a while. I could have gone on crying a lot longer, probably should have, but I just didn't want to because I'm so, so, so sick of crying.

A month or so after Janet wrote this, we both had the opportunity to participate in one of the extraordinary body rituals put on by Fakir Musafar and Cléo Dubois, rituals devised for the express purpose of allowing people to achieve ecstatic states through intense sensory experience. Here is Janet's account of how the ritual enabled her to process that blocked energy into a healing catharsis:

> Through the years, Fakir and Cléo have used various techniques, mostly drawn from body rituals in universal spiritual practices, to achieve altered states and ecstatic journeys. The one they're mostly doing right now is adapted from an Indian ritual. We spent the morning listening to them discuss the day's plans, watching videos of the tai pu sam festival in Kuala Lumpur and some rituals Fakir and Cléo have led. Then we warmed up and raised energy with flogging and light play-piercing.
>
> During the break, we had snacks and drinks, and were invited, if we liked, to draw a tarot card from various decks spread on a large table. The one I drew gave me a shock — it was the King of Swords, from a deck dating from the late '60s, and it could have been a portrait of the lover from whom I'd recently parted. Well, so much for any ambiguities about what I was here for today.
>
> Then Fakir and master piercer Raelynn Gallina worked to place two large-gauge piercings on either side of each participant's upper chest, following the needles with two large, scary-looking hooks, about three inches long. One end of a strong nylon cord was tied to each

hook, and each of us was given a mountaineer's carabiner. We could choose to attach ourselves to one another — in couples or groups — or to a stationary object.

The drumming started, and everybody began to dance — mostly slowly and cautiously at first (it reminded me of the feeling of stepping slowly into very cold water) — then more daringly as we got used to the feeling of the hooks, which was painful but not unbearable.

While I could see and hear that many other participants had gone into a joyful space, with lots of shouting and laughter, I went into a space of deep sadness, loss and mourning. I danced with Dossie for a little while but then asked to dance alone. I attached my hooks first to an overhead point, then to a point at my feet. I pulled gently and then strongly, wove back and forth, leaned backwards and let the hooks bear some of my weight, all the while with my face contorted — it felt as though my mouth were stretching wider and wider, trying to open up and scream but unable to release what was inside — and tears running down my cheeks. A few of the people serving at the ritual came by to make sure I was OK, but I waved them away.

Dossie came back, and by then I was ready to be with her. We hooked ourselves together and danced close, and with her there to ground me I was able to release howls of pain and sadness. I began to stamp my feet as I danced, hard enough to bruise my soles and to send shock waves up my legs and into my hips and torso. BAM. BAM. BAM — every stamp sending another jolt of my pain down into the earth, which could receive that and more without noticing at all.

Finally, I became too tired and dizzy to feel safe on my feet any more. We sat together and watched the other dancers wind down, which was quite beautiful and joyous to watch. One woman was on her knees, her body stretched backwards perpendicular to the floor, her hooks attached to chains from the ceiling so that she was suspended by the skin of her chest, her long hair spread around her in a black rippling fan, her face a study in bliss. Groups of ten and twelve people were fastened together like daisies by a central carabiner, jumping and shouting to the music. The drums slowed, reluctantly recognizing the limits of the flesh if not the desires of the spirit, and finally came to a halt, as Dossie and I cuddled, and I blew my nose and prepared to re-enter reality.

A feast was spread in the middle of the space, so we ate and had some water and tea to drink. When I felt OK to drive the twenty minutes or so between the playspace and my loft, I came home (to find my next-door neighbors having a very loud party — well, I guess we each have our own forms of release).

The next day I felt sort of like I'd been hit by a very large soft truck: achy all over, wrung out, drained, a little wired; but cleansed, and very glad to have been there. Another time, I'm sure the same ritual would hold a very different experience for me: perhaps I'd be hanging blissed-out like the girl with the long hair, or dancing in one of the daisies. But mourning was my job that day, and the ritual was the right place and the right way to do it.

Connection, clarity, creativity

And when the firestorm of bliss has passed, and we are left limp and awestruck in its wake, what a magical time that is!

The time spent coming down from an ecstatic journey is very special and precious, and uniquely vulnerable. While it often feels as though we're back in normal consciousness, frequently we are not — this is not a time to undertake a long car trip or to discuss the family budget. It may, however, be an excellent time to enjoy more mundane sensory pleasures like food or sex or a visit to nature — the senses are very heightened during this time of lowered boundaries. And it may most definitely be the time to reaffirm our connection with those we love, with words if that seems like the best way, or simply with loving touch, cuddling, warm hand to silky skin...

Many of us also find the minutes or hours after an ecstatic journey to be a time that gives us special access to our creative powers. Most of the foundations of this book were laid the mornings after scenes the two of us did together, as we sat in the sunshine in Dossie's or Janet's living room, drinking coffee and frantically jotting notes on legal pads, trying to keep up with the rush of ideas. Transcendent experience shakes up our brains, unsticks thoughts that are in danger of getting entrenched, frees us up to think in new and dangerous ways.

And perhaps best of all, we find that ecstasy changes us, maybe permanently. We're never exactly the same people after a blissful experience that we were before. We learn, we expand, we shift, we grow... and we prepare to do it all again, preferably as soon as possible.

How We Get There

Beginning the journey

Good SM, like all good sex, involves a transition from our everyday mundane grocery-list state of consciousness to another state — the state of excitement. Someday the scientists will be able to tell us what interactions of neurotransmitters, what parts of the brain light up, which dim down, what shifts in brain waves are required for the trip to turn-on. What we know about starting the journey to transcendent eros is gathered from a lot of sources, much of it our own years of practice in SM, and explorations of other spiritual practices rooted in the body: yoga, prana, ritual dance, drumming, western-style tantra — and, let's not forget, sex.

What they all have in common is following a path in the body to transform what is going on in the mind. We will describe for you techniques of shifting consciousness that have worked for us and people we know. We want you to know that it's fine to experiment with these scripts. You can change anything and try it a different way, and the order in which we describe various techniques and sensations may be different from the order that works for you.

There are no hard-and-fast scripts, no "right" ways — there are only the ways that work for you and your partners. Try things different ways, and if you light up with pleasure and joy and arousal, then you're doing it right.

Letting go

The first task in setting off on the road to ecstasy is to clear away the obstacles. Release mundane worries, forget about the bills, free yourself of any of the daily trash that you trip over in ordinary consciousness.

Dossie likes to do a lot of preparation in order to cast off all her cares and woes. She prepares food and drink as for a long journey, cleans the house, changes the sheets, puts out the toys, cleans herself (squeaky inside and out), dresses in costume, sews on the buttons. She takes care of all the details that she can think of, and the process both satisfies her anxiety and starts getting her excited as she fantasizes about where on the soft freshly vacuumed rug she intends to get ravished. She likes to wash away worries and cares as she bathes and shaves, imagining all the distractions whooshing down the drain, transformed into compost.

Janet uses a different sort of checklist to take care of her preparation process:

> To have the kind of experiences we talk about in this book, the first thing I have to do is want them.
>
> Sounds obvious and simple, no? Well, not really. These experiences aren't always easy to have: occasionally they're scary, often they're deeply moving, once in a while they alter your life. And that's not something I always want, or should want.
>
> To travel in the realm of radical ecstasy, I have to let go of many of the things that keep me safe in the rest of

my life — my identity, my coolness, my worries about how I look or what people think of me. While these are important things to have — they help me do my work, maintain my relationships, find my place in my world — they are all mediators of my experience, filters that alter the way I see and the ways I'm seen.

Irony, that ever-useful Swiss Army knife of 21st-century culture, is a very good way to appear hip and knowing, and a very bad way to travel through inner and outer space. Irony is a way of holding the world at arm's length, of saying to the universe, "Oh, did I say that? — well, surely you know I was just kidding." Which means it's also a way of holding myself at arm's length, of building a wall between what I'm really feeling and what I think I ought to feel. Out it goes.

Self-consciousness: very important. If I don't know how I appear to others, I will say and do inappropriate things; I'll dress funny and walk weird and make the wrong facial expression. Self-consciousness is an inevitable outgrowth of self-awareness, I guess. But it's also a way of creating a second self, the "me" that I see as other people see me. And only one of me gets to journey in these lands: the self that's as close to my core as I can get, my undecorated soul.

Fear — now there's a two-edged sword. Without it, I'd walk into danger every day. Fear is the parent that keeps me from running into the street, the cop that keeps me from slapping the obnoxious sales clerk, the vertigo that sends me staggering back from the edge of the abyss. But sometimes the abyss is exactly where I want to be... so I must give up my fear to you and to the scene we do together: trust you not to laugh at me, not to betray me, to

cherish the naked pink vulnerable self I'm giving up to you.

Distraction, one of my favorite addictions. How can any one problem become too important when I have so many to keep my mind whirling? Did I feed the dog? Will today be the day I overdraw my checking account? That cute woman I met at the last munch, did she like me? What's for dinner? — a soothingly familiar agitation, meaningless and omnipresent as Muzak. But how can I be there for you, totally focused on you and on whatever we're building between us, when my brain is skipping like a pollen-seeking bee? So out with distraction, perhaps the hardest of all to relinquish.

So: here I am, just me, as pure as I can become. I am touching you, hoping that you are as naked as I, no walls between us, all the filters gone. Let's play.

For most people, what works for releasing whatever needs to be let go is just that: *release*. If you find yourself holding onto thoughts or patterns or emotions that are getting in your way, just notice them, unclench your psychological hand, and let them float away. You don't need to push or shove, or beat yourself up for having the thoughts or feelings — just let them go.

Think for yourself of all the ways you can do the equivalent of taking a psychic shower. Imagine washing off your bad body image stuff. Imagine a box in which you could put your resume, your job search, your boss, your taxes; close the lid and lock those things away until you are ready to deal with them. Put the key somewhere comfy and give it a rest. Imagine yourself in a beautiful environment, dancing with nymphs and satyrs. Imagine whatever you like to imagine while you're getting to sleep or masturbating. Your imagination is a powerful tool: imagine a movie in which you are the gorgeous, confident, powerful star — rehearsing for a great performance.

Because when you get ready to do a scene, that's what you are doing — getting ready to be a star. A very bright shining one.

The breath

So you think you already know how to breathe? Chances are you do, if you're reading this. But there is an amazing amount to know about breathing — another never-ending exploration. We have borrowed wisdom about breathing from yoga practice and from bodywork therapies, starting with Wilhelm Reich, who indeed borrowed his ideas from yoga. Here are some new and interesting ways you can play with your breath.

Put your hand on your belly and take a deep breath and hold it. Pay attention to how your belly feels, your shoulders, your face, your sense of yourself. Now release the breath thoroughly — let this take a few seconds — and register how different you feel in your body and in your mind. First principle of breathing: holding the breath adds to tension, physical and mental. Releasing the breath promotes relaxation.

Take a few slow breaths and let yourself relax a little. Let the air flow without halting it or holding between the ins and the outs. Now imagine that the air you are breathing in is cool and fresh and blue, and that the air you breathe out is orange and hot. Imagine that the more of that hot orange air you breathe out, and the more cool fresh blue air you breathe in, the more comfortable you become. Imagine breathing out all your tensions into the hot orange air, releasing any charge, any burden.

There, you've done your first breathing exercise. Now you know how to increase and release tension — very useful in sex and play. Just about everybody builds up a lot of muscle tension as they approach orgasm, so if you want to last longer and not come yet, you can learn how by physically relaxing your body and slowing your breathing. And if you feel that a whip or a clothespin is getting

challenging, you can relax your body and let the pain flow through you with the breath. And when you do that you will feel more. Take more, too. And have more to give.

Further breathing tricks we learned from tantra are about raising eros in whatever form you like by breathing like a pump. First, you need to know how to squeeze your PC muscles. These are the pubeococcygeal muscles which stretch like a sling between your tailbone and your pubic bone. Animals who stand on four legs don't need as strong PCs as we do, because their internal organs hang down tidily from their spines, swinging freely. But we stood up, and developed strong PCs to keep our internal organs from falling out the bottom. And, lucky creatures that we are, lots of our sexual nerves travel with the PCs.

To find the PC squeeze, move the muscles you use to open and shut off the stream of urine when you pee. Those are the front PCs. Then squeeze and release the muscles you use to control taking a bowel movement. These are the rear PCs. Doing PC squeezes will also get you a little turned on (goody!). This is a fun way to find or increase your turn-on during sex or play. You can practice anywhere — in line at the bank, for instance. When you get good at it, you can amaze anybody who has some part of themselves inside you.

The breath used in tantra as a pump for eros is an undulating breath. Sit on the floor with your tail on the edge of a cushion, or on a chair with just enough of your butt on the chair to be comfortable. Take a breath in, and simultaneously rock your pelvis so that your pubic area pushes downward toward the chair. This will arch your back, bring your chest forward and up and, if you let the movement follow up your body, bring your head up. Try that a few times. That's the in-breath.

Now, while breathing out, rock your pelvis forward, which will bring your pubic bone up, make your belly and chest curl up and your head go down. That's the out breath. Try it a few times to get the hang of it.

Now we put them together, sensibly enough, inhaling while rocking the pelvis back and arching, exhaling while rocking the pelvis forward and curling. Arch and curl, that's the motion. Like your pelvis is a hinge, opening and closing, and the rest of your body follows like a wave. The tantrikas call it undulating.

You can also do this breath lying on your back on a firm surface with your knees, pushing a little with your legs, that same rocking undulation.

When you get good at undulating, you can add the PC squeeze. Most folks start by squeezing on the in-breath, and releasing on the out-breath, as if your body was a big pump that could draw up eros from the earth like hot red water to fill up your body with excitement and turn-on. (Other folks prefer to release on the in-breath and squeeze on the out-breath. One of us does it one way, the other does it the other. We don't care which way you do it, as long as you're pumping up plenty of hot energy for yourself.)

As this breath starts to work for you, pay attention to how you feel, physically and emotionally, and what you are imagining. It's lots of fun to practice this and fantasize at the same time. That's a good way to get familiar with the process of your own turn-on.

As the energy gets stronger, practitioners often speed up the breath, maybe with a loud noise on exhaling, like "Hah!Hah!Hah!Hah!" or any other noise that works for you. This will feel silly at first, but if you give it enough time it will make you very happy. As you get more excited and move faster, you may find yourself doing it differently, curling on the in-breath and squeezing on the out — that's fine, whatever works. If you lose the thread, go back to how you learned to do it first and carry on from there.

Breathing like this is intoxicating: it will get you high. If you feel dizzy or uncomfortable or further out than you want to travel today, slow the breath down and make the exhalation longer than the inhalation.

When your authors do this breath together we get really loud.

Here is a story of a scene Dossie played that started out with the easiest breath.

Slow Hand Trance Dance

It's not easy to find language to write about a person as gender-queer as the one I'm flirting with. Only two pronouns to choose from to describe this friendly, sexy person — not enough. Crewcut, slight beard, abundant tits, that sexy testosterone-rasped voice that promises all the horny surging hormones of a fifteen-year-old boy in a substantial warm body, and the connected sensibilities of a thoughtful woman — mmmmm. Best of both worlds — I love people who defy categorization.

"Do you prefer he or she?" I ask politely. "He, and thank you for asking," he responds, settling visibly. Which is fine by me.

He explains to me that he has a hard time with stingy sensations. Later, when I told my buddy Fang about this, she collapsed laughing. "Oh, the poor innocent had no idea who he had run into." Fang knows about me and sting, she has felt my cane before.

Well, it *is* sort of like telling Dracula that you're a little phobic about blood. So I let the cute boy know that I think I could help him with that, put my wicked grin on hold and we talk a little about limits. Poly agreements, his partner is at this party; pants on (his); wants it on his back; no ropes, claustrophobic. So he takes off his shirt and it's pants and boots and a broad strong back, complete with freckles. Very nice.

I'm wearing my front, a studded leather garment I devised that looks like a superhero with cleavage from

the front, and utterly nothing on the back but a few criss-crossed bootlaces that hold it on. Lots of skin — whenever I wear it I get petted a lot. Yum. Stockings and heels, of course; black, of course, with a loose mostly unbuttoned black chiffon dress over it all that keeps me a little warm and you can still see through it, if you like. We look good.

The party is in a set of crowded hotel rooms cleverly organized at the end of a corridor. A portable screen bars the gaze of the uninvited, and relays of volunteers make sure that entry is forbidden to the uninitiated. Hotel beds are stripped and re-sheeted to accommodate softer landings, and a bondage table and portable sling have been set up in the "living room." We find a spot on a couch, where he kneels on the cushions and rests his elbows over the sofa back; this lands him at a good height for me to work on. Two other women are sitting on the couch — fine, there's plenty of room if we're friendly. They will duck when I swing.

I am teaching a technique here, as well as playing a scene. It's been said that the last stage of learning is teaching, and so as we go along into the play, the connection, the turn-on, a part of my mind is registering what I do and why, how does it all work, so I can relay all that later. Right now, what I want is to get him entranced and deeply relaxed.

First I show him the breath. "Put your hand on your belly. Breathe in deep and hold it — pay attention to how you feel. Now breathe out even and all the way. Keep breathing, keep breathing. Feel your torso relax? Keep breathing. If you tense up, you won't be able to let the sensation in. And I want you to feel a whole lot. So I want you to remember to breathe. I'll help you."

I'm touching his back, his shoulders, his head, crewcut silky on my fingers — firm strokes down his spine, smooth, soothing, nothing tickly or sharp. Arousal will come later, this is about going down, down, down. I kneel behind him, my thighs holding him, and press myself against his back, my arm around his chest, and breathe with him. I can feel the energy in his spine rising, his heat rushing up to meet me.

I first learned about the breath when I was about thirteen, from a Readers' Digest article written by Wilhelm Reich, believe it or not. This would be about 1957. He pointed out that we don't exhale enough. I tried breathing per his instruction, and it helped with my asthma. Later I learned a lot more about how breathing relates to feeling, through yoga and meditation and childbirth.

One useful fact I learned: our bodies are hardwired to perceive the excess of carbon dioxide, not the absence of oxygen, as the signal that we are in danger of suffocating. In the presence of too much carbon dioxide — perhaps you have felt this in a crowded room — our bodies get defensive, we are struggling to breathe. So there are concrete physiological reasons why holding the breath can lead to tension and panic, and releasing the breath leads to relaxation and feeling safe.

In a massage workshop I learned to deepen a person's breath by placing a hand on the belly, lifting it slightly on the inhale so the stomach will reach for the warmth and take in more air; and pressing down lightly on the exhale to encourage further release. This is a good way to take control of someone's breathing. And their psyche.

Here on this couch at this party, I'm using another trick. Surrounding my bottom with my body is at once comfort and intrusion. My face close to his, my belly on his back, I follow his breathing for a bit, until we are easily breathing in tandem, and then I slow my breath down, just a little, and he slows down with me. Got that trick from Neurolinguistic Programming.

So we breathe till I get him real slowed down. My goal is to top my bottom's relaxation, to carry him into a trance state. So I continue till I feel his energy deepen, as if I could collect him under me, and then I get up, careful to keep my hands on him not to break the connection, and start shaking his shoulders, loosening his back. By moving his body with my hands and without asking, I am taking more control.

He is deeply entranced now, and responding to me very nicely, so I start punching his back with the soft outside of my fists, introducing a new level of intensity. I like this, feel my energy rising up to charge through my arm with a full-body smash, as if I could punch my energy into him.

I start to alternate the punching with a knee in the crotch — it would be too early, a distraction to go for erogenous zones, but some generally wide-spread attention to the crotch is nice for waking up the first chakra. I can feel red heat running up his spine, and my hands are attracted to the nexuses of power — the chi, the heart, the throat. I grab his head to my chest and hold my hand over his third eye. It pulses. He sees me.

He's ready for some challenge, I judge, so I pick up a thick heavy flogger and set the energy flying through the air — softly at first, while I get my aim and he adjusts

to the new sensation. One of the onlookers pushes the crowd back to make room as I step back for a bigger swing. When we have sunk into the rhythm of the flogger, I up the intensity, striking the broad muscles of the back with all my strength as if I could pour my power into him. I'm talking to him now like a labor coach — "Keep breathing, yeah, that's good, I like that, yes!" And if I am the labor coach, I wonder what he will give birth to. I especially want to honor the magical creativity of the bottom.

I work the flogger up to a string of truly brutal blows, hard as I can put out, loud, yelling at him to breathe, to take it in, and he stays with me till I throw down the flogger and throw myself over his back again. We catch our breaths as I reach for the cane.

The cane is my favorite implement for a pain-trance scene. I have two with me that I varnished myself — about half an inch thick, sanded and burnished with layers of marine varnish to glow like lacquer. I had soaked them in the bathtub of my hotel room last night, so they are supple and weighty — a dry cane is too light to carry the sensation deep into the body, and can be very stingy without much reward. It's also my experience that rattan canes give a little as they land, some very strict version of sponginess, so I prefer them to canes of less resilient materials.

I start tapping his back with the cane, and he tenses, scared. "Keep breathing, you're all right, you're just fine, I want you to stay down for me, honey, that's sweet, yes." I tap around lightly till he relaxes again, gets into the sensation, forgets about what might happen next, he's in the present moment, which is exactly where I want him.

I hold the cane across his back and instruct him to take a deep breath, breathe it out, again in — I'm taking more intimate control of his breath and the flow of his energy. At the end of an exhalation, at his most relaxed, I slash down with the cane and immediately, with my other hand, rub hard across his back to wipe out the sting.

This is a technique I was taught years ago — if you wipe out the sting from a cane before the muscles have time to tense up, then a lot of amazing sensation gets into the body and kind of reverberates, which is so fascinating and compelling that one forgets about the sting. It is important to leave time after each stroke so the bottom can fully process the sensations before you strike again — too many strokes too close together too soon can lead to involuntary and uncontrollable tension and resistance. It's also a good idea not to hit the same spot over and over again — the skin, I think, gets raw, and then the cane can feel too sharp, not the right sensation.

So I massage his back while he feels the cane's blessing rolling around inside him (at least, that's how it feels to me!), and wait till his breathing slows before again telling him to take a deep breath, let it out to my pace, I slow him down till he feels ready and slash and rub again. We find a deep slow rhythm, one strike then another, each time a complete experience. I explore different spots on his back — limited a little by needing to have both hands in position, one to strike and one to rub, but his back is broad, his shoulders are strong, and I'm not going to run out of skin soon. He is breathing with me beautifully — at first he had gasped for breath, and I would wait until his breathing slowed down again, blowing on his back to remind him to breathe. But now he is taking

the cane in without tensing at all, just blowing out his breath through the intense part, and taking in a smooth long drink of air as the sensations do their thing inside him.

So now he's got it, he knows how to do his part in taking in the cane, and I can up the ante. I start hitting sooner, on the edge of what he can process, and harder, now that I've got my aim down. He's breathing with me and it feels like we are one thing, two people doing their parts in riding one energy as the cane flies faster. Soon we are whirling in the center of a hurricane — me shouting, "Keep breathing that's great excellent I love it you're so good yes!" and his body clear and flowing under my cane. Wow.

We do this for a while — I'm entranced too, and who knows how much time is passing — later, I think this whole scene took about two and a half hours. While I was in it, there was no time but the next breath, the next stroke: when we are so connected, the top gets pulled into the present too.

Now he has entered what I call the Forever Place, and we could, indeed, do this forever, except that we are, indeed, mortals, and my arm will wear out eventually. So we dance in the storm for a while, and then I get close to his face and hold him and whisper, "You could do this forever, couldn't you." He grins, it's true, I tell him that we will have to find a way to get to closure, and ask him to pick a number from one to seventeen. "Seventeen," he replies instantly, not a moment's thought, just wants more. Yummy. So I beat his back with all the force I can muster, and am gratified to see welts starting to come up — this from the boy who couldn't take sting! And we are still one being, riding a tidal wave of sensation.

So who can count? Eventually I figure we should stop, so with a few last seriously vicious strokes, I take him in my arms and just tell him we need to end. I sit on the arm of the couch, and he throws himself into my arms and shakes for a while — I hold him tight, the connection is bliss, there is no reason to go anywhere, we are perfect right where we are. We take plenty of time to return to a more ordinary state of consciousness, enjoy our blissed out wildness while it lasts.

When we finally get up, and pee, and eat something, and land back on the planet, he makes love to me very sweetly — another long slow scene, very sensual, very hot. He gets me all slowed down with infinite patience so I get to go on another trip. And we get high again, and he turns into a cougar and bites me all over, and I turn into a snake and writhe a lot and it's all sweetness.

And light.

Connection

When you set out to play with another person, first you need to make connection. This is the beginning of warmup, foreplay, trance induction, whatever you want to call it. The breath is a powerful way to make connection. Some people like to lie like spoons and relax as their breathing synchronizes — it will fall into rhythm even if you don't try. Spoons is nice, lots of skin, sensual touch, warmth, cuddly feelings. You can also sit tantra-style (the tantra folks call it yab yum), facing each other with your legs wrapped around each other, and share the breath while gazing into each other's eyes. Some say the eyes are windows into the soul, but we also note that sustained direct eye contact is rare in normal social

interactions, and tends to generate, after perhaps a little embarrassment, a sense of deeper intimacy.

If you sit yab yum, you can undulate together, which is very sexy. You will very soon discover that the out-breath can be a form of dry humping, with your crotch banging against your partner's. If this isn't working right, you can adjust your pillows to bring you to the right heights. And since you are going to practice your breath for a while to get to a truly trancy state, the dry humping needs to be entered into without being in a hurry — so what if you're turned on, you've just begun, and it's not time to get off yet. We want to do this for a long time. Think of when you were a teenager and you could kiss for hours. Try alternating breaths, breathing in and out of your partner's mouth — more connection.

Other ways of connecting are also about aligning the energies of our bodies. Dossie recalls a top who, after securing her in standing bondage, just stood close behind her for a while, where she couldn't see, not touching, just there. The connection built palpably while they were doing utterly nothing.

Skin

Touching skin is another happy way to make connection. Start touching shoulders, necks, arms — warm touch, light touch, sensual touch, delicious touch. Focus on what you are touching. Move your hands very slowly. If you are the dominant this time, you can imagine that you are collecting everywhere you touch, making it your own. If you are the submissive, you can imagine that you are worshipping everything you touch, making it sacred. Imagine your own fantasy. Take your time, touch for the sake of the delight it brings, stay in the present, the future will get here soon enough. Dossie finds being touched feels to her like little swarms of snakes traveling inside her body to meet where her friend's fingers are trailing — she feels the flow of energy opening up as her friend

wakes up her skin, and all the nerves become roads from the surface to somewhere deeper inside.

Touch may or may not lead to immediate sexual arousal or desire for orgasm. That may happen later, or not at all. Stay in the moment and stay with the touch, and enjoy it for what it is, and let whatever happens go ahead and happen.

Sounds and senses

Another path to trance and turn-on operates by playing with the senses, putting them to unusual uses, giving our senses something else to do, breaking our minds out of their habitual algorithms. The blindfold is the simplest form of sensory deprivation, and has the effect, for many people, of shutting up the verbal thought train and the nagging voices of self-doubt along with vision. Oddly, wearing a blindfold may make a bottom feel safer, less exposed — even though they are more dependent on, and thus more connected to, their top. Helping someone walk around the room while they are blindfolded will probably get you very connected.

Music and rhythm are tremendous stimuli for trance and turn-on. Choose your music carefully. You might want a slow rhythm, or a faster sexy rhythm. Consider avoiding songs with words in any language you understand, as we're really trying to get away from the language centers and into less commonly traveled parts of our brains.

Silence is powerfully sexy. Your authors once played a kidnapped-pleasure-slave-training scene in which they pretended that they had no language in common. Communication was entirely through touch and body movements, and it worked. We both got very into it and flew out of reality for a while.

Rhythm, especially anything polyrhythmic (that means more than one rhythm at a time, most highly developed in wonderful

African ritual music), sends most of us into trance; and dancing to polyrhythmic music, as we have described elsewhere, can be a journey in and of itself. It can be very trancy to be a drum, getting beaten with two hands or canes by a ritual drummer, and to feel the rhythms take you over as you fly away into drum-ness.

The chakras

The chakras are junctures, spots where many people perceive intense energy: seven points along the spine, sometimes represented as a caduceus with coiling snakes, or glowing spots along an inner flute, or disturbances in a waterfall. Here is a list of them, with their traditional colors and locations. There are many individual differences in where we feel them in the body and what colors we might see, so please understand this list as places to start looking.

> *First Chakra: Root. Red, base of the spine, genitals or anus, connection to the earth.*
>
> *Second Chakra: Sex. Orange, where your womb is or would be, sexual turn-on.*
>
> *Third Chakra: Power. Yellow, solar plexus, center of gravity, chi.*
>
> *Fourth Chakra: Heart. Green, middle of the chest, emotions.*
>
> *Fifth Chakra: Throat. Sky Blue, center of the neck, speech and peace.*
>
> *Sixth Chakra: Third Eye. Midnight Blue, between your brows, vision.*
>
> *Seventh Chakra: Crown. Violet or white, slightly above your head, connection to the universe.*

Following is an example of a chakra visualization taken from Dossie's meditations. She likes to work with the snake image of kundalini. You will find out what you like.

The root chakra at the base of my spine starts out with connecting to the earth. I feel it at the base of the spine, as a sexy red swelling, especially at my asshole. Here we can let go of anything that no longer nourishes us — compost all our cares and woes, grow roses from shit. The root is also a gate of entry, where we can welcome into our bodies intense sensation, sexual penetration, and the red hot energy from the core of the earth. What I imagine at the root is a small snake that forges a path into my body through my anal sphincter, which feels both scary and sexy to me, and then climbs up my spine, pausing at each chakra for more focus. I got to know this snake through a garter snake who lived under my house, and came out and draped herself across our doorstep whenever we did ritual with drums.

She climbs to my second chakra and fattens in the womb, coiling thickly, glowing orange in the crucible. Her skin gets tight and she needs to crawl out of it, like getting born.

Thicker and more invasive, me breathing harder, she progresses up my spine to the third chakra at the solar plexus, where I see a yellow sun whirling into spirals, sometimes shooting out swarms of tiny snakes, and the feeling is of strength, central heating, source of tremendous energy and personal power.

From here Snake crawls up my spine to wrap herself around my heart, constricting rhythmically to massage that muscle and soften up my emotional center. Now I feel harmony and sweet unconditional love. If sadness or fear shows up, my snake comforts me. Bright green ivy sprouts out around the snake and spurts all through my body, tendrils up my arms and out my fingers, branches

down to my feet with roots digging into the dear sweet earth. And I get happy. A big foolish grin on my face, yelling with the breath, I am a child without a care in the world, giggling with delight.

Flowing up from my heart to the fifth chakra in my throat, Snake grows huge, charging up to fill my whole body like the trunk of a tree, I am stretched around her. In my throat, she opens her jaws very wide and I yell, I bellow, I scream, I whisper syllables in no particular language, I hiss contentedly. When my throat opens, I feel a tremendous love of my truth, my feelings are clear and real and important. I might cry. Sorrow, grief, anger, joy — the entire range of feelings, shouted out in enthusiasm.

Then Big Snaky pokes her head up into my skull and peers around. She sticks her tongue out through my forehead, as snakes do, testing the air for smell and taste and warmth. A big red eye opens up on the top of Snake's head, above the two eyes with their vertical pupils: her Eye is mine.

The night sky arches over us full of stars, mystery of darkness, gateway to dreaming, so we play in visions for a while, till Snake gets impatient.

The crown chakra, at or slightly above the top of the skull, is the seventh and final nexus. My skull resists this final opening, like a shell resisting a hatchling, and Big Snaky pokes her head against the roof and pecks and butts until the bone splits and she leaps up to the stars, her mouth gaping open to suck down sheer white light into me. The feeling is brilliant, shining, I know for sure that the cosmos is full of love, that I am loved, everything in the universe is love, love is the real cosmic principle, the initial force from which everything else flows.

And I am strung on Snake like a bead on a string,
on kundalini's journey from the earth to the stars. She
flows, and I get to ride.

That's how I do it. You, of course, will do it your
way, which will also be wonderful and amazing. And
different. And yours.

Ritual containers, ritual paths

When we talk about ritual, many people assume that we're talk-
ing about something formal, with candles and incantations. That
kind of ritual works for some people and not for others, but it's
not necessarily what we mean when we talk about ritual: part of
your morning ritual is probably brushing your teeth; your scene
ritual may have to do with turning down the lights, setting out the
toys, connecting beforehand with a hug or a collar.

Ritual has two uses (among many) that are important to how
we get into states of ecstasy, how we travel safely, and how we get
back out again. For our purposes, ritual can be like a container
that defines the mental space we are operating in, and that pro-
tects that space, keeping it, and us, safe and inviolate. We have
spoken already about how so much of what we do is about letting
down boundaries to find new paths, and to enter into more un-
bounded states of consciousness. So when we let down our every-
day boundaries, what will keep us safe? We can use rituals to set
and define sacred space. Many players borrow ritual from pagan
practices, and might make a circle around the space we intend to
play in with sage, or water, or herbs, and a prayer to banish every-
thing that doesn't belong in the space — anything intrusive or in-
harmonious from outside, and any distractions or anxieties that
might rise up from inside ourselves. For example, we might decide
to leave agonizing about the size of our bodies outside of this circle.
Some rituals make a place for that — a glass of ice water, or a trash

can. When you put parts of yourself outside the circle, you need to promise them that you will come back and reconnect with them when you leave the circle. Our cares and woes won't accept permanent banishment — wouldn't life be easy if they did? But they can learn to delay gratification. You might even provide them with a comfy place, like a baby blanket, to rest while you travel elsewhere.

The goal of setting a circle is to be in a safe and contained space, with its own particular rules, and where we intend to behave with particularly high consciousness. So we are protected, and reminded that we are sacred.

Dossie likes to walk a symbol path through the four elements when she sets up sacred space — air, fire, earth and water each contributing their own special wisdom to the endeavor at hand. However you make the space, and however you enclose it with your imaginary circle, when you are through, you will exit by reversing your steps: walking the circle in the other direction, blowing out the candles you have lit, with perhaps a few words of thanks for whatever wonderful journey you got to go on. Closure is important, and can be as simple as a warm cuddle until you are both ready to get up and go about life in whatever extraordinary way comes next.

When you pick your cares and woes back up, you may find yourself able to welcome them home with more insight and compassion than you had before you dropped them off.

The second use of ritual, for our purposes, is to create a symbol path that gets us to the state of consciousness we are looking for: the role we will play, the acts that will open us wider than we thought we could. Roles are in and of themselves the ritual, the story of the scene the myth we are exploring. Costumes can be symbols of shifting consciousness, and nakedness a further, sometimes scarier opening.

Breathing exercises, songs or chants, visualizations, and stimulations — stroking, beating, cutting, piercing — are all rituals we

engage in to open ourselves to our own and each other's gorgeous flowing life force, to connect to ourselves and to each other in a particularly profound way.

Magic-making

The roles we play, the costumes we wear, our collars and cuffs, the candles we light, how we turn bedrooms into dungeons by hanging up some chains, all this is setting up ritual as well. We are making a space and time in our lives that is set aside to be different. Dungeon or temple, this is sacred space, and we do well to come into it with good intentions.

We may play a character different from our everyday selves, or express a minority part of ourselves who doesn't get to be up front very often — we will discuss this at much greater length in the "Mind Journeys" chapter. We may be polarizing our roles, top or bottom, becoming intensely more dominant or more submissive; and in harmony or maybe in friction, perhaps pushing against each other, we push each other higher, further out.

Foreplay, bondage, rope, all the ways we set up scenes, these are our pathways as well. And while ecstasy can be reached along an infinity of paths, including the short steep ones, we've found that the most certain paths are the slow and gradual ones. We like short fast intense thrash-and-scream scenes sometimes too. But we suggest that once in a while at least, you might be pleasantly surprised if you enter into setting up a scene with the idea in mind of taking a long time warming up, setting up, breathing together, sharing massage, slow dancing, chanting or undulating. If you invest some time at the beginning, there will almost certainly be more rewards at the end.

You are, after all, not really in a hurry. You do intend to enjoy this for a while. If you start a scene or a ritual slowly, and take plenty of time at each step, you will move more smoothly into the

flow, travel further, and perhaps surprise yourself. Try something, oh, doesn't work, okay, let's try something else, and how about we rub a little skin in between to quiet down again: when you make friends with time, you can also afford to make mistakes.

What about orgasm?

Out in vanilla-land, orgasms are considered a pretty straight-forward phenomenon. There's one kind: you have it from genital stimulation; it goes on for a few seconds or maybe a minute if you're lucky; some women can have a few of them; most men only get one at a time.

That wasn't our experience even before we started working on this book. We were pretty sure we'd had the kind that everybody else described, the nice clear-cut binary now-I've-had-an-orgasm kind — but we'd also had ones that felt like we were skimming along the surface of orgasm without really dipping beneath it, and ones that felt like a huge wave that consumed our whole bodies without ever really especially involving our cunts, and a lot of different things that felt sort of like orgasms and sort of not. In fact, it seemed that there were almost as many kinds of orgasmic experiences as there were kinds of sexual experiences. Janet writes about this:

> When I first learned to come, I learned to squinch up my genitals, my face, my legs, pulling everything inward toward the center of myself, tightening every sphincter I have in my body plus a few that probably exist only in the noncorporeal plane. With exactly the right kind of stimulation to my erogenous zones, the proper tape running in my head, and a goodly dose of luck, all that tension struck a spark that flared up into — voilà — an orgasm!

Much much later, I learned to ejaculate — and all those skills were exactly wrong. I had to push where I used to pull, and open up what I used to close, and let go of what I used to hoard so jealously. And it was still an orgasm, but it was different — a pushy-outy orgasm instead of a pully-inny orgasm. I started wanting both kinds, not always both on the same day, but at least some of each some of the time.

And all along, I'd been having these other experiences during peak BDSM play — convulsions that felt like being grabbed in Something's teeth and whipped back and forth like a rag doll, huge waves that started at the site of the sensation and slammed outward toward my fingers and toes, whole-body quakes ranging from subtle tremors to somewhere off the Richter scale (I never fell off the table, but almost). During these, I wasn't pulling in or pushing out — I was beyond volition, helpless in the power of whatever it was that was shaking me.

I started to be able to feel them approaching, and to make preparations to welcome them. Sometimes I'd find myself bouncing or dancing, building rhythm, letting the inside of my head turn snowy white. Sometimes I'd feel myself inflating, my fingers and toes extending and quivering, my skin thin and tense as the skin of a balloon, impossibly full and getting fuller, waiting for the explosion. Sometimes I'd have visions, flames leaping, fireworks bursting, and I'd open up to their heat and feel it light the fuse that runs right up my center. I'd let go of my face and feel it contort, let go of my voice and hear myself making sounds I never dreamed I knew how to make.

Now, I go to classes and workshops about sex, I read books about sex. And they talk about learning

how not to squinch the way I used to, how to rreeeeelllaaaaaxxx. Well, OK. I think not-squinching is maybe a good thing, although an orgasm that you get by squinching is certainly better than no orgasm at all. But really, I think that the whole discussion of how to have orgasms is sort of beside the point.

I don't want to have orgasms, I want orgasms to have me. When an orgasm has me, I don't get to decide whether to squinch or relax, whether it's pully-inny or pushy-outy; it makes that decision for me. It makes all decisions for me.

But it won't take me unless I ask it to. So I dance, I inflate, I burn, I scream. My friends come and help. We do anything we can to get that bitch my brain to let go of me for just a little while, and then the orgasm, the energy, the universe comes and takes me, takes me, takes me.

A lot of what we've done in classic SM, though, is still aimed at the traditional genital orgasm. And in an SM scene, all too often, when one or both partners have an orgasm it means the scene is over. Orgasm works great for closure: everybody feels good, gets a release, and returns more or less naturally to a more ordinary state of consciousness. The transition is built into the physiology.

Yet so often, after playing with intense sensation or energy or roleplay or even sexual stimulation in the lengthy explorative manner that we think is typical of ecstatic SM, when the top goes for the genitals, or the vibrator, or whatever might take either or both of us over the edge to orgasm, we might feel a faint disappointment. We know we will be moved out of the transcendent state we are now inhabiting. It's almost over. The end is near. We have to come down. Dossie remembers:

I had a tantra date with a woman who was concerned that it wouldn't be possible for us to get close to each other without going for the genital, which was out of bounds for her. We had made an agreement about boundaries, that whatever we did in our energized state, it wasn't going to be genital sex. We went into altered space with massage, with some top/bottom energy, with holding and breathing and raising kundalini. And kundalini went up and up, way out the top, till we were breathing and laughing and shouting and sighing and breathing some more, playing with the third eye as if there were an electric conduit between hers and mine. Whenever either one of us moved a hand over the other's body, even at the back of the head (especially at the back of the head), the response was orgasmic: flowing and laughing and shuddering and gasping for breath and totally ecstatic. Going out, but never getting off.

We played in that space for more than an hour, all delicious and delirious, me sitting on her lap with my legs wrapped around her, total body contact, coming out of one paroxysm to catch our breath, only to dive back into the flow and rush onward to the next. We were ecstatic.

Ending wasn't easy. We had mentioned finishing a couple of times, only to find another fabulous way to rise up again to play with the life force. Finally, with the wisdom of SM, I said "I don't think this is going to come to an end. We're in the Forever Place. I think we're going to have to decide when to stop and actually work at it."

After a few more rounds of ecstasy, we went to work on it. We kept getting caught up in the rush of it all — we would calm our breathing, only to touch another fabulously alive bit of flesh and start yelling again, then

come down again. Finally we managed to move our bodies a little bit apart — I slid down so I was lying on her, my face on her chest. Our chakras no longer lined up right against each other, so the energy quieted more readily. We cuddled there for a while, trancing in little seismic aftershocks, until we were able to bear the notion of moving yet a little further apart.

Eventually we stood up — vertigo! Hugging and kissing, still connected in the energy, but somewhat less intensely. Getting clothes back on was funny — I was clumsy, couldn't figure out a bra, finally gave up and didn't wear it — I kept thinking, "Our left brains will cut back in eventually, right?" She thought we should go outside and get something to eat, so we went to a cafe (I drove: we were at my house, and I could drive the back roads on automatic). We radiated all over the restaurant. Food got us further and more firmly planted in our bodies, and also gave us a chance to talk about our experience.

Now, don't get me wrong, I like orgasms just fine. But sometimes, as I found that day, I can go out a little further if I don't finish us off.

So you can even take your time and the orgasm doesn't end, it just flows through you and keeps on flowing for as long as you can stand it; and sometimes it never ends, you just have to give up.

Time is your friend even when it becomes time to go fast and furious. Try staying with that longer than you usually would. Try elongating the gasping and heaving, the storms. Keep going when you think you can't thrust one more time, and then go on some more. Slow down, catch your breath, speed up again... wear yourself out, then take yourself back to the breath, relax, and

jack yourself up again. Each time you go further. And the endless beauty of ecstasy is that, miraculously and tantalizingly, there is always further to go.

Here is a scene that Dossie played with a friend of hers:

Ropes and Points

Rope. A meditation on rope. I'm wearing fishnet, black of course: stockings and long sleeves and seriously inadequate panties, all made of skinny woven cord. The rope is industrial cotton, unbleached, softened with many washings, tumbled smooth in the dryer for hours. It is straightforward, radiates a practical elegance. She pulls a whole lot of it out of her bag.

She has worn a dress shirt for this date, with a black satin vest that outlines a lean elegance, very hot to watch her moving around, gleam of cufflinks, studs. The tie makes her look Victorian, strict, unbending.

She starts by weaving a corset around my waist, an intimate endeavor. Her arms reach around me again and again, wrapping and looping, tightening — and tightening again. While my legs and arms are still free, I am cornered, constricted at the core: organs pushed out of the way, breathing circumscribed to her limits. My reality defined by her, not me.

When the corset is tight and my breath high and nervous, she pins me down with her body and closes her mouth over mine, breathing into my lungs, sucking the breath out of me. When I figure out how to follow her lead, she pinches my nose shut, her fingers across my face, and I almost panic, dependent on her for my breath. Her eyes stare into mine, pupils like black knives. It takes all my attention to keep the air moving between us, all of

my will to allow this dreadful intrusion into the pulse of my life. With tremendous effort, I give in.

Satisfied, she lifts her head, and I gasp in the cool air while her fingers explore my throat, isolate the pulse in the jugular. She watches my blood moving from the brain. She plays with the puluse for a while. She wants my blood.

My eyes cloud a bit and I feel slightly faint before she releases my circulation, turns the business of staying alive back over to me. "Keep breathing," she says. I feel relieved, now I know what she wants.

More rope. From the corset through my crotch, knots carefully placed to press here and there, the incidental stimulus of rope drawn across my clit before it is cinched down. Rope inside my labia, pulling them apart, cinched down wide open. She regards her handiwork while I feel the unaccustomed coolness of air between my lips, those lips, my cunt in a cage, clit exposed.

I can feel her breath on me, warm and purposeful, an exquisite sensitivity. She draws the tiny patch of fishnet back over my clit, protecting it from too much too soon, and laughs at me as I shudder.

More rope. Windings around my calves, my thighs, caught behind the knees, legs bent, fixed open, in the proper position for getting fucked.

More rope. Wrists are connected to ankles, then strapped to my knees — if I struggle, I will pull my knees further apart.

And I will struggle.

She will ensure that.

She stands by the bed, looks me over and nods in confirmation: everything is as it should be. She undoes her tie, places it on the dresser, unhooks the collar stud on her shirt, and then removes her cufflinks. Gold gleams in the candle as she places it neatly on the dresser. Thoughtfully, getting each fold just even, just right, she rolls up her sleeves.

She pulls a blindfold over my eyes, carefully rearranging my hair. I fall into soft fur, soft darkness — without my sight, my only focus is the sensation she offers me.

I hear her moving, organizing some things, clicks and rustles, then she moves close again, lying on me between my spread thighs, her hands on my breasts. Her knee, accidentally or deliberately, disturbs the ropes on my cunt. Fear shoots through me, I feel so fragile, so easy to hurt. Her hands on my skin, she carefully turns me on — stroking here, pinching there, bit by bit, all of my skin comes to full alert. She slips some fingers inside my stocking, feeling around to the inside of my thigh to get to more skin, more sensitivity — her other hand holds my face.

From the darkness I imagine her staring at me the way she looks when her lust rises, brown eyes burning in her relentless glare. I feel her digging into me. Letting her touch in beneath my skin, past my bones, into the vital vulnerabilities in my gut. Catching my breath, I lift myself toward her touch.

She laughs. "Right," she says, "Are you ready to fly?"

Earlier we had met for a hike on the beach, combing the tide for agates and sea-smoothed glass, fossil rocks

and petrified whale bones. We had talked about dreams and limits, boundaries and the wild red yonder.

She said she wanted blood. I saw the hunger glowing in her eyes, watched her swallow as she salivated. I felt a flicker of her in my cunt, a release of wetness as secret sap started to flow.

Back home, we covered the bed with an old sheet and set up the needles, alcohol, towels, surgical gloves, preparing a table like a scrub nurse before surgery. Hunting for the right scalpel, I noticed an old toy — a gift from someone — gathering dust on my dresser.

"Look," I said, "Somebody made these." A candle in a small thick glass pitcher, purple wax, ripe for melting. She lit the wick, set it aside aside to melt for later. So there would be plenty.

Now, pulsing in the blindfold dark, I listen to the small sounds, the rip of sterile packets opening, the click of metal on the tray, the snap of rubber gloves, while my imagination wanders in the warm grip of the ropes.

She climbs back onto the bed, settles between my legs. She plays a bit with the ropes on my cunt: is she adjusting something, or just trying me make me thrash? I lie entranced, nothing is real except the reality she creates, I am nothing but a creature that responds, canvas to her brush.

She drops her weight on my torso, a pleasant constriction. I can breathe easily until she catches my throat, pressing on the pulse to play with the channel that feeds life into my lungs. Pressing and releasing, compressing and lifting up, she dances over me till I fall into her rhythm. She lifts up, breathing out loud so I can keep following,

deep inhale, full breath out. She picks up a pinch of flesh on my chest — one breath, two — "Now!" she says, and a sharp pain pierces my consciousness, too bright, lasting a little too long as the needle finds its way in, leisurely, and then carefully out again. My body is still arched, my hands clenched, when I realize that she has finished and it doesn't hurt any more.

"Relax," she says, and she breathes on the needle. I breathe out, almost relaxed but her fingers are on the needle, twisting and pulling, stretching my skin — and me.

Something in me always has to fight the needles. She lets me, holds me down till the thrashing subsides.

"Now we need to bury the point." Her progress through her desire is deliberate, meticulous, painstaking — she has a design in mind, and intends to see it perfectly etched into my skin.

She collects my breath again. I follow the sound, the hiss of the in-breath, the aah of exhalation. Somewhere in here I remember that the blindfold allows her to turn the lights up so she can see, but right then her knee hits my crotch at the same instant that the point pierces my skin and her other hand holds me down at the heart. Again I fight as the point goes in.

"Hold still, little girl, don't mess up my design."

Her design. I wonder what she sees? Me blind and bleeding. She amuses herself with my clit, but when I start rocking and reaching, she puts on the brakes.

"Oh, no, I am nowhere near finished. You gonna be a good girl and wait for me?"

Crushed in the silence, I can't think of what I'm supposed to say. Is there an alternative? She climbs up on

me again, carelessly tugging on the ropes, my crotch leaps, she hisses into my ear: "Yes. You say yes now."

"Yes." I whisper. "Yes, what?" "Yes I'll wait." "Yes, who?" "Yessir."

She pinches my breast hard and vicious and before I can pull away another needle spikes into me. I bite back a scream.

"Ssh, ssh. Breathe, honey. Good. Now, we need to get it the rest of the way through." A sharp tug as she aims the needle, already inside me, and a fierce sting through the skin as it comes back out.

"Hmmm, not quite right." She backs the needle out — I am stunned, are we going to do this again? I struggle to catch my breath, to relax, to refrain from fighting her, to release my body to the ropes. "It's okay, you can struggle, you aren't going anywhere. And if you fuck up my aim, I can just set it again. So you figure out how you want it. Oh, yeah. Scream if you like."

She grabs her pinch of skin again. "Ready?" "Yessir!" I lie.

Again, three times the breath, and I am floating under the surface while the needle slides in slow and excruciating. I hold the float while bright pain lights up in my breast and travels around inside my body. Every muscle is clamped tight and the needle is still cutting its path through me and just when I'm sure I can't take any more and every muscle I used to own is clenched in terror, the spike heats up another notch coming back into the air. She burns, she burns.

"There, baby, you got that one good. I'm proud of you." I gasp for breath, stretching to open a channel

through me for all this acute burning brilliance, and she is soothing me, smoothing my skin, rocking me gently. I fall back in her arms, somehow she surrounds me with warmth and love and warm flowing turn-on. The juice stirs at the root and runs up my spine like sap in a tree to meet her. I get all sleepy and warm in her arms till she says: "Okay. Time to bury the point on this one."

Shit! I am riding the rising tide of her wickedness, she is riding my pain, she likes hurting me. I can hear her breathing hard, a little ragged, and she gets up, shifts her body and sits on me, pinning me to the bed with my legs and cunt behind her hung out to dry. Her knees clasp my arms tight to my flanks, she digs in her heels while my heart runs in place.

She reaches up and twists the two needles like reins to guide me, but the only things that runs is my blood. I can hardly feel the stream over my skin, so perfectly matched to my temperature. I only feel her gloved finger, touching and painting, and then her finger is in my mouth, the taste is strange and familiar, I am drinking my own heart.

"God, I wish I could taste that, it's so beautiful, it smells like lust. Taste it for me, baby."

She pulls on the ropes under her crotch and through mine so we rock in unison, predator and prey, one beast. Again I feel the pressure building, a shuddering starts in my womb and spreads through my body, my back arches, and she stops. "Now we get to the part I really like," she croons. "Now we put new needles under the old ones."

Again the process is fussy, picky, shrill. My pain, each bit, prepared and executed with exquisite attention, savored over and over until two needles become four. In exactly the right place. After several trials. The points keep

coming out and each one has to be reburied several times till she is satisfied. I am sunk so deep in the fire that there is no longer any question of self-control: I buck and scream, writhe and moan — at her command.

She shifts, reaches for something — which pulls the ropes over my cunt. I jerk, mindless. She keeps her seat, enjoying herself. She passes something warm and smooth over my skin, it takes me a minute to remember the candle. She gentles me down till my breath is soothed, and when I am rising and falling happily to her rhythm she pours liquid heat over the needles in a scalding stream.

I almost buck her off.

"Ssh, now, ssh baby. You are so beautiful, I love watching you like this, and I got a whole lot of wax melted here, and we have plenty of time, so ssh, baby, ssh."

Like molten steel from a crucible, the wax pours here and there, rivers on my chest, my breasts, flowing over my shoulders, a blaze that lights up the dark behind the blindfold. Hot and nasty, she is riding again, rocking the ropes, her fingers tugging on the reins till the blood flows with the wax in one burning scarlet river. On fire, I am cast into my own desire, rushing heat, blazing pain.

She slides down me, down between my thighs, I feel her hot at my cunt, nailing me with the smooth warmth of her dick. Piercing me to the root, she reaches my boiling womb and fucks me furiously, just short of explosion, building the heat and the pressure, surely the bed will catch fire. The ropes holding my cunt are all wet and slippery now, they slick off to the sides while she holds me open from the inside.

Even fucking, she stops now and then, a meditative moment when a point breaks free, to sink the dangerous

little sharpness back under my skin. Pain spikes through to my cunt, completing the connection from her dick to the needles, and she jumps, electrified.

"All right, little bitch, here we go." And away we fly, beyond the rising tide, we are fucking a hurricane, we are riding a wild flowing wind punctuated by the stabbing needles until she stops

dead

dug in deep:

"Hold still, little bitch, it's time." And I feel my cunt struggling on the brink while she grabs two needles and

yanks

and I nearly knock her off. Anguish rolls up and down inside me like thunder reverberating in a huge canyon while my cunt clutches her dick and before this all quiets down she

gets a grip on the last two needles and

rips...

I scream. Not so much in pain as in desperate need to release, no longer able to contain anything. I scream long and deep and loud, a wailing siren emerging, I flow all over her, and she fucks me.

Hard and reckless, out of control, her breath scrapes her throat as she groans, and that other noise is me bellowing over and over till the dam breaks, the flood cuts loose, and we flow out and into each other like crashing breakers until we are reduced to puddles.

Laughing puddles.

I shield my eyes as she opens the blindfold, the light is too much and I have to cry. She holds me while I

weep from the brightness of everything — her tender eyelids, the curl of her ear, her mouth kissing my cheeks, baby kisses. I weep for joy. She looks at me, her eyes — how can brown eyes burns so bright? And I fall onto her, giggling, happy.

After a quiet while she sits up — "Hush now, baby, there's more" — and puts the needles away, strips her hands and snaps on new gloves. Eyes still on fire, she slips out her blade with a pointed "click!" that sets off more sparks, I feel them burn from her eyes right to my cunt.

Carefully, she scrapes up the wax, pulling and picking, sparks on my skin, I am beyond holding still. She squeezes and pinches where the needles were till the blood runs from the wax, purple and red reflected in the hot glare of her pupils, so close to my face.

She plays in the mess she's made while I rest in the afterglow. She cleans, meticulous, only to make another mess with the flaking violet wax. More blood. I am loose and sleepy, her picking over my skin feels like luxury, I am cared for. When the alcohol comes, I welcome the sting, wishing there were more holes. I try to figure out how many — four needles, in, out and in again, three holes each, but multiplication is beyond me. Then she is stinging me again, mad wasp with the blade, the alcohol.

I bask, hissing softly, while she cleans me up. The wax, the blood, then the slow sliding ropes, the focus on lengthiness, the slither across the body, the odd freedom of foot or hand as if it were unnatural of them to be operated by me. Freedom, one limb at a time. She turns each one, stretching, as if there were some rite of passage, a dance to return control of my muscles to me.

The knees released, the legs stretched out, she rubs my knees, my hamstrings — she knows they get sore — and the blood flows in, following her hands as she massages and calls the blood back to the thighs, the calves, the feet. I am bathing in the warm blood she evokes, like warm sun. Turn and sigh, lazy, arms over my head reaching, until a wicked tug wakes me sharply. I open my eyes, catch the nasty grin on her face, and I recall — the ropes in my crotch.

This is intense — the soreness, my swollen lips, the once soft ropes unbearably scratchy, tighter even as she turns me this way and that to release each winding, from the front, from the back, ends trailing over my sensitivities, me hissing and writhing. She keeps me soothed down, stroking my skin — "Still now, snake girl, you let yourself be still."

As the ropes unwind I fall quietly deeper into her, until the last rope is gone, the sheet is gone, and she is holding me, pulling a blanket over us, she says:

"Sleep now, baby. Time to sleep." And she curls me up like a fairy in a ladyslipper, and carts me off to dreamland.

Touching Worlds

Janet wants me to write about how I make connection with other people, and the truth is, once again, I don't know. I do make connection, I've got lots of evidence of that, and I know how to emake connection — that's why I'm here writing this book sharing all the ways I know to make connection. But I don't understand about the magic.

One minute I'm nervous and disconnected and stuck and feel like an idiot, and then there's touch and breath and eyes and mirrors and eros rises and everything is magic.

Sometimes I don't even feel the magic. I'll be doing a scene or a ritual, playing my part, competent, I suppose, but maybe not seeing it as something that is getting very far off the ground, Then somebody tells me there are rainbows coming out of my fingers, or that they can feel the magic flowing everywhere, and I can't feel it. Luckily that only happens occasionally.

More often I get a sense of rightness, like the power is upon me. High contrast to my more normal state of worrying about everything, in the constant conviction that I'm doing something wrong wrong wrong. You see, much of the time — it's better now than it used to be — I'm a scaredy-cat, constantly checking myself out, worried that I'll somehow explode or break something or otherwise fuck up. For me, some of the magic of sex and SM is that when I get into the flow I forget about all this. My self-consciousness disappears, I'm just there, with the other person, and we're wonderful and beautiful and glowing.

Other people always appear amazing to me. They do things I'd be afraid to do. That sounds ridiculous — my life is terrifying to most people — SM, writing books, being a therapist. So I look brave on the outside, and I'm scared a lot on the inside.

My slut lifestyle is a great joy to me, and a creation of which I am very proud. I know I created it partly in response to my self-loathing. Despite the dirty roots, it has borne fabulous fruit. In radical ecstasy, in sex, in trance, all the uncertainty disappears.

All my relationships are colored by my pain. I grew up in a family that wanted me to be someone different from who I am, and believed it was their task to chisel me, sometimes violently, into a nice young lady. I am very proud of having fought back against this oppression, but still I grew up believing that I was the wrong one. I just made a huge mistake on this manuscript because, when I was missing some chapters which were precious to me, I assumed that Janet wanted to delete them. Being really good at believing that what I do has no value, I managed to operate for a month on that assumption. Which, it turned

out, was incorrect. You have the chapters right here in your hands, and I'm not going to tell you which ones.

I approach relationships as if something is wrong with me. Perfectly nice people get interested in me, and I assume they can't be turned on to me, that I've made a mistake. Lots of my lovers initially thought, when they were trying to connect to me, that I didn't like them, so carefully did I protect them from contact with my wrongness. I have profoundly insulted people.

In partnered relationships, sadly, what quiets my anxiety is somebody who reiterates my oppression, somebody who wants me to be smaller and quieter, wants me to hide my light under a bushel. Somebody who doesn't want me to shine as brightly as I can. I live in constant fear of being too much: too loud, too bright, too smart, too sexy. I have fallen in love and felt a mighty relief in believing that I have found someone who is bigger than me, who can release me from this constant struggle inside myself. The outcomes have been dreadful, as you might imagine. I write this with great shame — it seems to me I should have conquered this as I've conquered so many other fears in my life.

A man recently asked me if I wasn't lonely living without a primary partner. He didn't accept my usual off-hand replies — I've been lonelier living with a partner, my loneliness is partly because I live in the country in breathing exile, doesn't everybody get lonely sometimes? His worldview, narrower than mine, couldn't imagine how life would be without a committed partner. I felt ashamed to say, "I'm just not that good at it."

I do better as a slut, in friendships and loverships that are not about partnering. There are so many differ-

ent kinds of intimacy. So many wonderful ways we fit together. I love my tribe. I love my friends. I love my lovers. I live in a sea of love.

Writing about connection, I feel sappy. Sentimental, foolish, ridiculous, as if I've fallen into the traps set for me by a culture I don't believe in. And yet, the sentiment I find fellow-traveling in ecstasy is all about the wonderfulness of connection. Not just about orgasms or other exciting adventures, it isn't just about the excitement. It's about love.

Once I figure out that love is not about joint checking accounts, I become free to be a fool for love. To dance in lovelight, swim in warm moonlit pools, sing like a babbling brook. Writing this, I'm renewing the vow I made when I was twenty-five: I will be loving, affectionate and demonstrative with all my lovers.

When we were teaching in Detroit, we had a circle of sixty-three people lying on the floor, with their feet toward the center. With one hand on their crotch, and the other on the heart of the person next to them, we raised kundalini by breathing and visualizing the awakening of the chakras. Then we took that gorgeous energy and ran it out of our hearts and down our arms and into the person next to us, so that the beautiful energy ran round and round the room, like a fabulous running rainbow. Leading the group, we stood in the center of the circle, calling out the breaths and the images, and felt the room fill with love. Yes, love.

And in that moment, the energy was so powerful and so palpable that I didn't need to think about what I was going to call it, and I didn't feel sappy or silly. I just told them to feel how the room was filling with gorgeous

glowing love, and I knew for sure they could feel it too. In that moment, love was what it truly should be, and in no way ridiculous.

When we call it love in a group, everybody pretty much understands that it's a different kind of love from pair-bonding. And when we play with all the lovable others that we have described in this book, and every other lovable other we have been privileged to encounter, we want to acknowledge the love that rises in us, the golden glowing ineffable love.

Love at the moment of orgasm, love in the fumbling moments when we're trying to figure out how to make something work, love in the phone call when somebody's had bad news, love visiting in the hospital, love at the play party. Dear, sweet love.

Sometimes we call the divinity that flows through us energy, or source, or kundalini, or eros. Why are we so scared to take the risks of getting close, of dropping our shields, of connecting our skins (isn't it interesting that we call them "hides"?). Why are we so scared to call it love?

What is love?

One of the most extraordinary experiences that play or sex or intimacy can offer is the moment when we feel ourselves merging, accepting another's essence and feeling ourselves accepted as two flames held close merge into one — a feeling that it is not too grandiose to call love.

We've heard curmudgeons ranting about the devaluation of the word "love," storming on about how we should keep it only for the people with whom we intend to have our children and our mortgages and, we suppose, our conjoined gravesites — that it's practically criminal to talk about loving our friends or our fuck

buddies or the other people with whom we connect. We'd argue that theirs is the devaluation of the word. We think that our hearts are capable of holding huge, stupendous amounts of love, of every variety and gradation; and to keep such a stunning word for only one of its infinite possible meanings is like chaining an anchor to a butterfly.

However, we both grew up in a culture that attaches a lot of baggage to the feeling we call love. During the era in which we grew up, and we suspect still in the present, if you started feeling tender and passionate and intimate about someone, it was expected that a certain sequence of events would inevitably click into place: a specific number of dates, with increasing levels of sexual activity... then an agreement, or more likely an assumption, about monogamy... moving in together... commitment, often signaled with a ring and a ceremony... purchasing of property, having kids... you don't need us to tell you the drill. Both of us have seen it flash before our eyes, like an insane movie on fast-forward, every time a hot new potential sweetie comes into our lives — in spite of the fact that neither of us consciously wants ever to walk down that particular pathway again. This programming is strong, and it would take stronger women than us to erase it completely.

At some of the tantra events we've attended, an announcement is made in the beginning that goes like this: "During some of these practices, you may have feelings that will feel a lot like you're falling in love with your partner. That's because you are — you're falling in love with the love in the universe, which you're seeing manifested in your partner. When that happens, it's absolutely wonderful. Just accept it for what it is, and don't feel the need to attach anything more to it than what it is right here and now — nothing about the future, nothing about anything outside this room, just what it is." In SM, a similar truism holds that you always fall in love with your first top.

This is very good advice to keep in mind as you travel in the realms of radical ecstasy, where you may over and over again have experiences that feel like falling into the deepest and most passionate of love. Remember, we are your friendly neighborhood ethical sluts, and pluralists to boot, so our intention is to show you some ways to celebrate lots and lots of deep connections of sex and SM and spirit — including how to fall in love with the whole wide world, or at least as much of it as you can manage.

Self awareness

What is the "self"? While most of us put some effort into making sure our externals are attractive — that we look good, that we can tempt the kind of partners we want — we also yearn to be seen as more than the packaging. Large-breasted women resent being looked at as a pair of boobs with a woman inconveniently attached. Successful men fear being viewed as walking wallets. "I want to be loved for myself," we wail.

And what if you feel like you're loved because you're highly intelligent, or extremely kind, or — in the BDSM world — a natural, brilliant dominant or submissive? Or because you write books? Does that feel like being loved for yourself? And if your intelligence or your generosity or your personality isn't your "self," what is your "self"?

Excellent question! We wish we knew the answer. We suspect that the "self" is less a thing than a process, or a dynamic, or a permanently flowing sense of awareness. We sometimes wonder if the self lies one layer down under whatever layer it is that's being seen at the time — that it exists mostly as a hunger to be revealed, to be known. Like all hungers, this one can be satiated only temporarily... but how wonderful it feels when it happens!

The moment when we feel like we're being seen for our selves, when the barricades are down and the armor is off, is, of course,

the moment of transcendence, the moment we have attempted to describe in this book. When it happens between two people, it feels a lot like love. In fact, we would argue, it *is* love, as Janet describes here:

> We'd known each other for a while, enjoyed one another's company. He's smart and funny and so am I; he's tall and broad, the way I like, with the softest blue eyes you ever saw. I'd been flirting with him for ages — well, I guess you'd call it flirting; I don't do subtlety very well, so I guess what I mean by flirting is "So, hey, when are we gonna play?"
>
> And then one day I got an e-mail: he wanted to, at the party coming up Saturday night. Yay! My gut started telling me right away that this playdate was more than just a playdate. The negotiations certainly didn't predict anything special — the usual I like this; well, I don't, much; OK, then, we won't do it; oh, well, if you really want to we can. Our desires and fantasies overlapped to a reasonable degree, enough to fashion a pretty decent scene, but certainly not a perfect match.
>
> I had actually bought an outfit — for some reason my usual butchish attire wasn't right for this date. I bought *heels*, goddammit. I put on *makeup*. What was going on?
>
> We went to dinner, fine-tuned the negotiations, chatted. He'd worn a special outfit: leather cap and jacket, jeans that fit just the way they should, boots that added another two inches to his height, a cologne I actually liked (and as a rule I hate men's scents). He looked big and tough, and yet there were still those *eyes* gazing out from under the leather brim of the cap...

We got to the dungeon, grabbed my favorite cable-spool table with the padding and the eyebolts, started setting up the scene. He likes bondage, I don't, so we compromised — my feet fastened firmly in place but my arms left free so I could stand or bend over. He asked if I liked blindfolds, I said I did; he slipped one on and I started to float. He pulled my tight spandex outfit down from the top and up from the bottom, turning it into a very tight wide stretchy belt. And then he held me from behind, letting me feel the thick leather of his jacket against my awakening skin, allowing me to trust his strength. My core started to soften, melting outward, bones blurring, blood warming.

He began to flog me, softly at first, building quickly — I'd told him I didn't need too much warmup. Caress, caress, *thwack*, caress, *thwack thwack*. I began to make sounds, grunts and small moans. A heavier flogger now, more thud, more bite on the edges, hit me *harder* dammit I'm right on the edge... yes, like *that*, let me feel how hard you can hit, how much you've got in you, knock me over, let me catch myself so you can knock me over again, — or better yet you catch me.

And then suddenly a fit of giggles, contagious — what started it? Hell if I know, but I probably laughed first, you're too polite to laugh when I'm working this hard, but you're happy to let me take you flying with me in a gigglestorm, and I twist my neck back to look in your face and your eyes are crinkled up with pleasure and laughter; I can feel your chest shaking against me. And then the arms and chest are gone and *thwack*, and I pull myself back together and straighten up and brace myself for more, and the laughter's made you even stronger, and

you're hitting me as hard as you can, and screams are pouring through the space the laughter opened up. And I start to bend over to hold the table for strength and you bark "Stand up *straight!*" and whatever last little bit of resistance I might have felt is gone, and I stand up *straight*, and my arms fly out to my sides, and no part of me is touching the earth any more: I'm airborne.

More, please, more. Three floggers held together at the handle and swung like a baseball bat, knocking me off balance, making me grab the table and brace myself because god knows I don't want you to stop, this is too wonderful, you're snapping yourself right down those big arms and those big floggers and pouring yourself right into my hot welted skin, into my simmering core, and the heat of the skin and the heat of the core meet up so I'm lava through and through, and the joy is just overpowering.

And just as you've landed the hardest blow and I'm teetering against the table you grab me, pull me upright, hold me so I don't have to hold myself up any more, and I'm yours, completely yours, for just that moment — and I know that moment is permanent, that I'll have it forever and just because of that I'll have a little bit of you, forever.

... and after that same scene:

"Shhh... it's all over now... it's OK... it's all over."

That's what he said to me after the scene, softly into my ear as he held me, after he'd reduced me to a screaming sobbing begging lump. And when I think back on the scene, that's the moment I remember best, and with the greatest longing. Something in me has been waiting all my life to hear those words.

How often in life do we really get to know that the hard part is over? When we have a baby, one hard part is over when we push the new life out into the world — but there's a couple of decades of even harder stuff lying ahead. Completing a task at work usually simply means clearing it off the desk to make room for the next one. Solving a problem generally creates a dozen more.

So for that one moment I get to be soothed, to be reminded that I've survived an impossible ordeal, and that I'm being rewarded with petting and affection and reassurance because I did it well, and it is all over. I can feel proud of myself and know that he recognizes how hard it was to do what I did.

And I also get to learn that bruised, beaten, snotty and hiccuping, all pretense gone and all defenses dropped, I'm still lovable: without any of the shows I put on to make myself attractive, someone still wants to comfort me and make me feel cared for and nurtured.

That moment, those words murmured into my ear so softly that I can barely hear them over my own sobs, feels a lot like love to me.

The unscratched itch

When we first started work on this book, we were both fairly recently out of relationships that neither of us would hesitate to call "failed" — both feeling raw, bitter and very uncertain about our possibilities for ever getting involved again. Although things have improved quite a bit since then, those dark days did lead to some interesting — if uncheerful — thoughts about the nature of loneliness, especially for those of us who like our sex and play very, very intimate. It was during such a period that Janet wrote:

Is a sadomasochist who hasn't gotten to play for a while "impervious"?

Sure, I can make puns about it, but it really isn't funny. I've been snappish for days. Everything I think of annoys me; there's no calm place for my mind to rest. I miss people who are gone and resent people who are here. I can't think of what I want to eat or what I feel like doing. My reflection in the mirror looks ugly.

Nobody can tell there's anything wrong: I'm socializing as merrily as ever — but by the time I get back to my car I feel frantic, sorry to have left but desperate to get away, utterly unable to conceive how to stand going home by myself but unable to tolerate anyone else's company for another minute.

I run through my mental checklist of what could be eating me. No, I'm not premenstrual. Hmm. I've gotten plenty of exercise in the last couple of days, and I've been eating OK if not with wild enthusiasm. No changes in medication, no broken sleep, no fights with friends or business troubles.

Well, that's not it — so what the hell *do* I want?

A thought comes to me suddenly and forcefully, and I begin to cry, alone in my car. I want to be touched. Not just with physical touch, I get plenty of that. I want someone inside my skin, or I want to get inside someone else's skin. I want to feel that sensation of wanting to devour someone entirely, to erase the air between us so there's a perfect synergy of minds, hearts, bodies. I want to connect. And the best way I know to do that is with SM.

This restless flame inside me seeks to join with someone else's flame, to leap toward the sky together. It's happened in various ways throughout my life. Sometimes

during long intense intellectual conversations, the ones where it feels like our minds are two horses yoked to the same chariot, pulling together to go someplace neither could go alone. In tantra practice, when I gaze into someone's eyes and feel myself falling into her pupils, plummeting inward, a tiny me reflected in her eyes, a tiny her reflected in mine. Occasionally during bouts of un- controllable laughter, where your face hurts and your stom- ach aches and it doesn't feel like you'll ever stop, be- cause as soon as you slow down, you look at the other person and it all starts again.

But mostly, I go there in scene. And I haven't played in a long time, and I haven't gone there in even longer, and it hurts.

And I drive on, and I wonder if these tough bound- aries I've built with such effort and pain have finally fenced me off completely from everyone I love and everything I enjoy, and I cry.

Scientists describe a basic animal need called "touch-hunger": babies who aren't given plenty of physical touch wither away, just as they would if they weren't given enough food. We think there is a subtler but just as real need to be touched at an energetic or spiri- tual level. Clearly, this spiritual touch-starvation feels very awful indeed — so bad that we may wind up opting for self-destructive behaviors (bad drugs, bad partners, bad behavior of various kinds) rather than feeling it a moment longer. One of the reasons we wanted to research and write this book is to help make sure that nobody has to feel this awful feeling any more than absolutely nec- essary — that everybody has as many tools as possible to make con- nections with the universe and the people around them when they need to.

The masks of love

There is another way in which love *seems* to manifest, a way that has drawn each of us in on more than one occasion. That naked raw hungry self, the one that yearns to be seen — what's the easiest pathway to it? Through the weak spots, of course — through our frayed places, our places of vulnerability, our wounds. So when an attractive stranger comes along and puts his or her mouth right up to one of those wounds and speaks into it the way an announcer speaks into a microphone, it can feel a whole lot like being truly seen, like a promise of real satisfaction for the hunger that's gone unfulfilled for what seems like forever. Unfortunately, what's being seen isn't the whole us; it's our weakest, neediest selves, the least acknowledged parts of ourselves, that are on display. But since those aren't the parts of ourselves that we normally spend much time with, we can easily mistake them for the whole thing — not noticing the mistake until there are two names on top of the joint checking account or the birth certificate.

Janet writes:

> *Crazy In Love*
>
> I've only been searingly, impossibly in love twice in my adult life — once with someone who loved me back, the other with someone who didn't. The second one did me the bigger favor.
>
> This kind of love is a kind of craziness, a delusional state with obsessive-compulsive overtones. It bypasses rational thought and self-preservation. The only experience I've had that came close to it was the feeling I had about my kids when they were tiny infants — completely occupied with them, endlessly fascinated by them, not sure where they ended and I began, wanting nothing more

than to curl up around them and shelter them forever and ever.

For me, crazy-in-love manifests as mad protectiveness, the complete conviction that I and I alone can see this person's inner beauty, and the certainty that I'm strong enough and good enough to make them happy. Believing I can do that, that I'm that strong and competent and empathetic and intuitive, makes me feel immensely powerful. This is, of course, megalomaniacal and delusional, but just try telling me that when I'm tossing and turning because my skin won't be calm unless it's touching *that person*.

Why is it that the people who activate my worst instincts — egoism, martyrdom, manipulativeness — are the ones I fall in love with? Not coincidence, surely. There must be a part of me that longs to feel those things and leaps at the opportunity to inflict them on someone else. And the worst part is this: even as I work to build boundaries, to leave those behaviors behind, I know that if another one came along — someone who's tough yet needy, unpredictable, irascible, very smart but a little bit nuts — I'd do it all over again.

No, wait, that isn't the worst part. The worst part is that I want to.

This is scary truth: that we can't depend on our lovers to prove to us that we're not broken because actually, in some ways, we are. Wounded, anyway.

And if you're feeling scared, or upset, or worried about this, or about anything we've presented here: back to the breath. Remember about self-acceptance and being kind to yourself. Take another breath. Always return to the breath.

Learning how

Opening yourself up to connection is not a skill that most of us have automatically. Babies and very small children have it, but it gets schooled out of most of us early on, when we're taught to restrain our emotions and behave ourselves. These are important skills in terms of learning to get on with others, but they require closing yourself off, putting up filters between yourself and the world. Later, when you want to learn to make intimate connection, you have to learn all over again how to drop those filters — and it's not always easy.

Hardly anybody gets relationships right the first time, or the second, or the nineteenth — in fact, we have a big question about whether it's possible to get relationships "right" at all, or whether we just do the best we can with the cards we're dealt at the time. Perhaps the best we can hope for is to grow together and take care of each other as well as we can — to see each other and touch each other and try not to harm what we see and touch. Perhaps that's not such a small thing — perhaps that's one of the biggest tasks we face on this earth.

Here's a relevant exercise we learned in tantra. If an exercise seems weird in the midst of all this cogitation, that's really what this book is about: to show you a lot of the ways that have worked for us to open a path to connection.

> *Sit across from a friend or a lover, and gaze into his or her eyes. Breathe together for a moment. Imagine that you can see so deeply that you can see your beloved before they were ever wounded. Innocent, clean, unafraid, sacred. And remember, your beloved is seeing you the same way.*

Imagine you could make love from this place. Any kind of love that fits. Maybe gazing like this is making love.

The reality is that there are as many ways to touch, as many ways to love, as there are combinations of people and circumstances — which is to say, an infinite number. The trick, we find, is to remain open to the moments and the dear people in them when they present themselves — there's presence and acceptance again — to welcome the moments in which all the love in the world presents itself to us with a human face for a little while. When we treasure each connection for what it is... not what it might become, or what we might make of it... when we simply cherish that dear person in front of us, perhaps we might still be cherishing tomorrow.

Putting it all together

To close this chapter, we'd like to recount in both of our voices an evening that we spent combining what we know of tantra and SM to achieve mutual ecstasy. Dossie is in the plain text and Janet in the italics:

We are having a date at my house in the country. We've spent the afternoon with the outline of this book you are reading. Janet has brilliantly organized all the scattered bits and pieces, and the evening is set aside for play by the fireplace. The feeling is good and easy and connected, and the dog is happy.

We negotiate the scene before dinner, which is a little complicated — Janet has a couple of clear fantasies, and I'd like to be able to fit into them. She's hungry for spanking and viciousness, imagines a teenage boy who comes home to find the babysitter smoking weed and blackmails her into sex. I had been wanting to do a scene starting out with tantric breathing and raising the energy, making the energetic connection. Last time we did this I was the top, and tonight I have eyes to bottom for it. I had

just topped the scene in this book about trance dancing with the cane, and I really wanted that for myself. There's a little fumbling around — can we script a scene that includes both of our desires?

I've been carrying around a lot of stress and frustration, and I haven't had the chance to do much intense play in quite a while. Typically for me, this situation has built up into some very nasty fantasies. There's a playstyle that I love topping and often enjoy bottoming to, but not too many bottoms meet me with it — a no-holds-barred, harsh, punitive kind of play. Of course, it has connection built into it, but not overtly, and it looks pretty scary from the outside. I'd been hoping for such a scene that night. Dossie can sometimes go there with me, but not always; I have my fingers crossed...

We can't figure out how our nasty horny hostile teenage boy could top a good trance induction, so Janet offers to change the cast of characters to a corrupt guru with a naive disciple. We both like this — trance induction for betrayal, sounds like a hot scene to me.

We actually discussed quite a few options before we came up with this one. Later on, as you'll see, the discussion paid off — it turned out that what we were doing was defining a circle of possibilities. I enjoy playing the wicked betrayer, too... and once Dossie gets tranced out and warmed up, she can usually follow me almost anywhere I want to go.

So Janet sets out the toys she wants while I get dressed in a chiffon sarong and velvet cleavage top with dragons — girly tantra wear. We put five hours of Hildegard von Bingen on the stereo — 12th–century intense monastic music is all about flagellation. The titles

include "Canticles of Ecstasy" and "Canticles of the Blood." So imagine this long slow exquisite singing throughout the scene.

We start out sitting on pillows in front of the fireplace, me on Janet's lap with my legs wrapped around her, and we go into the breath. Kundalini rises very quickly, and I can feel the intense connection between us as Janet gazes into my eyes. It feels like she's raping my soul, or maybe that my soul is a butterfly mounted for display. We undulate with the breath and get very turned on, until Janet is lifting me and slamming our crotches together, still with the breath coming faster and faster, and both of us are shouting — it sounds like Janet has an orgasm in there. Feels like I'm sitting on her dick, a strong illusion even though she hasn't put hers on yet.

I often grow a dick when I do undulations, and if Dossie's sitting on my lap it's pretty much a sure thing. And with me running that hot frustrated energy, let me tell you, it's a BIG dick.

For a while she controls my breath, first by putting her hand over my mouth to tell me when I can breathe and when I shouldn't — I get quite dizzy in the process. She initiates some mouth-to-mouth breathing, back and forth between her life and mine, careful to breathe in some extra air so we don't deplete the breath we are sharing. This feels intimate, and I get an image that she is taking me over by breathing herself into me. I'm definitely trancing now, and she's holding me up and pushing me at the heart, back and forth to the breath, as though I'm on a swing that she controls.

The "guru" fantasy becomes very strong for me here. I'm teaching her the breathing by doing the breath-

ing for both of us — this in spite of the fact that in real life she is far more experienced with these breathing techniques than I. And then an idea comes to me — a way to build a bridge to bondage by integrating rope as part of the breathing practice...

She takes some silky thick black rope and winds it around my chest and arms, tightening to constrict the breath, my arms bound to my sides, my chest wound around tightly. As we continue the breath I get dizzier and higher and more distant from myself, as if Janet is operating my body. She uses the rope on my chest as a handle to throw me far back and then pull me back up before my head hits the floor — I trust her with this. She is growling now, and I can see her evil man top is in control. This is a little scary, which is exciting.

The "evil man top" is a familiar character to both of us; he shows up in various ways when I play with Dossie — all very vicious, all very precious to both of us. This betraying guru-fellow is a new incarnation of an old friend. I am punching her hard in the chest to throw her backward, grabbing the knot of ropes at her heart chakra just before she hits the floor, yanking her back toward me in an embrace, meeting her mouth with mine... then doing it again... and again...

Then she wraps a long satiny rope around each of my wrists, leaving a length of rope hanging like a leash, on each one. She pulls my hands around her back, holding the ropes in front of her, and we breathe with me attached to her like a monkey baby. Kundalini comes up and up, and out the top of my head. I can feel our inner snakes twining together above us, my snake reaching out to hers when she puts her forehead against mine and

stares into me, my snake licks her third eye, she is staring from her soul, and the arousal has us shouting and thrusting. I am sitting on her dick in a violent and out-of-control upheaving — out of my control, anyway. We are happily gasping and bellowing, me hissing and spitting.

All of this takes much longer to do than to describe. With each change in position, each new bit of bondage, we bring the breath back up, raise the snake, and explore each new form, physically, emotionally, spiritually, as far as we can go with it.

In the last position, she pushes my arms behind my back and ties the leashes around in front of me, so as we breathe and rock, I am completely dependent on her to keep from falling over. I can feel the heat rising in my cunt right now while I'm writing about this.

I am panting, out of breath, and my arms are tiring... and I'm still itching to make her scream and cry. It's just the kind of girl I am, I guess.

When we have exhausted all the possibilities of this configuration, Janet helps me move to the couch and places me over her lap for the spanking, pillows arranged to protect each of our rather fragile necks. She starts with a sensual spanking, while I get comfortable in the position and sink into the sexiness of it. Then she tells me she wants to hear me scream. That scares me a little — I know she knows how — and I know that means she will push me beyond what I can channel with the breath.

I believe in asking for what I want. If I want to hear someone scream, I tell them I want to hear them scream. It sets the direction for the scene, it gives them permission to open their mouth and throat and let the screams come out.

She proceeds to cook my ass with the back of a wooden hairbrush — a stinging, relentless implement. For a while I work on surfing the pain, keeping my breathing relaxed, staying with the ecstatic current, but Janet knows how to push me over my own edges, and she strikes without mercy till I cry and thrash, telling me all along about how Daddy likes to hear his girl scream...

Daddy? Where on earth did he come from? Hell if I know. Something about seeing her over my knees just tells me that I'm Daddy now.

By this point in the scene I am morphing roles in my own head with manic speed — daddy, guru, rapist, Big Bad Wolf, torturer, gangbanger — but it doesn't really matter, since they all seem to have essentially the same purpose: to beat and then fuck Dossie.

With tremendous skill, she rides me back and forth, easing up till I can catch the wave and then pounding down beyond my ability to process with serenity. We go back and forth for a while from floating to bucking, with her occasionally grabbing my crotch and making me writhe in a different way, shaming me with my wetness.

I know that if I give her a completely ecstatic ride, I'll be frustrated and unhappy... and that if I take her into a place of pure miserable punished-girl pain, she'll safeword and we'll both feel awful. So my job is to walk her right along the edge — we've been playing together so long that I can read her signals well enough to know what both states look like for her.

When her arm gets tired and I get to where she can't throw me off my stride from this position, she gets up and has me kneel over the couch — another adjustment of pillows for the neck — and cuts into me with a

cane with blistering ferocity. I can feel her now, feral and hungry, ripping me open to taste the emotional equivalent of blood, and I fall into the sweetness of victimhood, wriggling and crying and screaming and thrashing, miserable and ultimately delighted at the same time. This is one fine ride.

When she is ready, she tells me that she is going to put her dick on and then give me twelve more strokes of the cane, at maximum impact, and then fuck me till I scream. The intermission while she gets into the harness resets everything, and strips me of the dissociative cloud that had been making me immune to the stinging anguish of the cane at full force.

Hmmph. I'd like you to believe I'm doing it this way on purpose, but the fact is that the O-ring in Dossie's harness is about an eighth of an inch smaller than her biggest dick, the one I need to be wearing right now, and it's sort of like trying to load a cannonball into a rifle barrel. I'm gritting my teeth and swearing softly under my breath. But then when I start up again, it's like the interlude never happened — I am sadistic again, my ears hungry for the whistle of the cane and for Dossie's cries...

When she comes back, each strike of the cane feels like a fire blazing across my ass. When she attacks in threes and fours I lose my place entirely, unable to hold still or silent, falling into involuntary convulsion. We lose count — twelve or twenty or who knows — it's all out of control; and then she fucks me.

Long and deep and hard, yelling nastiness in my ear, I am hers, she can do whatever she wants with me, she's going to fuck me till I can't take it and then fuck me some more, and I'm so far out I believe her, and it's all

heat. She has two or three of what she calls top-gasms, and I have the equivalent, until we are both exhausted and it's time to give it up. She gets up and reaches for the knots that tie my hands behind my back — and I beg. Please, please, can I have the vibrator before I'm untied?

It takes a minute to get it clear — it's not like I'm exactly coherent right now, mind you — that I actively want to be on my back on the floor with my hands tied behind me. And when we get there almost instantaneously I come. Hugely.

This is when I can really tell I'm in male headspace — there's a part of me that is just a tiny bit peeved that I haven't been able to make her come by fucking her. And she's right, I was all set to untie her — with my bum shoulders I'd have been in agony if my hands had been tied behind my back a fraction as long as hers have been; I've forgotten that, with her much greater flexibility, she can handle this much and more. But when I see how fast and hard she comes with the vibrator, all that is forgotten. What a glorious sight, her flushed and straining and shouting and streaming radiance in the bondage as the orgasm possesses her; and what a wonderful feeling to let her float back down to earth in my arms, the glow ever so slowly abating and settling down over both of us. The fireplace crackles and the dog comes over to be petted and reassured. We come quietly, gradually, giggling back into ourselves. What a joy. What a friendship. What a love.

Inside and Outside the Shell

On one hand, human beings have clit and cock, ass and breast and belly, the skin and the pulsating heart. On the other, we have spirit and soul and brain and the electricity that runs from the center of the earth, through the spine and up into the flaring guts of the sun. How are they connected, and how can we possibly conceive, nurture and maintain that complex and ever-shifting connection?

Western culture, and most religions both western and eastern, are far more comfortable in the realms above the nose than those below the waist. As a result, we all have been taught from child-hood to separate our spirits from our bodies as though they were separate entities, as if it were possible and desirable to have flavor without food or food without flavor. (A koan: what would be the taste of a cheeseburger if a cheeseburger had never existed?)

Most of us grew up in a world that fears and distrusts the body aside from what it can produce toward the greater good — e.g., work and babies. One word for this philosophy might be puritanism. We encourage you to work toward the idea of integrating body,

mind and spirit, to reject the thinking that has historically separated them.

Embracing the body as more than a clumsy receptacle that carries your brain around, but as the vehicle that expresses your spirit — a magical gift of pleasure — opens a miraculous door to other transcendence.

Many spiritual traditions have discouraged body consciousness: you're not supposed to hang out in those nasty bad lower chakras, you're supposed to move your consciousness up into the pure ethereal higher chakras like some vibrant bodiless violet being. Well, that may be all very well if you're trying to solve the riddles of the universe, but for achieving radical ecstasy it kind of sucks. It doesn't work to believe that any chakra is higher or more valuable than any other: think of it as an electrical circuit, where you have to connect *all* the poles or the electricity won't flow. We suggest that you embrace and occupy and breathe into your full body, all the way from the top of your beautiful head to the tips of your vibrant toes, with particular attention to the points in between.

Both of us grew up as brain-dwellers, easy and comfortable in the realm of the intellect, poorly coordinated as children and tormented by body image problems as adults. (No wonder we grew up to be writers!) Sex and BDSM provided pathways that have allowed us to reclaim our rejected bodies and heal the wounds of separation caused by the apparent rifts between our intellectual and physical selves.

Here, Dossie describes an inspired night of music and dance we spent together:

> The music is persistent: the didjeridu, the drums, the intense powerful repetitive chant from the Qawwal singers; at first, I can't quite figure out how to get into it and fear looking foolish. Only a handful of people are dancing. A slender woman in black flows through a series of movements that look more like a martial art then a

dance, intricate hand movements following her turning body, repeatedly reaching down for some imaginary thing and then lifting it into the air.

I thought, if I were beautiful like her, I wouldn't be embarrassed to dance my dance. I wouldn't worry that everybody would see nothing more than an old fat lady with clumsy aging joints.

Two of my friends are dancing. They are brother and sister, their connection happy and profound and familiar, visible in the shifting space between them. I feel the warmth and dearness of participating, even only by watching, in their lifelong connection.

Still the beat persists, the chanters shouting now, the didge growling out a relentless rhythm, with occasional high calls like cries of ecstasy, and I'm not holding still any more. Standing on the edge of the dance floor, I release my body to the song. My foot turns, lifting me and slamming down on the floor to meet the beat, my arms flow out of my body, grasping at air, releasing, pointing and shaping the air around me. My hips move to the center of the music, a constant restless seeking, side and swivel, arch back and thrust, over and over. I feel the energy rising in my spine; thoughts subside; the music is bearing me up, carrying me along, as if the floor, vibrating into my feet, is driving up into my torso which responds like a whip, head thrown up and back.

I'm in the river of the music, this endless rippling current carries me along like a leaf, spinning to some unknown destination, just in it for the ride. The beautiful woman pauses in her dance, catches my eye, speaks: It is such a delight to watch you dance! Thank you, I say, almost losing the thread — but I am dancing magic

now and the river is still flowing and there's no way I can lose my place in it.

The Sufi singers are still carrying us on with tremendous strength and power in their voices, the insistent long song of the whirling dervishes that can dance us into transcendence for longer than our bodies can hold out.

Janet appears in front of me — she has found her place in the dance. We match up our energies to dance together. I'm pleased — inviting her here, I had some worry she might not like it, but I should know better. When the subject is energy, Janet is right there. Our only differences arise when we are talking about it: our language, our concepts, what we are comfortable with. When we play with the energy in any of its amazing forms, the magic always works.

We connect first at the arms, reaching out to touch the energy around the head, the shoulders, the heart, dancing with our hands in the air, palm to palm, testing that we can feel each where the other is without looking. As we connect up all the nexuses in our bodies, the smoky current flows from heart to heart, belly to belly, forehead to forehead.

Janet touches her throat and I roar. We both think this is hysterically funny so we roar some more, still dancing, and Janet grabs me and pushes her forehead into mine.

It's like plugging into source. To each other. Palpable connection, thick in the fingers, we are dancing close. I pull the hair on the back of her head to make the pictures come, and she pulls mine, and the Great Snake laughs and coils between us. Our hands flow to the top of each other's heads to feel the crowns, and kundalini flows through both of us, out our skulls and up to the stars.

Still the music persists. We dance close now, clutching each other, grinding bellies and pubes, grabbing the heart at the back, the chi, the sun in the belly. (Oh, that must be why they call it the solar plexus!) We dance into each other — she becomes the Great Snake that flows through my body, her eyes peering owl-like into me, and we flow like this till the music

finally

stops.

Oooh, lovely. We curl up into each other on some chairs, dripping sweat and gasping for water. I pour some down my blouse, back and front, to cool down. Our connection becomes a cuddle with distinct and dangerous sexual overtones. It would be nice to go home and fuck, and we savor the turn-on, knowing that the dance took all our strength and that, anyway, the dance was orgasm enough. So we go home and cuddle our way into the flow of dreams.

We both suspect that stunning adventures of the kind Dossie has described here have been made possible for us solely by our kinkiness and our sexiness; we would be brain-journeyers only otherwise, and what a diminished life that would be.

Janet struggles particularly vexatiously with "the mind-body problem": when it comes time to actually play or dance or fuck or whatever, she's generally fine, but for hours or days or even weeks beforehand, her stubborn brain will generally think up approximately four thousand three hundred twenty-nine excuses why she should not do that thing... right up until she starts to do it, at which point it humbly subsides and integrates into her mind/body/spirit like a trouper. (Yay!)

In keeping with that struggle, she notes that the following essay was the most difficult piece she wrote for this book — her brain got so

scared and so stubborn about it that she had to write it in several small chunks, taking breaks for walks, snacks and breathing in between:

> Memory: My therapist's office. I've just finished telling her a dream: I was cutting my lover's skin off with a knife as part of a scene, and she came from it. The therapist asks, Do you realize how often your dreams are about skin?
>
> Memory: Maybe six years later, a play party. My partner has me tied, standing, in a trapeze-like sling. He is piercing my breasts and chest with needles. I have a vision: My skin is not solid; it is made of molecules, spaced broadly apart. The needle is a tool for pushing the molecules farther away from one another. With the molecules so far apart, there is nothing keeping me here in my body. I leave.
>
> Memory: My wrists are tied together. I look at them curiously. The rope is holding my wrists immobile, but my wrists seem to have very little to do with me. I cannot understand why, just because my wrists are here, I have to be here, why I can't just float away like a wraith in a cartoon, and leave my body behind in the bondage.
>
> It's true: My dreams are very often about skin. There is a part of me that simply doesn't believe that I am stuck here in this thin saggy sack. And really, as I move through my life, I'm the kind of person that people identify as not being in her body a lot of the time: if you come up behind me and say my name, you'll usually startle me; I often bump into doorframes and miss freeway off-ramps; nobody who's known me for more than a week ever tries to throw me anything without warning me first. Fact is, I don't like it much in here, and I wish I didn't have to stay here.

Last week, I had my first cutting. I asked a friend to open my skin very shallowly with a scalpel, not to make me healthier or prettier, but as an intentional exploration of the nature of this thin pink layer that makes the difference between me and not-me.

I am not very good at telling the difference between me and not-me.

Ever since the cutting, I have been in a state of terrible turbulence, alternating between pathetic neediness and hermitlike hypersensitivity. Something got opened up, something much more than a layer or two of epidermis, something that really didn't like getting touched and that apparently really needed to get touched.

I have always been terrified of being too much for people (probably because a lot of people have told me that I'm too much for them). As a result, I've always picked people who are needy enough that I've felt sure they can use up all of me — what, after all, would a self-contained person be able to do with someone like me?

And even when I get such people in my life, I'm still so terrified of being too much that I pretend to be less than I am. Yesterday I wrote a hard letter, long overdue, setting a boundary I should have set quite a while ago. As I sit here right now, I don't know whether my relationship with its recipient will recover. I have had so little practice establishing the difference between me and not-me that I have no idea what the aftermath of such a letter is likely to be.

My one true phobia (true, I'm not wild about cockroaches and other bugs, but I mean the real racked-with-uncontrollable-shudders-for-no-logical-reason-type phobia) is hard even to explain. What triggers it is a certain sort

of something that looks like its getting stuffed fuller than it can hold. I read a scientific article once about a bird that had an injury to the part of its brain that told it when a task was completed. It kept on building its nest until the hole in front of the birdhouse was stuffed full of twigs like a broom, and it was still trying to put more twigs in there; and I shuddered for days. A blocked street grate full of dead leaves creeped me out; I couldn't think of anything else for hours. And what that phobia is really about, I realize now, is me: the me that is too much, that is too full of emotion, of me-ness, for anybody to take, for the world to contain.

And I wonder why allowing someone to open my skin, on purpose, for fun, has me just the teeniest bit *verklempt*. It's a wonder I'm not exploding all over the landscape like an overstuffed sausage casing.

There's exactly one place in my life where I get to stop worrying about being too much: you guessed it, in scene. When I top, I'm allowed to know as much as I can and use my knowledge any way I want to. I'm allowed to hit as hard as I can and be as loving as I want to afterwards. I don't worry that I'm too much for my partner - that's what they're there for; I'm supposed to be too much for them.

When I bottom, I can scream as loud as I can. I can let go all the anger I can bring up. I can struggle and be violent. I can cry as though my heart will break. I can let my heart break. Nobody will tell me that my anger is inappropriate, or that my sadness is too much for them, or that they'll give me something to cry about — as though a person had to have something to cry about.

> There's exactly one place in my life where I get
> to stop worrying about being too muctoo small to con-
> tain me. And one small dungeon, with the right person
> in it, is plenty big enough.

So here we have an apparent paradox: Janet has gotten to do something that feels a lot like leaving her body — at least that's the way generations of journeyers, traveling on spiritual techniques and psychedelics and BDSM, have described it. But she's done it precisely by getting deeper *into* her body, through experiences of intense sensation or intense focus on someone else's sensation.

We suggest that perhaps what is called an "out-of-body experience" might be instead a transcendent moment during which one recognizes the illusory nature of the division between oneself and the rest of the universe: you haven't left your body, you've just let the boundaries between it and everything else dissolve for a little while. Feels nice, perhaps even a little miraculous — doesn't it?

When the shell doesn't match the spirit

Many of us have had the experience of waking up in the morning, feeling seventeen years old and full of hell — then looking in the mirror to see the face of a sleep-raddled, slightly saggy and wrinkled forty-year-old peering back with a startled expression. Whose face is *that*?

For some of us, the outside not matching up with the inside is more than an occasional moment of startlement. Gender represents a serious problem in self-expression for a great many people: very little is as tightly prescribed, and proscribed, as how we are supposed to express gender. In our culture, gender is supposed to mean that we can always tell the girls from the

boys; to do that, we are supposed to polarize maleness and female-ness, separate them as far as we can. Anything in between the poles is obviously wrong. In 2002, more than two dozen people were murdered in the United States because they were transgendered.

So how can we express what's in us when it's constantly be-ing held up to somebody else's yardstick? And how do you find yourself in this sea of other people's meaning? We think that we are only starting to even explore what gender is. Exploration has been forbidden for so long that we have only a little glimpse of what gender might be like in the world if we were really free to express however it came to each of us, at each part of our lives. One thing we can observe is that gender is not necessarily fixed. We ourselves, and others we know, have lived in a num-ber of gender expressions during our lifetimes.

We resent being asked to choose. No one should be closing doors for us: each of us can choose our own doors, thank you very much. We don't want to be forced to conform to somebody else's standards of male and female, masculine and feminine, butch and femme.

When Dossie was first a feminist, she made two very visible changes in her life. One was that she learned to repair her car and use power tools — with much delight, since she wasn't al-lowed to take shop at school when she was a little tomboy. The other was that she collected a whole lot of vintage evening gowns from the thrift stores, and set about being visually flamboyant for the first time in her life. To Dossie, there was no contra-diction in this — she was setting out to be the person she wanted to be, which is sort of a cross between Jane Russell and Rosie the Riveter.

Yet another advantage of transcendent play is that while you're doing it, your "body" sometimes magically adapts to fit your sense of yourself, as Janet writes here:

My Cock

Quite a few years ago, I had one of my good male friends face down on a bed. I'd been whaling on his butt with my favorite cane, and had just come in close to touch him and connect with him. He looked back at me over his shoulder, his face smoothed out with endorphin-y bliss, and said in a small voice, "Oh, Sir, that was just wonderful."

At that moment, I sprouted the biggest, hardest boner you ever saw in your life. Thing is, I don't have a cock — not a flesh-and-blood one, anyway.

My cock is made of energy. When I picture it, I picture a cock as clear and shimmering as crystal, but as warm and pulsating as any man's. It's only there when it's erect; the rest of the time, it goes away, and I'm no more aware of it than I am of my toes inside my shoes.

My cock shows up at odd times. The first time I ever took a tantra class, I was shown how to do undulations — those rolling pelvic thrusts that travel up and down the body like waves — and on the very first undulation, my cock was sticking up, as obvious (and slightly embarrassing) to me as a 14-year-old boy's unwanted erection. The fact that nobody else could see it didn't matter — it was there, and I had a strong feeling that the other people in the class knew it was there even if they didn't know exactly what it was.

I can come from sensations to my cock. I once had a man tied spreadeagled to a bed, and I lay on top of him and pumped between his legs, and my cock ejaculated into his cunt, and we both felt it, and I came. My orgasms from my cock aren't as intense as the ones from my clit, but they're deeply satisfying, like scratching a long-unscratched itch.

The one time in my life I've ever given what I think was a really good blowjob, it was because my own cock was erect too, and all I had to do was think of what would feel good to my cock and then do that to his cock. Afterwards, he looked wonderingly at me and said, "Wow, what got into you?" It wasn't so much what had gotten into me as what had come out of me.

Sometimes, I like to give my cock a body of its own — so I strap on a cock of silicone or rubber. But when someone sucks the toy or I fuck them with it, it's my energy cock that's feeling it.

I've wondered sometimes if my cock would be happier on a man's body, if it would like to be surrounded by a man's muscles and hair and smell. And while it's a nice fantasy, I don't think I'd be any better at being a man than I am at being a woman. Why go through all that work and trouble to be unsuccessful as a different gender, when I already have a perfectly good gender to be unsuccessful at?

So my cock and I stumble through our odd life together, surprising each other occasionally, surprising others from time to time. While it lacks some of the benefits of a flesh-and-blood one — I'd sure like to be able to pee out of it — at least I don't have to put condoms on it.

Willing but weak

If you, dear reader, are eighteen years old and in perfect physical condition, and intend to play only with other physically perfect eighteen-year-olds for the rest of your life, you have our permission to skip this section now.

But for the rest of us, one of the areas in which the whole body/mind/spirit issue is most frustrating is when our minds or spirits

are hot for play or sex but our bodies just can't keep up — either because what we want is physically impossible for anybody — sex with deities, death during sex that you get to have over and over again, those wonderful SM fantasies that in real life would land you in the intensive care ward — or because our individual body is, by virtue of age or injury or illness, simply not able to do what we wish it could.

In our previous books, we've written about one way to let your brain carry you beyond the limitations imposed by your body using role-playing, fantasy and imagination. With those tools, you can be people you aren't and do things you can't. Now, we will propose that your entire body/mind/spirit can contain far more hot juicy sexy energy than your body alone can sustain, and that even fragile bodies can attain unbelievably intense transcendent states by opening themselves to the forces of joy, power and sex that surround them.

Dossie suffers from chronic breathing problems, serious environmental sensitivities, asthma that sends her running for four different inhalers several times every day. Yet she writes:

Breath Comes Up Flying

The breath comes flying up fast these days. A mere focus at the root, opening the spine to let in the Queen of Snakes. Fat and golden, She drives up my spine. At each nexus, an image: the asshole, the crucible, the power spiral, the green sprouting ivy at the heart, gasping blue sky at the throat, midnight between the eyes, and the top of my head blows open, crown rising, sucking in the opal cosmos, filling me with light.

And somehow, in that state, I forget to worry about my aging body, how I look, how I need to lose weight, what about a face lift... With decaying disks and arthritis in my feet I can fly in the dance for hours, while my asth-

matic lungs pump up so much life that sometimes people have to tell me the drummers are exhausted and need to stop.

When I need further confirmation of the miraculous nature of trance, others tell me they can see it. In me. They tell me they see rainbows flowing down my sides, colors sparking from my fingers. I wonder about that till I realize I can look around the class while I'm leading an exercise, see the flow of the breath, the easing of the face, the little jerks and stretches of kundalini working her way through a tight place. The light glowing through the skin. Stretching you. And me.

It never fails to amaze me how fast this can happen, how easily my spirit opens. And the confirmation that the magic really works. This energy is learned by being felt.

Even those of us who hunger for more intense forms of SM, for bondage or whips or clamps, can often find in our breathing and our connection a way to sate our hunger when our bodies, or those of our partners, can't keep up the pace that our fantasies would set for us. Here, Janet writes of her first time topping her lover, who suffers from the aftermath of a serious spinal injury:

I want this so much, and I'm so scared — how do I top someone whose kinks are so different from mine, and who, moreover, lives in a damaged body whose fragilities I'm just starting to understand?

But we've been planning this for a week or more, we're both faintly dizzy with lust. I know public play is a near-limit for him and that he's pushing himself to do this, and I want it to work for him. Fortunately, it's a small party, attended mostly by people he knows well and feels

comfortable with, and the space is a small one, dark and warm, with lots of intimate private nooks. I can find a way to make this work, I know I can. I can ride both of our fear and use the emotion to build the scene from. Can't I?

The party starts with a small ritual. Damn, he's already having trouble: we're standing in a circle, and standing on concrete for so long is challenging for him. The circle is swaying, and that's even harder. I try to use my body to block the swaying so he's somewhat protected from it. Hang in there, hang on…. whew, he's made it, but not by much. We collapse onto a nearby mattress and he rests until he's stronger. Then we get away to a quieter place where he can get some medication, and we can regroup and figure out whether play is still an option.

We wait. The meds kick in. What the hell. We decide to give it a shot. What the fuck have I gotten myself into? Am I insane?

Ah, the perfect playstation: a small prison cell, a mattress on the floor, bars for bondage, plenty of privacy, nice and warm. Not knowing exactly what we're going to do, I've dragged along the Monster Toybag, loaded with everything I can think of — flagellation toys, sex toys, bondage gear, safety equipment. I don't think I actually put any construction equipment in there, but that's probably only because I didn't think of it. I wheel it in, open it up, start unloading. And then there's his bag too: a weight belt to protect his back, a posture collar (cool, I've always wanted to put one of those on someone — this isn't just about the protection for his neck, I like this thing), some rather fey little drag items that are quite sweet, more bondage stuff… well, you could probably supply

the entire party with the stuff we've brought. Not that we were, well, nervous or anything.

Ha ha, me pretty, I have ye just where I want ye. To put it more bluntly, he looks beautiful. Tied on his back, with his hands down by his sides in bondage mitts, his booted feet tied to the bars at the end of the cell, blindfolded, gagged, and — a last-minute refinement that sent a beautiful wave of resigned, erotic helplessness across his face — loops of cord running from each side of the posture collar to secure his head to the bars at the top of the cell. In other words, quite, quite immobilized. And while I'm not usually all that turned on to bondage in and of itself, I'm quivering like a Jell-O mold and running a high fever.

Hmm... what now? Seems to me he'd mentioned something about having rather responsive nipples. I take one gently between a thumb and forefinger and pinch it.

Wow. I've given blowjobs that haven't gotten that emphatic a response. Wonderful, whole-body tremor and a gasp with a little bit of a moan behind it. Oh, boy, this is gonna be fun. I settle in for some experimentation: pinching, flicking, rubbing... they all work, and the effect doesn't seem to diminish — in fact, it seems to strengthen. I lower my mouth and try out a little tongue and teeth, and the response triples and I can feel my cunt begin to throb. I smile to myself: I can keep this up for a long, long time...

...and in fact, I do. There's a brief interruption: "Sir?" he asks faintly. (I grin: he's already pretty short of breath.) "Yes?" I respond. "The blindfold? It's itching like mad, I think I'm allergic to something in it." "No problem," I reassure him. I grab the spandex shirt I've already taken off and position it to tie over his head, hood-style, as soon as the blindfold comes off — no interruption in the

scene at all to speak of — and I'm back to tormenting his nipples again...

By this time, I can tell that the sensation isn't just sexual; I've tenderized the little nubs — he's beginning to sob. Oh, boy, dessert! But I don't want to wear him out too soon, so I reach down to his genitals to balance the pain with some pleasure. He's not hard, but there's a nice gooey blurb of pre-cum at the end of his dick. I massage it and he moans, but I don't let up on his tits, except to take a break to probe his mouth deeply with my tongue...

I press my fist deeply up into his perineum, giving him pressure up against his prostate; and his sobs grow deeper, part pleasure, part pain; and god, if I could get him hard enough I'd mount him right here and now because I am so horny I am just about to keel over and die...

...but he's just not quite hard enough for that, although I set a condom close at hand just in case, and go back to work on the nearest nipple; and now there are tears on his face. God, if I have a fetish, it's tears. Nothing makes me hotter than to see a bottom crying because of the pain I've given him. This is too much, it's unbelievable, I could devour this man like a dog eats a steak...

...and I've totally lost track of the time. Has it been an hour? two? three? I haven't even taken any toys out of the bag, I feel like I've hardly gotten started. I take out two little toys, a horse's currycomb with brush bristles on one side, and a soft scrap of chinchilla fur, just a couple of new sensations, really, and he stirs, and says, "I think I need a change in the bondage now, sir." The energy shifts, and I give him his arms back and lie down beside him, and it's over, and it turns out we've been playing for

almost three hours, and all I've really done is play with his tits and genitals with my hands and mouth, and, oh yeah, fall in love a tiny little bit.

And we lie and cuddle and drink some water, and eventually I figure out how to untie everything I tied and undo all the straps and stuff and get everything more or less back into the bags and us more or less back into our clothes. Everyone else went home hours ago and we never noticed. We walk back to our car through the deserted streets as the last bar closes, and a drunk sings a Christmas carol even though it's mid-January, and the magic doesn't start to wear off until a day and a half later, and hasn't all the way worn off two weeks later as I write this, and maybe with luck never will.

So there you have it — hearts and spirits connect with each other and with the universe, minds and bodies really are one, time and space drift out of the picture, bodies are happy to carry the sensations (and the toybags), and what you get is ecstasy. No wonder it feels like love — it *is* love.

Something Told Us To Write This Chapter

Your authors decided to write this book after a remarkable scene we played together. It might seem like one of our simpler scenes: not much in the way of role-playing, lots of physicality. Bondage, whips and canes, what some people might be shocked to hear described as "the usual sort of thing." But, as Dossie recounts...

> I have this story fantasy that I have put myself to sleep with for decades. Still the same story, although it constantly changes, gets embroidered, new details are added, old pictures drop out. The kind of story you can always match to your masturbation, because you know it so well you can rewind when you need to spend some more time getting turned on and then zip! Fast forward to the orgasm part. Lots of you reading this have stories of your own.
>
> Now Janet and I have been playing together for umpteen years, and she certainly knows what I like, but

she doesn't know this story. Not in all its details, not in its particular sequence, not perfectly. So when she tied me up and started doing all the wonderful things in my story in exact detail and in perfect sequence, I was quite, quite startled. Well, not startled enough to stop her, let me reassure you, gentle reader. I thought about that for a moment, interrupting the scene to inquire into what in heaven's name is going on here, but I know what side my ass is buttered on, and I figured out right away that I'd rather do the scene than talk about it.

And the scene felt beautifully connected — of course it was a perfect fit from my point of view. And am I going to tell you all the details? Oh, no, gentle reader, even I have limits. And an occasional sense of privacy.

After we were through, while we were cuddling, I asked Janet if she knew what she had just done. "What?" she inquired. I told her she had just completed a perfectly psychic scene, and she said, "Oh, yeah, a lot of people tell me I do psychic things when I play."

!!! This from Janet, the left-brained empiricist, who doesn't like all that woo-woo stuff, and has to be patient with my metaphysical bent. And so we decided to write a book about it.

And this chapter is about that woo-woo psychic stuff. Pardon us, intuition. Let's say you're in the moment, you're completely in connection with your partner, and all of a sudden... something just comes to you, a piece of information about what needs to happen next, what your partner needs to hear or what their body needs to feel, that you have no rational way of knowing. What's going on?

What's going on, most likely, is that your intuition, that lovely bit of your consciousness that gathers up information that your

busy cerebral cortex has overlooked, is kicking in and feeding you the good stuff that you need to send you both rocketing into the cosmos.

The best definition we've heard of intuition is "knowing what you know without knowing how you know it." Everybody has intuition, although some people are in much better touch with theirs than others. And we can't really teach you how to have intuition — but we can suggest ways to listen to what you've already got.

Some people believe that intuition comes from subconscious observation of phenomena that are too subtle for the conscious mind to observe, like very small shifts in body language, pupil size, odor, things like that. Other people believe in genuine paranormal phenomena, psychic links, and so on. What do we believe? Please refer back to earlier chapters: we believe both of these things and neither of them — does this surprise you? Actually, we feel no need to believe either of them — we just do what works for us, which is what this chapter is about.

We do think, however, that the processes we're teaching in this book, the breathing and connection and all the rest of it, make intuitive leaps far more likely. When you open yourself up to energy flow, you're connecting yourself to new sources of power and creativity — if you'll pardon a rather geeky metaphor, it's like you're adding more processing power to your CPU. That means you'll be able to take in and process more information, right?

The most important step in grasping your intuition is to open yourself up to it. Because we live in a culture that loves to be rational, people learn to ignore their intuition the way they learn to screen out other "distractions" like buzzing flies and minor aches. So when the time comes that they want to be intuitive, they don't know how — they've spent so much effort tuning out that channel that it's difficult to tune it back in.

Tuning in is often a particularly difficult task for people who place a high value on rationality, because when they get "messages"

that they can't account for, they discount or ignore them. Sometimes, they may even be frightened by their intuitions, which can be accompanied by strong and inexplicable emotions. Well, if this is you, please stop that immediately — you've got a good brain, and if it's telling you something there's a reason, even if you don't know what that reason is. Trust your brain; it wants you to have fun.

How do intuitions come to us? In day-to-day life, sometimes in dreams, in "irrational impulses," in daydreams. We may find our attention lingering on an object or thought for no good reason, or find ourselves drawn over and over again to a particular color or shape. We might feel an itch or a thrumming somewhere on our skin, or our body might want to change position, or our hand might open or make a fist. A smell might call to us. We may hear a song lyric playing itself out manically like a stuck record in our head — what is it saying to us? Janet had an amazing discovery about one of her intuitions:

> This is a little bit embarrassing to talk about. But I've had this fantasy for decades, since earliest childhood, although it's had different casts and settings through the years.
>
> Here's the broad outline: Person A is a Bad Guy of some sort, a criminal or maybe just a pain in the ass. Person B takes him in hand, becomes a sort of parental figure, reforming and redeeming him (and, of course, spanking him a lot). I never thought much about it; it was just My Fantasy, as much a part of me as my face in the mirror.
>
> A couple of years ago I was working on a presentation called "Intuition and Reading Your Bottom." I was doing a lot of thinking and meditation about my own intuitive process, trying to understand it in a linear enough way that I could present it to an audience. During one of

these meditations, my mind drifted, as it tends to do, to My Fantasy.

I noticed that Person B in this particular fantasy (well, it was Jean-Luc Picard, if you must know) was taking his shirt off. Hmmm, I thought. That's odd. He's never done that before. And then it hit me: one of the ways I get my intuitions is through skin-to-skin contact; that's why I almost always take my shirt off when I top. The fantasy was telling me something.

Oh God — the tops in my fantasies were my intuition, speaking to me in their stern parental voices, telling me what I needed to know. Can't I even have a fucking sex fantasy without it turning into some sort of lesson?

The good news is that this knowledge didn't destroy the fantasy, as I'd feared it might; it still soothes me to sleep at night (and when I'm not sleeping it makes the night a lot more interesting). And sometimes, really, it is just a fantasy, nothing more. But now, when one of my fantasy tops speaks, I listen very, very carefully.

When intuitions come to us during play or sex, it's usually in the form of impulse — something telling us which toy to pick up next, or what words to say, or where to place the next clamp. (A black-belt friend of Janet's once observed, "If you look at a body, it will tell you where to hit it." Janet agreed, "Yes, I know," and got a very startled look in return.)

This can get a little tricky, though. If you're playing and connected and high and turned on, how can you tell the difference between an intuition and your own desires? Well, truthfully, you can't — even professional psychics will tell you that they can't work with clients that they know personally, because they can't tell the difference between their own emotions and desires, and the information that comes to them psychically.

So, say you've got your bottom all trussed up beautifully, and the flogging has progressed from the light flogger to the medium flogger to the Flogger Of Death, and your bottom has flown along the top of everything you've fed them, laughing joyously, and something is telling you that the next thing that bottom needs is a heavy caning — even though you haven't really talked with them about canes before.

Well, that could be your intuition talking... or it could be your dick or your clit talking. And you don't know which, and neither do we, and we don't suggest that you gamble your reputation and your relationship with that bottom (and your karma, if you believe in such things) on the outcome. So what you could do, for example, is pick up a cane and try a couple of light taps on that bottom's ass to see how they respond, and if they flinch and tighten up, you have your answer — that was your gonads, not your intuition, talking. But if, on the other hand, they begin to breathe heavily and their pelvis begins to undulate and they stick their ass out for more, you might try a couple of slightly heavier taps; and if you get more of the same reaction, then you have reason to suppose that Lady Intuition was whispering in your ear. You can confirm her presence, if you like, with some verbal affirmation such as "So, you like that, do you?" (The appropriate response, for all you bottoms reading this, is "Ohmygodyyesssss...")

Other tops like to use other ways of getting a bottom's assent to their intutions, like having the bottom kiss the whip or other toy. Which gives the bottom a moment to say "I tried that one before and I hated it, Sir or Ma'am as the case may be." Whatever — the important thing is that you have some way of checking your intuition before you wade in there and start flailing away.

Some not-so-good signs include muscle tension (tight, bulging or quivering muscles), tight breathing (fast or high up in the chest), or a high-pitched voice. Some generally excellent signs include rhythmic vocalizations like "babbling," humming or groan-

ing; rhythmic body movements like bobbing or dancing; or pelvic undulation. Usually a bottom who's vocalizing or moving in these ways is heading toward an ecstatic experience, and will take you with them.

What if it's not so straightforward?

So far, we've talked about using your intuition in scenes where consent and pleasure are clear-cut, which is nice and easy and direct. But what about scenes that are darker and less certain — scenes that are about resistance and tension and struggle, where you're playing with consent that looks like nonconsent? Can you still use your intuition there?

Yes, of course you can — in fact, in those scenes you need it more than ever. Intuition can help guide you along the razor's edge between almost-too-much and over-the-line, the edge where such scenes are played. But we aren't going to be able to give you as straightforward a set of rules about this kind of play, because the guideposts here are far more individual — which is why it's essential that you know your partner very well before you try this kind of thing. Misreadings in resistance play can be disastrous.

Janet writes here about such a scene, played with a good friend:

> "I don't think I'm going to be up for playing tonight," she said.
>
> She'd been under an amount of stress that was unusual even for her — kids in trouble at school, arguments with her husband, car trouble, friendships at risk. She was on edge, angry, weepy, unsure where she'd go in scene or how she'd react to whatever stimulus I fed her. I understood, of course, having had way too many such weeks myself, but we both also knew that it might be months before we'd have another chance to play

again. Finally, we decided to give it a try, but to go slowly and to back off if things seemed weird or out of control.

So she stripped down to her panties and stepped up to the St. Andrew's cross. I slowly and sensually bound her to the wood, adding more bondage than usual, knowing how she enjoyed lots of rope. When she was firmly attached, I stripped to the waist and came up behind her, putting my arms around her, feeling the warmth and chamois softness of her sides and chest, nuzzling her precious neck.

I bit her softly on the big muscle that runs up the side of her neck.

I heard a soft choking sound and looked at her face. She was sobbing. A tear was running down her face.

I pulled her body closer to mine and held her harder, pulling her into me. I felt an orgasm start at the center of her torso and thrum outward, pulsing through her limbs, making her groan, spreading her fingers and toes. We were perhaps ninety seconds into the scene. I wondered whether we'd reached any definition of "weird or out of control" yet.

I decided we hadn't, reached for my warmup flogger — a decade-old familiar of green suede that's practically a limb of my body — and began to oh-so-gently caress her back with it, running the tips down her skin as though I were painting rice paper with watercolors. She sighed and arched herself backward against her ropes, asking for more. I gave her just enough more to remind her that what she was feeling was indeed a flogger. She began to giggle, and giggled harder as I flogged harder...

... until suddenly the giggles were tears again. And then, as I surprised her with a few hard flogger strokes upward between her legs, another orgasm.

At this point I saw that my job that night was to squeeze catharsis from her like squeezing juice from a lemon, and summoned all my strength — physical, emotional, intuitive — to pull every last drop of energy out of her. She needed it so much, and I knew how to get it out of her, better than anyone else, I thought; and I loved getting it from her.

I struck again — and again giggles, and again tears, like a three-spoked wheel turning, as I flogged and flogged, as minutes stretched to what must have been an hour or more, using heavier implements, and later a strap, and a cane, until sweat was dripping from the ends of my bangs and she hung limp in her ropes, too exhausted even to tremble, purged for at least one evening of all the petty anger and worry and little fears that had bowed her shoulders and made lines around her mouth.

I am always amazed by how young someone looks right after bottoming — the innocent look of bliss that steals decades from cheek and forehead.

I untied her and supported her to a nearby table, where we curled together and purred like big spoiled cats, with nothing much to say and no reason to say it — until thirst and low blood sugar led us to pull ourselves together, put on some sort of clothes, put the toys away and wander out in search of cold water and chocolate.

How had I known to go on, after that first thunderstorm of tears? I can never really answer such questions. I could have stopped, untied her, taken her out for a burger and let her talk about her troubles, and that would prob-

ably have served her well too. But I've been where she is, with kids and PTA meetings and an unfulfilling marriage, and I didn't have anyone to beat me and let me cry and come and cry again in their arms. Back then I would have given anything for that — so I kept on going. Instead of a few more grams of cholesterol, we savored a scene that both of us will remember for a long time and that brought us closer in a way that no burger ever could.

How to find your intuition

If you feel like you need some help finding your intuition, here is a meditation you can try sometime when you are by yourself. Practice it a couple of times a week. You will find that it gets easier and easier, and that your intuition will be easier to find when you need it.

This is not a short-term project, but it it's kind of a fun one, and we think you and your partners will both reap a lot of benefits from it — not just in the bedroom or dungeon, but in all your personal interactions.

> Sit in a comfortable chair in a place where you won't be interrupted for at least twenty minutes. Make sure you're not hungry or thirsty, that no light is annoyingly in your eyes, and that your bladder is empty. You may wish to place a notebook and pen nearby in case you have any thoughts that you want to write down afterwards.
>
> Close your eyes and breathe deeply from a place deep in your belly. With each breath, let outside worries and distractions drop away, and move fully into your body. Simply breathe like that for a couple of minutes.
>
> Now, bring your attention to your toes. With the next breath, notice if there is any tension in your toes,

and exhale that tension out. With the following breath, exhale out any tension you find in your feet. Then your ankles. Then your calves. Keep on breathing out any tension you find in your body until you have gone all the way up your legs, hips, torso, chest, up your hands and arms, shoulders, neck, face and scalp. While you search for tension, if you find anything about your position in the chair that seems uncomfortable, adjust it.

Now, imagine yourself standing at the base of a large hollow tree. Step into the tree, into the dimness. There you will find a circular staircase leading down, lit with torches so you can see. With each of your breaths, take a step down this staircase, until you have reached the bottom.

At the bottom of the staircase you will find yourself in an open area with a stream running through it. Look around you and register what you see. You might want to explore this space with a dance, or feel your toes in the stream. Spend some time in this space. This is your own space, the space where your intuition lives. You can come back here anytime you want to.

Now, with your mind, invite your intuition to join you here, in whatever form it chooses. Your intuition may be a person, an animal, a voice or perhaps even just a feeling. Only you will know what form your intuition will take.

When your intuition arrives, spend a moment registering the form of your intuition. Then see if there is anything your intuition wishes to say to you. Are there questions you wish to ask it? Some suggestions: "How can I invite you into my life?" and "How will you guide me?" and "How will you connect me with others?" You may have some other questions of your own.

When you have finished talking to your intuition, wish it goodbye for now and send it back to where it lives. Turn back to the staircase. Continuing your breathing, slowly climb the stairs, gradually bringing yourself back into normal consciousness as you do so.

Spend a minute resuming normal awareness and bringing yourself back into your body. Open your eyes.

Did your intuition tell you anything that you'd like to remember later? If so, write it down in your notebook.

Next time you're feeling annoyed by a thought at the periphery of your consciousness, or having trouble reading someone, or otherwise feeling stuck with a problem that your conscious mind isn't having much luck with, try summoning a mental picture of your intuition and see if it has any messages for you.

Mind Journeys

Whee — a whole day with Daddy! This was an unprecedentedly rare opportunity, since he had a full-time job and I had a primary relationship; usually we only got to squeeze in an hour or two in an evening. So we'd set up a lengthy and elaborate role-play with plenty of our favorite nasty sexy punishment games. I didn't know exactly what he had in mind, but he'd asked me to bring along "something to be punished for." Knowing the kinds of things he liked, I'd borrowed a handful of extremely smutty magazines from my roommate, and showed up as my nine-year-old alterego "Jessie," in pigtails, an indecently short schoolgirl outfit, and a hangdog expression.

All had gone quite satisfactorily so far: Jessie had been a very naughty girl indeed. Daddy and I had been doing some magnificent improv based on the magazines, and it had evolved that Jessie had not only showed up at school with the smut, but she'd been showing it to her

little friends, *and* she'd been selling peeks for 25 cents a look, *and* she'd stolen the magazines from the corner store, *and* her purse was full of against-the-rules candy she'd swiped while she was in there, *and* she'd told the principal that she'd taken the magazines out of Daddy's nightstand! — all this, of course, extracted from her after many threats and many more spankings. What could possibly be a nicer way to while away a pleasant Tuesday?

But then Daddy decided that I had to apologize for my terrible behavior. He sat me down at the dining table with a lined pad and a ball-point pen to write a formal letter to the principal, Mr. Fisher, detailing my many transgressions and offering my apologies.

I was instantly catapulted nearly forty years back in time. At eight years old, I was promoted to do reading and writing with kids a grade ahead of me. The reading, and the content part of the writing, were no problem — I could easily have kept up with children a lot older than that. But I was a poorly coordinated child even for my age, and kids a grade ahead of mine were learning the flowing Palmer cursive that was being taught to schoolchildren in the early '60s — hand motions far beyond my physical abilities. I spent hours that year struggling, frustrated and tearful, over smudged pieces of lined yellow paper, trying to get my letters to look like the perfect ones on the strips that hung over the blackboard in every classroom, and failing every time... not understanding why I was the only one having to do this special, impossible work, and bringing home report cards with A in every square except for the mocking Cs in Handwriting.

Daddy would never have known the difference had I decided to print my letter to Mr. Fisher, but it never occurred to me to do that: I was nine years old, and I wrote in cursive. Laboriously, I wrote in the best Palmer cursive I could manage: "Dear Mr. Fisher: I am sorry for being a bad girl. Love, Jessie Hardy." I tore off the paper, and handed it to him hopefully.

He looked at it and tore it up. "You have to write everything you did wrong and apologize for each thing separately," he said. "And you don't sign 'Love' to a letter to the principal, you sign 'Sincerely yours'."

Mutely, I began again: "Dear Mr. Fisher..."

He found fault with that letter, too, and made me write it over. And the next one, and the next one — I'd left out one of my naughtinesses, or I'd spelled a word wrong (OK, so I did that one on purpose), or it was too short, or too messy. I sank deeper and deeper into my old space of shame, anger and frustration, closer and closer to tears.

Finally, abruptly, he accepted my latest letter — to my surprise, since I didn't think it was as good as its predecessor — and we moved on to more spankings and sex and fun. (He told me later that he'd seen me getting more upset than he felt that he wanted to handle, and so had decided to move on.)

So my special day with Daddy had turned out to have a special gift in it — a visit to my own past, and a reawakening of a buried memory, a chance to re-experience feelings of injustice and frustration — and to see where, perhaps, similar feelings today might have their origins. Not bad for a day of playing hooky and a couple of pieces of borrowed smut.

We have spoken so far mostly of journeys into altered states in which the vehicle that carts us down the road to somewhere else is the body: sensations in the body, stresses to the body, the breath, the skin, physical connection to another, intense SM stimulations, sex, or any other way the body can lead us into ecstasy.

But within the enormous repertoire of BDSM, there are also many journeys in which the vehicle is the mind... where what is sexy, what raises the life force, what wakes up kundalini, is mind games.

Who knows what evil lurks...?

We have a theory, perhaps better described as a metaphor, for how SM works in the psyche. This theory explains, for us, a lot of our drive to travel in dark dirty places, and why playing these games often results in our feeling more whole, more ourselves and perhaps healed in some way.

Carl Jung's "map" of the mind (please remember that the map is not the territory — this is a metaphor!) can look something like the ocean. If you think of it like this, the air is our everyday consciousness: things like grocery lists, things we do for work and so on. The water is the unconscious mind, which we usually perceive in nonverbal or nonintellectual forms like feelings and dreams — the oceanic depths of the psyche, where are found sunken pirate ships, fabulous stories, archetypal creatures like mermaids and dragons. At the very bottom of this metaphorical ocean Jung places the Collective Unconscious, which he saw as the divine energy that animates and connects us all, the gate to spiritual awareness.

Jung talks about a gray area between conscious and unconscious which he calls the preconscious mind. It's sort of like tide pools: sometimes you can see it, sometimes you can't, sometimes it's under the water, sometimes it's in the air. Here we find dreams and fantasies, fleeting desires, experiences we only occasionally remember. Like

the creatures we see in tidepools, certain parts of ourselves thrive better in this alternating environment than anywhere else.

Now imagine a big iceberg floating on this ocean, a small part visible above the surface, much more of it hidden beneath the water. Jung called it the Shadow, and thought of it as the repository of everything we have forbidden ourselves to be aware of: painful feelings, shame, trauma, family secrets, the things Aunt Edith did when she had too much to drink, cultural taboos, incest and sin, doubts we have about what we are told we are supposed to believe. We have all been brainwashing icky stuff from our awareness since birth. A lot of our deposits into this scary account were made when we were small children and afraid of things we no longer fear. Everything in the Shadow carries a huge emotional charge: Forbidden!

We suspect that many of the dark fantasies we love to explore in SM are paths to the Shadow — paths to parts of ourselves that we wish to bring back into consciousness, split-off parts that we want to welcome back so that we can be whole. Seen in this way, the theater of SM is a sort of psychodrama, tracing a scary painful path to some dark cave in our iceberg, but with someone else to share in the journey and act as mirror to validate our experience. What if we can walk that path and write a script that gives the story a new ending — a denouement that resolves conflicts, leaves us feeling more sane and more powerful? What if our companion on this journey, our top or our bottom, then sees us as lovable or desirable? What if when we shoot that story full of eroticism we are injecting it with the healing power of the life force? What if bringing our dark fears into the light of awareness can heal us, make us more whole?

This is what we and the players we know have done, time after time, in the mind journeys of deep BDSM play. For many of us, ecstasy and traveling in the Shadow are one and the same thing: from the messy bottom of our fears, from the roots in the dirt, up

through us and out to the cosmos. Many, many people find healing in the Shadow.

We believe that shadowplay often entails a different sort of journey than the embodied practices we've described so far in this book — a sort of emotional or spiritual deconstruction, a breaking down of the component parts so that they can be reassembled into a structure that feels stronger and better afterwards. Janet writes here about her discovery of such a possibility:

I bottomed for the first time this weekend to someone new, someone who I think will become very important in my life. And I already know that he's used to playing very differently than me — not with the simple straightforward give-me-pain-and-let-me-fly scenes that I've always excelled at, but with twisty little games of give-and-take, mindfuck and control, confusion and misdirection: a whole new roadmap for me, as different from my skydiving ecstasy as the jungle is from the Antarctic.

Partway through the scene, I felt myself teetering on an unknown edge, and wasn't sure I liked it. I couldn't find the words then, but what I figured out later was this: there's a kind of SM that's about getting to win, and a kind of SM that's about getting to lose. And I'm used to playing the kind that's about getting to win. About both people getting to win.

I once watched a workshop/demonstration on interrogation play come close to a fistfight, when the demo bottom realized that being interrogated meant that you didn't get to win. You could see it cross his face — this was going to hurt more that he could take, and all these people were watching, and there was an awful moment when it was clear that he was about to take a swing at the instructor (who was about half his size and twice his

age), and then he safeworded. I felt awful for the instructor, and I knew just how the bottom felt. Winning feels awfully good, and if you're not turned on to it, losing feels lousy.

Last year, when I was recovering from a painful breakup, I started wanting scenes where I didn't win. In fact, even when people tried to give me scenes where I won, it didn't work — I broke down anyway. I didn't have it in me to be big: I needed to be small, to fall apart into all my little component parts so that they could reassemble in new ways. I sought out some of the strongest, meanest sadists I knew, people who were willing to push me further that I'd ever gone before — frankly, further than I'd have been willing to push me under the same circumstances, right up to the edges of consent, into full cathartic shrieking begging meltdown. It was then that I began to learn something of the reward of smallness, of being reduced to my irreducible minimum, of finding out what I was made of.

It takes trust to go this far. When I bottom like this, I trust that my top will respect the bare quivering pink self that's all that's left when I let myself lose: a hint of the wrong kind of mockery, the slightest indication the next day that anyone's opinion of me has been lowered, and I may never, ever be able to go there again. And I could never top anyone this way whom I didn't trust absolutely — it takes the strongest person in the world to let themselves be this weak, and if I can't trust their strength I certainly don't feel safe playing with their weakness.

So now, when I look back on my experience of this weekend, I think I may have discovered a new limit for

myself. Once upon a time, I might have said, "No los-
ing." Now, I think my limit is, "No losing on the first date."
The second date?... well, that's an essay for another night,
I guess.

Roles and games

Before we get too deeply into the subject of roles, we want to
clarify one issue. We've talked to a lot of people who are turned off
to the idea of role-playing, imagining something very theatrical
like Robin Hood and Maid Marian, because they think it would
feel artificial and awkward to them. Our belief is that everything
we do in life is to some degree role-playing, and most especially
that everything we do during sex or BDSM has to do with playing
roles. We suspect that the way you behave with a lover or play-part-
ner isn't the same as the way you behave with your boss or your
mother-in-law. So in this section, when we discuss roles and games,
we're not necessarily talking about very theatrical scripts with props
and costumes, but simply about the intensified roles that we adopt
in order to find our turn-on and our ecstasy.

Roles we play in mind games tend toward archteypal extremes:
we polarize the power between dominant and submissive to turn
up the voltage.

In Janet's scene at the beginning of this chapter, the roles were
polarized by age, by making one player the child and the other the
adult in power. In other scenes, the top might have the flavor of
the teacher, the guru, the empress, the slave trainer, etc. The heat
of the scene often comes from the extreme polarization of roles,
with the dominant taking on enormous power and with it enor-
mous responsibility, and the submissive giving over that power for
the delight of feeling free in a myriad different ways.

BDSM primarily focused on the mind journey is often called
DS, or dominance and submission, to distinguish it from sado-

masochism, which gets defined as playing with intense stimulations like pain and sex. Actually, in our experience, much of DS involves physical connection, and much of SM involves mental domination, so there's probably more gray area than pure anything. Your authors aren't known for valuing purity of any sort.

What role does the role play?

The roles we play in SM, and the power exchanges we practice, offer us infinite ways to connect, and present many confusions of which we need to stay aware. Especially the difficult truth that who we are in our fantasies is part of us — an important part, but not the only part.

Many submissives' fantasies are of the big bad wolf, the Klingon, the ice queen, the arrogant unyielding bitch or son-of-a-. They dream of complete subjugation by an ever-dominant and ever-certain Someone. And the same submissive may also want a romantic hero or heroine who will gaze into their innermost soul and wholeheartedly accept whatever is to be found there. They want to be cherished, respected, recognized for the valuable beings they are.

Therein lies the paradox of dominance. Love and domination seem, at least on the surface, to be mutually exclusive. How can we love unconditionally while demanding subjugation of will? If we love someone just the way they are, how can we require them to be another way? If we want them to be happy, how can we make them do things that they don't want to? Yet if we don't provide adequate subjugation, if we don't enforce our will on theirs, they feel uncared for, abandoned. It's enough to make a boy or girl go vanilla.

The problem arises, we think, when people get "stuck" — stuck in the source material for their fantasies of control, ownership, force. We all want our play to seem "real" — some go so far as to disdain the word "play," insisting that what they do is real owner-

ship, real control. And the harder we push to make it real, the more we may lose track of an essential truism of kink:

Everyone involved in a scene is in service to that scene.

This truism applies whether the "scene" is a friendly smack on the tush or a lifelong 24/7 relationship. Everyone involved needs to have a roughly similar picture of what the scene is or will be: the more similar the picture, the greater likelihood of a successful outcome. Some aspects of that picture may be externals, things like what outfits we wear or who gets hit on what body part, but that's usually not the whole picture. What do we want to feel? Are we stern but caring, lovingly parental, terrifyingly sadistic, serenely shamanistic? Are we terrified or adoring, child or warrior, pathetic or ecstatic? A rebellious captive, an adoring pet, a hardworking servant, a precious jewel? What kinds of words or sensations or behaviors or environments make each of us feel that way?

When we know the answers to these questions, or at least have discussed them and begun to recognize where our fantasies meet and where they might stray, we know what the scene is. And from here on out, whether we're King or Queen of the Universe or the lowliest of the low, we are now in service to the scene we've mutually chosen and entered into. We are playing the same game.

The amazing thing is, once we recognize and truly accept that control is illusory and that we're in service to something greater than ourselves, we often find that issues of control and ego, which may once have seemed important, have melted away. We neither give nor take away power. Rather, as we raise eros, everybody's power gets amplified, and together we become enormously powerful. We enter that magical realm of consciousness that athletes call "the flow" and we call "scene space," where we and our partners and the environment and the activity all become one, working together to create a mutual reality in which time and space float away. Each moment follows inevitably upon the one before, and the communion

and the sensations and the emotions all feel so perfectly right that ego and control seem as distant and irrelevant as the temperature in Bangkok. We are in a reality no less real than our morning commute.

So many choices...

Let's look at a variety of ways people journey in the life force by the scripts they choose to play. For our purposes, roles define scripts, and the scripts become the rituals through which we transit into the divine state of consciousness.

If you're wondering where these scripts come from, you need look no further than the sweet or not-so-sweet stories you soothe yourself to sleep with every night. Fantasies are a wonderful window into the Shadow, reflections in the tide pools of consciousness of beasts from the deeps. They are a great way to see your archetypes, your story, what's important to you. Look in your daydreams at what you want to do, how you see yourself in scene. Then look at who you have imagined as your ideal Other: who are they, what do they do? Think about what your fantasy says about how you want to be received, what about you you imagine your partner responding to and how the partner responds.

Dossie, the abuse survivor, has a lot of fantasies that involve a parent figure, simultaneously vicious and nurturing, who sees her pain and gets turned on by it, and thus is moved to love her and treat her (eventually) with sweetness and lust. Perhaps this is curative to the horrible feelings of the battered child — the beliefs that her parent can't see her pain, is refusing to help her with her pain, hates her when she is in pain ("I'll give you something to cry about!"); and that when she is in pain, or in want of nurturance or support or love, she is ugly and unlovable. Only we clever schemers of sadomasochism can script a scene to go from pain and victimization to lust and love and orgasm and cuddling.

Janet's root fantasy is more likely to make her the parent figure, with her sense of power and righteousness channeled into loving punishments that transform her bottoms into the beautiful people they indeed can be after she chisels a little on them.

You can see why your authors love to play together. And had we met when we were first starting out in the scene, we might have wanted to explore one fantasy over and over again together, seeking out all its permutations. But we've been at this a long time, and we've both expanded our repertoires quite a bit. Today, these are not the only roles we play — we explore lots of scripts, and often Dossie is the top and Janet is the bottom.

We've learned that when we set out down the path of a fantasy, we must allow the fantasy to take us where it will — overscripting doesn't work in this realm. And we've also learned not to get hung up on whether or not our partners would have chosen that fantasy themselves, or whether they're helping us with a fantasy of our own choosing; energy and turn-on get raised no matter where the fantasy had its origin. The important part of a journey isn't where it starts, but where it takes you.

We call our original fantasies our "root" or "core" fantasies — they are the dreams we started into SM with, and they're still the ones we return to when we want to soothe ourselves or turn ourselves on. And they're still a source of self-knowledge and healing for both of us. Enriched by many people over the last few decades, your authors now have lots of dreams and scripts and games, a constantly expanding repertoire for traveling in Shadowland. Because, you see, when you decide to play with somebody, and it turns out that their fantasy is different from yours, then you are blessed with the opportunity to explore a whole new and fertile territory in which you may discover new delights and new visions of who you can be.

In our time in the scene, we've met thousands of people, and their root fantasies have been inexpressibly multiple and beauti-

ful, an ever-shifting kaleidoscope of imagination and lust. Here are just a few of them.

Submission and dominance

For some players, the essence of eros in DS is the issuing and obeying of orders, commands, the giving and receiving of service. The rush of being in control or out of it, the creative delight in making the script evolve while the submissive, following orders without knowing the plan, watches the sequence unfold like stunningly potent theater. Dominant as director: it helps to remember that theater as we know it today actually evolved from religious ritual; and that ritual was invented as a way of speaking with the gods.

Submission and dominance takes thousands of forms — perhaps as many different forms as there are submissives and dominants. We tried breaking this section up into subsections labeled "owners and slaves," "masters/mistresses and servants," "pleasure slaves," and so on, but found that such divisions didn't really work all that well — each individual identifies with some terms and not with others, and is often turned off or even angered by terms that aren't a good fit for their individual identity and experience. So instead, we'll talk about what we see as some of the ecstatic rewards of the different kinds of experiences, and let the labels take care of themselves.

One friend of ours tells us that service is her spiritual practice. In putting another's needs and wants always ahead of her own, she can escape from ego into a state of selflessness, with her dominant providing any boundaries she needs. For her, DS service as a spiritual path is very similar to bhakti yoga, the Hindu devotional practice, or altar-tending, or any practice based on caring for things or people. The slave, who has devoted himself or herself entirely to the needs of an owner, travels even further into selflessness,

buoyed up by the support of the owner, and by the script of responding to the owner's desires.

Both slave and servant are often required to do a lot of functioning on their own initiative. The altered state is maintained by the need to stay closely attuned to the owner's desires, often striving to anticipate needs and wants, to proudly show up with the right cup of tea at just the right moment without being asked. This practice promotes selflessness, emotional (maybe even psychic) attunement and competence. One slave told us he lives for the appreciation he gets when he does something well.

Pleasure slaves are focused on being superb sex objects or sexual performers, to delight the recipient of their attentions, and are valued enormously for their skill and art. In the land of BDSM, sexuality is seen as an arena for art and creativity and skill and mastery of technique. We understand that some people have wonderful talents at various aspects of sex and SM, and we admire the work of the great artists in our field.

And what does the dominant get out of all this? A good master or mistress travels with the sub, and treads a path of enormous responsibility which sharply focuses attention, similar to contemplative meditative practice. The dominant is responsible for balance, which requires that he or she be centered. Janet reports that at moments of peak connection as a dominant, she feels herself to be moving at superhuman slowness — although to an outside observer, of course, she is moving at normal speed. She feels as though she is channeling light, energy and knowledge from an outside source, sometimes feeling as though she is glowing with light or standing at the center of a pool of light. We have read of athletes reporting similar sensations when they are performing at peak competence during their sport, and who is to say that they aren't channeling the same energies that we are?

"Less than" human

Some of us like to leave our humanness behind entirely, becoming furniture, or objects, or animals, shutting down our busy brains as completely as possible for the duration of the scene. One friend of ours coped with a disabling injury that had him bedridden for several years by eroticizing the idea of becoming a human "toy," completely immobile except as his dominant desired; he collected medical devices that made him even more helpless than his injuries dictated, and turned his damage into a source of erotic opportunity.

Human pets leave the ranks of humanity entirely to frolic in the realms of dogs and cats and ponies. Dossie recalls a puppy scene she once played with a gay male friend:

> The first thing I wanted to know is, was I a good dog or a bad dog? Was this a brat scene? My master told me I was a good puppy, albeit a little untrained. I inquired about housebreaking, and he reassured me that this wasn't going to be a housebreaking scene. He put me on a leash and had me crawl around behind him, teaching me to heel and sit and stay and the like, all very gently, in a loving voice, with lots of petting and stroking and "Good puppy!" encouragement. It was like falling under a spell. With nothing to do but follow simple directions, my chattering monkey mind soon shut up, and I felt empty and at peace. Free of all that human sound and fury and drama, free of worrying about the future or fixating on the past — puppies don't have much in the way of memories, do they? Although we continued on to do a flogging and caning scene, the part that sticks out in my mind was the simplicity of being a puppy. Pure and simple.

Resistance and takedown

There is a special joy in being able to fight back like you mean it, genuinely exerting all your physical and intellectual will, knowing that when you lose, it will be to someone who will take care to ensure that you're given exactly what you came there to get — just the kind of pain or sex or humiliation you want and need — so that the pain of losing is magically transformed into an extraordinary kind of winning.

Some people like to enter into these scenes with a closely matched partner, fighting for supremacy and not knowing until the outcome who will be the top. Others decide going in who will lose, and arrange for multiple tops or a bit of creative bondage as a handicap, to ensure that the bottom can fight back with everything they've got and still get taken down as hard as they want. We have one friend whose fantasy is to be kidnapped, tortured and raped, and who has a trusted acquaintance who assembles groups of kidnappers, unknown to the "victim," who will grab her at an opportune moment, spend several hours performing chillingly realistic scenes of torture and gang rape (all within the limits she has negotiated with the acquaintance who is stage-managing the production), and release her when she is bruised, exhausted and fully satiated.

The payoff for the top in these scenes can vary. The power and control can make you feel enormous. A lot of resistance play is based on the rush of the roller-coaster ride of playing with the bottom's most vulnerable places, and riding the razor's edge of keeping the bottom from falling out of the scene entirely while you seduce them further and further out of ordinary reality.

A subset of resistance play is the interrogation scene. Here the roles are prisoner and interrogator, and there are a bunch of ways to write the script. Do we imagine that the prisoner actually has the information being sought? Or is this an ordeal

where the prisoner is pretending to withhold information? Is the prisoner in the completely hopeless position of being tortured to discover information that she doesn't even have? Here the top is conducting the bottom on a very tricky journey, playing with power and double binds to unhinge the mind and generate a state of willlessness — which can be a profoundly peaceful condition for the bottom.

Dossie remembers:

> We did one scene recently where I was a streetwalker and Janet was my abusive pimp. I put on my sluttiest clothes, including a long leather coat I had found at a thrift store, and walked into my bedroom. "Where did you get that coat?" "At the thrift store, it only cost forty-three dollars, honey." "You're lying, bitch. You could never get a coat like that for forty-three dollars. You're holding out on me."
>
> I knew I was supposed to be afraid, but she was so brilliant, all I could do was admire the gambit. And then we hung in with it a little longer, and we did this very sexy punishment scene, and Janet had orgasms with her metaphysical cock, and I felt all helpless, and all I could do was take it in and ride it. And it all worked very well.

Or perhaps the scene is designed to be an ordeal, in which the prisoner confronts various difficulties and triumphs over them; or maybe the interrogator triumphs and rewards the prisoner with love and positive regard for speaking the truth. Some interrogation scenes go deeply into mindfuck: we have seen interrogators ask, "What's the most embarrassing thing that happened to you in high school?"

None of us likes to answer that question. And yet, speaking about our adolescent humiliations in the context of an erotic

connection, to a listener who (maybe) won't put us down for being human, can have remarkably redemptive qualities.

Age play

Daddies and mommies and babies and kids and brats — what a field day for the player! And what a huge choice of highly charged scripts, forbidden connections, punishments and rewards, love and nurturance, abandonment and despair — the entire range of human experience to choose from. Age play gives bottoms the opportunity to bring our inner children into relationship with another person, to enact the dramas that the kids think are important and to see what comes out of that.

Going into our child roles can be scary, and we often feel ridiculous, especially at the beginning of a scene. We don't suggest deep inner child play with strangers. We want someone we trust at the other end of the equation, someone who will welcome us back into our adult selves when the play is over, somebody reliable to whom to expose our old wounds.

For tops, the opportunity to be both Bad Daddy and Good Daddy, the powerful Good Mother and the Betrayer, can be a healing journey — an opportunity to journey in the psychological Shadow and reclaim forbidden parts of ourselves, to inject our old traumas with eros and write a new ending to all our old scripts. Janet's scene at the opening of this chapter is a good example of how age play can be a journey into the light and a healing revelation.

Humiliation

There are aspects of humiliation in a lot of SM play, but most often the scripts are negotiated to limit the extent of humiliation. Because in all our ambition to break ourselves and each other into our component mental and spiritual parts for fun and healing, we

are not really out to degrade each other. Nevertheless, some genius players find ecstasy and enormous eros in gross humiliation. To play with humiliation is tremendously powerful — we are playing directly with shame, a profound human emotion that we all carry from our childhoods. We all have memories that make us cringe.

Humiliation players get right in there and revel in it. One woman we know tells us that humiliation makes her happy, That's the experience she starts from — it feels really good. Her play often looks like triumph over degradation, just because it makes her so happy. She reports that she goes into serenity when she is being degraded, and describes her state of consciousness as spiritually awake.

Years ago, Dossie used to be a professional blackjack player, counting cards in the casinos in Vegas. She was amazed to watch all the people who actually enjoyed gambling — what she was doing was business. And she realized how much of our lives we spend working with money, struggling with money, budgeting money, saving money, worrying about money, balancing the checkbook — what a relief to go to a casino and actually *play* with money.

Similarly, we think the humiliation players are onto something amazing. If we only had the courage, we could all play with our shame, and for that bit of time it wouldn't be serious at all. Wouldn't that be wonderful?

It may interest you to know that the words human, humble and humiliation come from the same root, *humus*, the word for earth or dirt. To be human means to be close to the earth — good and dirty.

Old wounds

Deep emotional play. Going deep, deep down into profound emotions, digging down into old wounds. These are some of the scariest and most rewarding forms of ecstatic SM mind play.

We've talked about playing with breakdown, with taking our scenes to the levels of intensity that crack walls, blast open doors, fracture thick cement foundations — tearing us apart so that we can see ourselves and each other in the lovely bright light of eroticized consciousness, and building ourselves up again with more choices, freer, more aware, more whole.

Old wounds might be about child abuse, losses, deaths, the terrors of the playground at grade school, the more recent lousy breakup, the horrendous job hunt, the performance that the audience (silly fools) was bored with. Dossie, the therapist, points out that recent wounds are almost always connected to old wounds — that's the most likely difference between the disasters of the present that bother us and those we can weather with relative ease.

Old wounds might also be about cultural trauma, and we might enter them by deliberately invoking the stereotypes, and the judgments about those stereotypes, that represent our oppression. A friend of ours once set up a scene to deal with her rage at men for all of the assaults and belittling and insults and assumptions and presumptions she had suffered throughout her life. She asked four gay men to tie her down and beat her up while calling her "chickie," "bitch" and "cunt" and berating her as dumb and stupid and incompetent and little and basically less-than. Actually, the sight of four gay men pretending that they believed that a women's place was in the kitchen and in the bedroom was pretty comical from the outside; but as the scene got going, and the struggle got real, it was impossible to trivialize the journey. She had arranged to be tied down so she could go fully into rage, and thrash and fight and scream — without falling off the table or hurting anybody. And she did. And it was loud. And it was a terrific catharsis. She felt afterwards that she could accept men in her life much more wholeheartedly, now that her rage was no longer a secret. And the men who topped the scene had a sense of healing about it — bringing

that guilt about being male out in the open and playing with it moved their stuff down the road a little further too.

Our experience is that playing with sexism is a button-pusher, and that playing with cultural traumas like racism, enslavement and genocide is even scarier. To travel with SM and ecstasy through the gates of old wounds, a respect for safety is utterly mandatory. These journeys are reckless enough without being devil-may-care.

We are used to negotiating physical limits to our play... here we must figure out and communicate about our emotional limits. This is always to some degree a guessing game, even if you've done it a few times — because the oceans of the unconscious are truly bottomless, and you never know for sure what you're going to find down there in the deep. Dossie likes to play with sexism — *after* she has done a whole lot of negotiation to make sure the people she is playing with are just pretending, and that true respect and care are the foundation for this reckless journey. A genuinely sexist creep pushing her around and calling her a bitch raises serious questions about how far a girl ought to go on the first date.

Limits, and the risks that make thinking about limits important, belong to tops and bottoms both. Would you think twice before playing the role of raping and murderous father to your bottom's victimized child? We hope you will. Because we are playing with fire here, and tops are as vulnerable as bottoms to getting burned.

A commitment to aftercare is important too: the scene is not over until everybody in it is back on the planet in their everyday state of consciousness. Janet recalls connecting for the first time with her very angry precious inner bully during a scene in which she was topping Dossie. Both of them could feel the intense dark energy fueling that scene. Afterwards, after kidnapping and beating and insulting and raping Dossie, it was Janet who needed to be held and cuddled and comforted.

24/7

Some players live their roles 24 hours a day, 7 days a week. There are families of players, with masters and slaves and puppies and children, all adults, all written into the same piece of theater. Like all aspects of BDSM, players who do well at 24/7 have a high sense of integrity and tremendous respect for boundaries. You have to have respect for boundaries if you're going to spend that much of your life in boundarylessness.

24/7 relationships are the monasteries of kink: people who maintain a high degree of ritual and protocol on a daily basis, and thrive in that circumstance. For those of you who are unfamiliar with the practice, please remember that slavery is indeed still illegal, and that anyone who wants to leave is free to do so. So 24/7 works as long as the various members of that relationship feel that it works. The reality requires more cooperation than our fantasies might suspect.

And the roles aren't prescribed. The bottoms are often male, and frequently earn more money than their tops. The tops might have less power in the culture at large and still be adepts at administering power in BDSM and spiritual space.

The wisdom that 24/7 practitioners develop is what happens when you go as deep as you possibly can into your roles and archetypes, when you live the part, as it were. Balance and healing can be found here, and a profound sense of rightness when people find the place in a relationship or an SM family that works for them. For many, living full-time in their roles is living full-time in spiritual connection.

Shapeshifting

Some of us combine spiritual practice and SM by channeling entities, deities, archetypes or creatures that we feel connection to as the motivating or inspirational force to a scene. Channeling is

allowing a spirit, angel, saint, deity, diva or any other entity you identify with to enter you or rise within you or become you, temporarily: there are a variety of beliefs that people explore to explain the phenomenon. It doesn't matter whether you believe that something from the outside comes into you, or that something within you comes to the forefront. What matters is that we dig deeply into a role or an archetype and bring its particular power and vision and wisdom up (or down) to power a scene or a ritual.

Channeling deities is another way to move from role into ritual, and can be done from both the top and the bottom. A bottom might choose to invoke Persephone, say, or Hercules in drag. (Thirteenth labor of Hercules: he sold himself into slavery to Queen Omphale of Lydia, and spent three years as her body slave in female clothing — it's true, look it up.) This kind of deep roleplaying is sex magic; so is everything else in this book.

Dossie channeled the goddess Kali during a flogging ritual with her dear friend Coyote, whose roommate had just died of AIDS. Kali is the fiery Hindu goddess of creation and destruction who blasts open doors, tears down old structures, throws out our old treasured garbage we keep hanging onto and makes room for something new. Sort of like spring closet cleaning, only a lot scarier. And more profound. Every religion ought to have a goddess like Kali.

Tied down so she could fight if she needed to, Coyote chanted to Kali, who was flying down Dossie's arm and into her body through the whip until they both erupted in a hot flow of grief. After this directly physical manifestation of pain and suffering, she felt cleansed and ready to go on with her life.

Dossie once attended a class called "Practical Shapeshifting," in which the participants were taught to imagine the animal who had the skill and wisdom for a particular task, and then imagine being that animal and having those skills. A woman in the class who was looking for work produced a fine fantasy of being a seal safe in her silky fur, who could slip through the waves, rise and fall

easily with the tides, and swim so powerfully that she need never fear crashing on a rock or any other hard sharp obstacle.

Here is an example of an SM shapeshifting healing in which Dossie participated:

Playing with the Goddess

Durga tells me I'm the only item on her dance card. My cunt contracts. A small adrenaline rush of fear accompanies the swelling of labia. Just how intense will this game be? She says she has been having hard times, a bitter breakup. She needs the purging and reunion with herself that only our play can accomplish. I am at once honored and vulnerable: this will be intimate.

Durga wants me in the leather corset, it will protect my physical vulnerabilities so she can unleash the storm inside without worrying about hurting me. She doesn't want to hold back. Her slave puts me in the corset, and Durga tightens me down to breathlessness. As she straps in my waist, I feel both small and strong in black stockings and heels. Rivets on the wrist cuffs catch the light as she secures me to the cross. "Do you want the ankle cuffs?" I inquire. "No." She laughs. "I want you free to buck."

Durga is tall and wide and immensely powerful in her flowing skirts. She is corseted like armor, Athena's breastplate. Her hair is pulled back, Cretan curls falling down her back, jewels on her forehead. Her dark skin sucks in the light and reflects it back warm and somehow more alive. Her smile reveals teeth bright like stars in the night, her tongue red like life, her eyes flash fire in the darkness. Brightness flows from her face as her incandescent grin kindles everything in her path, only to re-

turn everything to itself, cleansed and beautified in her loving gaze.

Her nails are lacquered purple, burning claws as she takes my face in her hands, turns my head to take my mouth in hers. Hot like the jungle, she pours herself into me.

And when her breath is mine and mine is hers, she trails her talons down my arms, my sides, my legs. Stockings split in her path, running down my leg like blood from ripped skin. The sharpness of the sensation is hard to take in without tensing; I writhe and jump. She gets a good grip with one arm and lifts me off my feet while she continues with her extremely free hand — I hang helpless, she is my only ground.

Every pinch, every scratch, every ripping sensation is all too much — as Durga has told me her miserable breakup with her last lover has been too much, too much pain, too much intensity, all the hurts in exactly the places that hurt her the most. She traces this history on my body, all the pain that is too hard to take. I struggle to take it in, to keep up with her. She is shapeshifting, snarling and predatory, a huge panther clawing and biting, finding her strength through her impact on me.

And I become prey, a leaping impala, a dancing gazelle, the object and leader of the chase. I dodge and dart, crying out in purrs and growls, sharp cries of distress, and Durga keeps catching me, over and over. We are speaking in tongues now, mysterious words in a language neither of us understands, emotions voiced with no particular meaning but intense force. I hear her pain, her betrayal, her questioning herself: How could I have

let this lover so close as to bring me to grief? What other choice is there if we are to love?.

I turn into a snake and hiss and writhe — "Go for it, snake girl!" chants my Durga, and I bare my fangs and grin in her face, "Come and get me!" And we are traveling, heart to heart at the end of a whip, her life and her pain flowing out down the lashes into my ass. I take her into me and up into my heart, all green and soothing like aloe, like the cool fresh jungle on a hot day, like shade and understanding and relief. I take her in.

It is wondrous and amazing to be able to be at once healer and bottom, giving while receiving, emptying out a beloved's stored-up rage and grief, offering catharsis to my top while leaping like a gazelle over streams and rocks, pursued by a fierce gleaming panther.

There's no particular climax to this play. We just carry on till we are done, and Durga takes me down and carries over to a chair, nestles me in her lap, and we are wrapped in one skin, warm and loving, for a while — until gravity asserts herself and we return, each to her individuality, intact and full of love.

SM ritual

We've said all along that all SM is ritual and that scene space is sacred space — indeed, that everything is sacred. Which is utterly true. And some players gather together to do formal ritual, using intense physical sensations from the SM realm as the vehicle that carts our consciousness into the present, the pain that forces us into acceptance, the boat that carries us on a tidal wave of ecstasy. Janet described her experience of a flesh-hook ritual with Fakir Musafar earlier in this book.

All generalizations are untrue. It would take an entire book to describe the full range of SM ritual practice, so here we will include a few common guidelines. In SM ritual people gather together, usually do some form of symbolic cleansing to wash off the junk of everyday life, and connect to each other in a circle. Each participant might state her or his intention, what they would like to get out of this journey. The intention might be as simple as communion with the divine, or more complex according to each person's needs in the moment. Dossie once got pierced with sixty spears, with the intention of making spiritual contact with her ancestors. It worked.

Here the roles of top and bottom shift. The journeyer is going to be pierced or whipped or otherwise done to, but for their own purposes, essentially to prepare for a more or less solo journey. So the ritual is about the bottom, for the bottom's use and purposes. The top, the person who does the piercing or tying up or whatever, is not so much dominant as guide, priest, support person. Large rituals require a lot of support people: piercers, drummers, volunteers who organize the physical environment and volunteers who stay present with the ritual, but not journeying, ready to offer support to any traveler who needs it. A shoulder to cry on, water, somebody to dance with. At the kavadi, the ritual with spears that Dossie journeyed in, priests would drum on the frames that held the spears in place, driving rhythm into the body through the holes in the skin. At the flesh-hooks ritual, two bodyworkers had set up tables and were available to help anybody who wanted their services.

Piercing the skin has a particular place in SM ritual — we say that opening the hide is a spiritual as well as a physical opening, an intense way to drop our boundaries and flow or fly with the divine. All the journeys are mind journeys. Clearly there is no way to leave the mind behind, and luckily there are thousands of ways to change our minds, alter how we are seeing and feeling, and a thousand

purposes for traveling down these paths. Some qualify as healings, others as deep emotional explorations, and still more as ritual dramas that we do because they delight and fulfill us by allowing us to open to energy that is bigger than us.

A lot of these scripts are designed to let us escape from ego, from rigid patterns, from our own blind spots — to escape from our ego masks, top and bottom alike. Remember, everyone in a scene is in service to the scene. The priest/ess serves, the god/dess serves, the slave serves, the child serves. We all serve.

So we end this chapter with a mind journey enacted by the two of us, told first in Janet's voice, then in Dossie's:

Villain

Well, I thought it was going to be a simple straight-forward little flogging scene.

It was Friday night, at the end of an agonizingly long week. Dossie had come over for dinner (getting delayed in traffic for nearly an hour on the way), and we'd gone out to a movie. We were both pretty tired and frazzled, but we don't get to play that often, so we decided to go ahead and at least do *something*.

I started to tie her to the bed, face-down. I noticed that she was being very quiet, her limbs responding passively as I moved them into position; I assumed she was just trancing out as she so often does.

But then I picked out my softest suede flogger and just drew it across her ass, like painting her skin with a soft brush, not even a stroke, really. And she shuddered all over and whimpered.

A part of me thought that she was just doing it to turn me on, knowing how I respond to helplessness and vulnerability. A bigger part of me didn't care. I brushed her butt again with the flogger, a bit harder; she whim-

pered louder and tried to roll off to one side to shield herself. I wasn't sure whether or not it was acting, but I was getting turned on.

I took the intensity up as slowly as I ordinarily would on anyone, slower than I usually do on Dossie. It didn't seem to matter — she'd clearly gone into a space that was about feeling punished, brutalized, abused. We'd done such scenes before, but always with intent and a lot of negotiation. I was a bit concerned, but not concerned enough to stop.

I was hitting her pretty hard by now, and she was sobbing, her face contorted. Her ass looked incredibly vulnerable and helpless. I was suddenly seized by the idea of fucking her up that ass and was more aroused than ever — I wanted to beat her raw and then fuck her so it hurt with every thrust. I gloved up, lubed a finger or two, and began to explore her asshole, but it was tight and unyielding. She came out of whatever place she was in long enough to tell me that she'd had some intestinal upset that morning and was too sore for anal activity. Speaking as sanely as if we were planning a grocery expedition, we agreed that we'd enjoy a butt-fucking scene some other time, but this wasn't the night. And then we were back to where we'd been before, victim and villain, as though the conversation had never happened.

I was using my meanest toy, a heavy leather two-fingered tawse that I know from experience is almost im-possible to enjoy: vicious bite with a lot of weight behind it. I was using it as hard as I could. She — who could ordinarily soar above such a sensation laughing — was shrieking and sobbing and struggling to get away from the blows. I was dripping wet.

I ordered her up on her hands and knees and pushed a fat bolster under her hips to raise her butt up to where I could get at her cunt. I slipped into my harness, added my favorite double-ended dick, lubed up and knelt behind her. Finding my way with my fingers, I jammed my cock up her and began to fuck her hard. She sobbed and moaned; there was no question that I was raping her.

I grabbed her by the back of her hair — an interesting moment for me, as the brute in my hips kept pounding away at her, but the loving friend in my head said quietly, give her plenty of slack, you don't want to hurt her neck. I snarled, "Tell me you like it." She cried harder. The idea of making her tell me she liked it, knowing that she didn't, became terribly important to me. I pounded and pounded and repeated my demand. "I can't," she cried. I threatened her with more tawse if she didn't say it, and she still couldn't, so I pulled out and struck her a dozen or so times, as hard as I could. She screamed.

I began fucking her again and repeated my command. Coming slightly out of headspace, she gasped something about feeling painted into a corner, and I began to realize that she really couldn't say it — something of a disappointment, but if she couldn't she couldn't. So I just let that one go, and cast around for another strategy. And then I had it...

"Mmmm, you make Daddy feel good," I growled. Her head came up, and in a tiny little voice she said, "Daddy?" And in that moment the scene refocused — I was no longer the violent rapist, instead I was the daddy who must violate what he loves best, and she was my beautiful little girl.

The resolution of the scene became clear to me. I went on fucking her, but now my incoherent growls were promises that if my little girl made me feel good, I'd make her feel very, very good. I brought myself to a crescendo — I didn't actually come, but I didn't care all that much; I'd had a top-gasm if not an orgasm. Now, I told her, Daddy was going to make her feel good. I got another dick, bigger than the one I'd been wearing, and eased it into her. Then I began to use a vibrator on her clit. She came explosively within moments — she, who usually has to be cajoled slowly and expertly toward orgasm — I could hardly believe it was over so fast. I lay on top of her back and held her close until her breathing slowed. A few minutes later, when I was pretty sure we were both back in relatively normal headspace, I untied her.

Later, in the kitchen, dishing up ice cream, I found myself humming an unfamiliar tune. I cast around in my head and recognized it: "My Name," the song that the murderous brute Bill Sykes sings in the musical *Oliver*. I realized that I had just liberated my inner Bill Sykes, and grinned like the sadist I am.

Victim

We decided to play something easy, it being a little late to start, expecting to do a simple flog and fuck, some SM version of a quickie.

Janet tied me to the bed with soft restraints, very comfortable, spread-eagled on my stomach. Lying with my face on the pillow while she secured my ankles, feeling relaxed and taken care of, I felt myself beginning to sink down into some deeper part of myself. Not my more

ordinary defiant powerful I-can-take-anything-you-can-dish-out mode. I felt small.

When Janet started the scene with a light and sensuous flogger, even though this was a gentle stimulus that had nothing to do with pain, the very fact of being tied down and done-to precipitated me into a warm bath of helplessness. I felt confused and lost: why would she tie me down and do these strange things to me? I felt surrounded. I felt, not surrendered, but taken.

As Janet increased the intensity of the striking, I started whimpering. Whimpering and thrashing. Usually, I use my knowledge of my body to channel intense stimulation, breathing it through me, tensing muscles in a happy response that welcomes the incoming fire. When I do this, I feel a sense of joyful control, and sensations that may be difficult to take in become the occasion for delight in feeling and transcending them. At these times, my top feels like a guide, a nurturing parent, a generous person who is working very hard so I can experience this literally sensational journey: in short, Santa Claus.

But not this time. This time I fell into my victim space. As Janet struck me with the usual fiendish array of instruments, I felt lost and helpless, and the sting of the strike made me want to cry. A terrible sadness awoke in me. And serious confusion: why was I being subjected to this? I felt no sense of guilt or justice. I just felt abused.

Somewhere in here, a more rational consciousness suggested that to play this kind of a deep scene, which can be scary to a top, I really should negotiate some consent. Tops like to feel like Santa Claus. They less often enjoy feeling like heartless criminals. Even though Janet and I have been here before, I felt a need to check in and

make sure she was all right with this. I looked up, and saw in her face what I needed to reassure me: a cold, hard stare. Janet's precious inner bully was awake and enjoying himself.

So we set off down the path of victim and villain, in search of whatever truth might be found there, which might include why we wanted to go there in the first place. Janet attacked me with increasingly unforgiving implements of punishment: the tawse, the cat, the paddle, the cane. And I sank deeper and deeper into my own fathomlessness, whimpering and feeling helpless, with a curious sense of luxury in all this. It surprised me that, having abjured my customary methods of surfing pain, I still was able to take a huge beating. I could have safeworded at any time; I could have asked her to go a little lighter. When Janet and I play, what we do is always collaborative, and we would be appalled at the idea that either one of us should actually suffer for the pleasure of the other. Besides which, last week I beat her up.

And Janet, indeed, was making the unstated accommodations to the limitations of reality that actual abuse seldom regards. She was striking only well-padded parts of the body, and allowing time between intense strokes for me to process the sensation. So my body never went completely out of control, or maybe only for a second or two.

Although Janet was certainly allowing me the time to process sensations, I was not doing the processing. I was choosing (choice is an important concept here) to be the victim, to be frightened and hurt and betrayed and tortured for who knows what reason, and to respond with

whimpering and misery. Luckily Janet has within herself the top who can enjoy this.

We went on for a while. There wasn't any scripted end to this in sight. No climax, no culmination — I suppose I could have safeworded, but we were both looking for a denouement, some conclusion that answered the state we were traveling in. We were beyond the question of what could I take — I was beyond deciding much of anything, and the game we were playing did not include the villain taking consideration of the victim's misery.

Janet decided to take it out in sex, giving me the reward of feeling good for taking my punishment. This made little sense, since in the crazy logic of my state of mind the beating itself seemed to be the purpose, the *why* of why we were there doing this in the first place. So Janet rewrote the orgasm at the end, from "Daddy's going to make you feel so good," which she tried first, and which obviously didn't make a lot of sense to my precious inner victim. So she raped me, with the stated rationale that I would be a good girl by making Daddy feel good. Somehow this made a certain amount of sense to both of us.

We leapt together into the Daddy/girl script. I felt a kind of internal jerk, as I translated my sense of helplessness into childishness, and my victimhood into betrayal.

And Janet was right — translating the scene into the language of child abuse gave us a way to find a closing. She fucked me until she got off, telling me constantly about how I was a good girl to make Daddy feel so good (and isn't that the ultimate betrayal?), and then got out the vibrator. That was a revelation. After a couple of hours of victimhood, where my own pleasure was (ap-

parently) not being regarded as at all important, when we got to the clitoral stimulation, there was a huge orgasm right in there, as if it had built up and was just waiting for an opportunity to express itself. Loudly.

It hadn't occurred to me that the scene we had played had a lot to do with sex. Deep psychological exploration, maybe. Living mythos, maybe. Deep emotional play, for sure. Shadowplay, absolutely.

But sex? There it was.

Without my being aware of it, I had become terrifically turned on. And when the vibrator started up, my body woke up instantly to a flood of exquisite pleasure, as if the vibrator was pouring delicious light into me. As though my body filled up as Janet pumped me full of ecstasy. And that exploding ecstasy was the resolution of the scene. Not exactly an answer to the dilemma of why I like this. But the answer to the deep need inside me: to make that profound sexual connection to my lover from my precious inner sadness. For Janet to come and love me in my misery, this is the healing. This drives the pain away and fills me with light. This works.

When we talked about this a couple of days later, we discussed the possible purposes, rewards, outcomes of such a scene: healing? catharsis? opportunity to playact what would be unacceptable in the real world? And what does this have to do with spirit?

My inner truth became clear: there was no purpose, no goal. What I desire is to go on the journey, to be, for a while and with the mirror of another, that part of myself that I fall into in these scenes. Just to be that victim, which indeed I have been in real life, both as a

child and as an adult. Playing like this gives me a way to remember, to relive it, for a little while, with the ever-so-important proviso that this is psychodrama, not real abuse. When I try to seek out meaning in this, the answer I get is: I don't know. I only know that sometimes I want to go there.

Open Heart, Open Skin, Open Everything

So here we are, almost finished with the book, and we've got a piece of news for you that may or may not be welcome: you don't get to open yourself up to ecstasy and then slam yourself closed again right afterwards. It's pretty much impossible, we think, to be one with your partner and the universe at 10 p.m. Monday, and then go to work Tuesday morning kicking widows and orphans out of their slum apartments; we suppose it technically can be done, but in our experience, opening yourself to bliss also means opening yourself to a whole bunch of other stuff, among which are capacities like empathy, generosity and compassion.

That doesn't mean that every great player you meet is also a great person. We've both played with phenomenally great players, connected and transcendent and spectacular, who are, to put it frankly, kind of shitty people. About the best thing we can say about them is that we suspect they'd be even shittier people if they were less connected and transcendent and all that. Radical ecstasy isn't a panacea for all life's ills; it won't turn Ebenezer Scrooge into Lady Bountiful.

And of course, this doesn't mean that reading this book, or having experiences like the ones we describe, is going to turn you into a saint — we're writing the damn thing, and it certainly hasn't turned us into shining exemplars of perfection. We have our moments of judgmentalism and selfishness and harshness and small-mindedness, just like everybody else. But we also feel that every time we travel in ecstasy, the experience peels away a tiny bit more of the fear and unhappiness that hold us apart from our fellow beings, makes it just a tiny bit harder to stuff ourselves back into our armor.

The experience of living in the world with an open heart is, we believe, genuinely different from most people's everyday experience — more vulnerable, more trusting, more empathetic, with greater emotional extremes. And of course, living in the world with an open heart and expressing that openness through the paths of sexuality and SM has even greater differences — the joys of extreme physical and emotional intensity, the freedom of seeing the world through a multiplicity of lenses.

Therefore, we decided that this book wouldn't be complete unless we wrote a bit about our experience of living in the world with the results of that slow peeling-away that we have both experienced — about what we think it means to try to live with emotional and sexual and spiritual openness, its joys and its tribulations and the responsibilities it carries.

Janet writes:

High-Wire Acts

Today is Day Three of Dossie's and my big retreat to whip a huge, unwieldy pile of pages into something resembling a manuscript. I am fighting a troubling set of physical symptoms, of which by far the most disturbing is vertigo.

Last night, I dreamed all night of having climbed into high places from which I could not get down. In the last of these dreams, I am attending a celebration of some

kind. As part of the festivities, I am putting on a show. Surrounded by a group of women, I am masturbating exuberantly as they cheer me on, laughing, applauding, singing. I am shouting my fantasies aloud as I bring myself to a loud and lusty orgasm. The fantasies are boundaryless and frightening, utterly socially unacceptable, and the crowd is loving them. Dossie is there among the group of women, holding my head and shoulders from behind, quietly reassuring me amid the laughter and applause that she is holding the emotional truth of my fantasies and will be there afterward to clean up any messes I've left behind.

After my orgasm I fall immediately into a deep and dreamless sleep. Still in the dream, I awaken the next morning to find everybody moving sluggishly, hung over, preparing breakfast; there is a thunderstorm outside. I want to fix Dossie something nice to thank her for the previous night; I make her lovely buttered toast and set off in the storm to give it to her. I climb a cliff looking for her — she is not there; I cannot get down; I am stranded, with the toast, in the storm. Mournfully, I eat it myself, and settle alone at the top of the cliff to wait out the rain until I can find another pathway.

I have joked for many years about being an "emotional exhibitionist." I see it as integral to the work I do as a writer and educator to put my own emotional processes on display; when I heard about Annie Sprinkle's work in opening her cunt with a speculum and allowing audiences to step up one by one to view her cervix, I felt an immediate shock of sisterly recognition. But this book has tested as never before my ability to go on doing my highwire act over and over again, without letup.

For the last two years, we have both written about all of our SM play as part of the process of writing this

book. That means, for the last two years, I have done no scene that has not been about pushing my own edges, and after which I have not then required myself to examine those edges under a microscope and note my findings in a lab notebook for the perusal of others.

Part of my job is, like any good performer, to make it look easy; and I think I do. In fact, while I'm doing it, it *is* easy, and fun, and sexy, and thrilling. It's only by stepping back and looking at what's going on in my life that I can see that things are getting a little haywire.

I think the task Dossie and I took on when we decided to write this book was more than just the decision to write a book — it was really a commitment to extreme, exaggerated spiritual openness over a period of approximately two years, an experiment in living without skin over an unnatural period of time. I don't think we knew this when we decided to do the project, and I'm not sure it was a conscious decision, and I'm sure glad we decided to do it together, because I *know* neither of us would have survived it sanely without the other.

Well, the experiment is nearing its end — the book leaves for the editor in a couple of weeks — and I think we're both nearing our breaking points.

For Dossie, this is manifesting as fear of the book itself: she wakes up in the night having anxiety attacks. I work with books every day and have a pretty good sense of what they can and can't do to me, so this one doesn't scare me all that much (usually).

For me, it seems as though everything inessential in my life is closing down, bit by bit, as I focus all I've got on this single task. I haven't been able to read a

book for pleasure in many months. I am doing no casual play and very little masturbation. I have rearranged my life so that I spend most of my time in solitude — my only employee now works elsewhere, my son sleeps different hours than I do and my lover comes over only on weekends. My skinlessness makes it difficult for me to talk about anything but trivial matters with anyone but Dossie, and my conversations with Dossie are almost always tearful because I cannot talk about anything that is not deep. And then, of course, there's the vertigo.

So when we write about the joys and terrors of living as an open person, you have before you the evidence. In this book, we have written tale after tale of having our hearts torn open with ecstasy, of soaring higher than we ever believed possible. But here in this little cabin out in the country sunshine, I have dreamed of huddling alone on a cliff in a rainstorm — and I can't write this book without telling you about that part too.

What does openness mean? If there were such a thing as a tribe of perfectly open-hearted people, here's what we think they would be like. They wouldn't withhold emotion; they'd express joy or sadness, anger or fear, without reservation, but without dumping on others. They'd trust easily and give easily, relaxed in the assurance that whatever they gave would somehow be given back to them. They wouldn't try to control things that weren't theirs to control. They wouldn't judge others — they'd understand that most people are simply doing the best they can with the tools they have at the time. They'd be generous with their time, their energy, their possessions, their affection. And most of all, they'd love freely, without worrying about whether they were getting as much love back as they were giving (as though love were some sort of karmic checking account that had to be kept balanced!).

In order to do all this, of course, our mythical perfectly open-hearted people would also understand that they had to love themselves and take care of themselves in order to love and take care of others — they'd be as empathetic with themselves as they were with everyone else. Each heart would be as open to itself as it was to each other heart; each individual would take care of himself or herself with the same kindness with which they take care of their lovers and friends.

Are *we* that open, that balanced, that perfect? Hell, no, not even close. But we're a bit closer than we used to be, and we're pretty sure that the experiences we've recounted in this book are the reason.

Open your heart — easy to say. Open up to you, to how you feel, to me, to how I feel, to everything and everyone around me ... sure. But nobody can live full-time with no personal boundaries and no psychological defenses. So openhearted always means as open as you can be right now, while still maintaining awareness of your own boundaries and taking care of your own needs.

All of us at times fear opening our hearts. It's scary to open up to our own feelings — the intensity of joy of grief, pride and regret. What if we open our hearts and we're not keeping our most intense emotions on a tight leash and somebody sees them? Would we feel embarrassed? How can we love ourselves with all our fear and shame and childish delight right out in the open? To be this open, we need to practice a very high level of emotional self-acceptance. We need to be kind and accepting and loving toward ourselves — as kind as we are towards our friends and loved ones. Really scary.

Probably the hardest part for us is the part about taking care of ourselves — it's sometimes very difficult to remember to be as nice to oneself as one is to everyone else. Here's a piece Janet wrote about some self-caretaking we've had to do while writing this book:

> The Book and the Mirror
> In a fairy tale somewhere, a magic mirror shows you your greatest fear — yourself bitterly old, poverty-

stricken, wincingly ugly, riddled with disease-weeping sores.

Dossie and I are discovering that this book is something like that magic mirror. When I make a minor copy-editing change to something of hers, she instantly decides that I hate what she's written, and moreover that I hate everything she's written in the book — and that I probably don't like her much either, and that I'm probably right to feel that way. When one of her workshop exercises goes better than mine did, I wonder why she even bothers to bring me along on the damn workshops anyway since I'm obviously just getting in the way, and people are just being polite about letting me stumble around after her.

We've both spent an embarrassing amount of time at other folks' workshops and retreats sitting in corners sobbing because something has triggered our shared childhood trauma about being too much smarter than the other kids, about nobody liking us or wanting to play with us — this in spite of numerous intervening decades having proven to us that plenty of people like us fine, and plenty of people love to play with us, thank you very much.

Let's not even talk about how many post-scene emotional crash-and-burns we've had since we began playing with the knowledge that most of our scenes were going to get written up for a book about transcendent BDSM...

So, here's a friendly tip: if you want to know what you're most scared of, what you're most insecure about, what you like least about yourself, all you have to do is decide to write a book about a complicated and evanescent topic with your dearest friend and lover of upwards of a decade. It works perfectly, I assure you.

All joking aside, I'm writing this almost two years into the process of creating *Radical Ecstasy*. Most of the bones of the book have been created and we're now trying to string them together into a functional skeleton. And it's not getting easier — in fact, it seems to get harder and harder the further we get into the process. What the hell is going on?

I think I've finally come to some understanding of it. The essence of what we're writing about is skinlessness: letting go of the walls that hold our place in space and time, that make it possible to tell where we end and the rest of the world begins. That sense of — I guess it's not really a pun to call it "boundless joy" — is the core of the state we're trying to describe and to achieve in this book.

But to write about it requires that we our my best to sustain it, during our time with each other, and during the time we spend with the book itself. And that, goddammit, is one fucking scary task.

Is this a plea for reader pity? Well, yeah, maybe a little bit. But it's also a call for compassion for yourself, because anytime you're doing anything that calls for this kind of openness, you may find yourself looking into your own scary mirror and doing some of the same things we're doing.

And if you do, please do the same things for yourself that we've done for ourselves and each other: Hugs. Reassurances. Treats (I'm particularly fond of chocolate-covered crystallized ginger — chocolate and endorphins all in the same package, yum). Tears, with strategic Kleenex as needed. Drink a lot of water and get a lot of sleep. And then, get up the next day and do it some more, because it's the hard stuff that's the most worth doing.

I'm honored and awed that Dossie and I were given the task of writing this book. Maybe someday, after it's finished, I'll even be grateful; but right now it's still too hard and tedious and frustrating. I suspect I've got eight or nine more paranoid attacks, crying jags, sugar binges and long walks to go before I can get there. One thing I know for sure, though: it will have been worth it.

The joys and the sorrows

We want you to make yourself a promise. A sacred vow that you will take care of yourself, be kind to yourself and listen to yourself with compassion. Do that now, and then you may continue.

What, do you suppose, are some of the consequences of this kind of openness? What can you imagine might happen if you opened your heart to joy and trust and giving, if you gave and were given all the sex and love and ecstasy you wanted?

One of the things we've found is that living this way just gives us a different perspective — we see things through a different lens than most people, and it often makes us seem kind of odd. We get used to being called "weird" a lot. We feel out of step, discombobulated, sometimes even a little disoriented. It feels like a huge relief to be able to spend time with our immediate circle of friends, who either share our perspective or who understand us well enough that we don't have to explain ourselves constantly, and who don't get startled or upset when we speak truths that seem perfectly ordinary to us but that are a little too uncensored for most folks.

A lot of people are frightened or threatened by openness, whether it's the emotional kind or the spiritual kind or the sexual kind. It calls into question many of their assumptions about the way they've chosen to live their lives. Thus, when they're confronted by such a person, they react by mocking that person, or running away from them, or taking advantage of them, or even by outright

trying to do them harm. Living with the frustrations and terrors of being singled out for persecution for no better reason than that you express your love differently from other people is no fun, and is a reality for many of us reading (and writing) this book.

Now, being mocked hurts, or doesn't hurt, in exact proportion to how balanced we're feeling at the time — in fact, if you want to know how sane you are at any given moment, just arrange to have someone make fun of you or insult you, and see how much it bothers you; and you'll have your answer.

It's harder if someone you like turns away from you because you're too open-hearted. It's human nature to fear rejection; if what's being rejected is your most vulnerable parts, the parts you expose by being as open and forthright as you can, that can feel very hurtful. And we're sorry to say that we don't really have much help for you if this happens to you, except to say that it happens to us too, and it isn't the end of the world. Sometimes that person gets over their fear and begins to recognize the pleasure of opening their heart too; sometimes they don't, and you have to take your lumps and move on, trusting that another person will be there for you later. At least you have the advantage of being open enough with your own emotions that you can recognize your own sadness — see above regarding treats and water and Kleenex and long walks and such.

Ever had a totally ordinary moment — something that happens to you every day — suddenly present itself to you as extraordinary, transcendent, seething with infinite life and meaning? Imagine what it might be like to wash a sinkful of dishes... immediately after surviving a near-fatal auto accident. Imagine being acutely aware that you were almost dead but now you are alive, alive and washing dishes, so that you can completely feel the hot water and slippery suds, and see the glistening bubbles and the gleaming glass, and recognize the cosmic significance of cleaning the surfaces from which you and your family consume

the food that sustains your beautiful lives. That's the kind of moment that openness allows, whether it's in a sinkful of dishes, or the gradations of color in the petal of a flower, or the texture of a lover's cheek, or the way the sensation of a cane stroke blooms and fades and blooms again on your ass.

And here are some of the things that we've found have happened to us when we've allowed ourselves that kind of openness. The world has showered extraordinary blessings on us. As we've moved into and through middle age, we're still considered interesting, attractive, desirable (to our considerable surprise, frankly). Our friends take care of us in ways that amaze and touch and awe us. We've had experiences that have moved us beyond all description — we've written more than 200 pages trying to describe the beauty of some of the things that have happened to us, and feel like we've barely scratched the surface. We've shared love and sex and ecstasy with untold numbers of people, both directly and indirectly, which has made our lives incalculably bigger — and which has made it so much easier for us to love ourselves, never all that easy a task for either of us.

In other words, even when it's been hard to be open, even when it's scared us, even when we've felt lonely and isolated, we wouldn't trade it for any other way of being — not for anything. Even if we could. Which we can't — we suspect that once a spirit breaks out of its old package, it's pretty tough to squeeze it back in.

And let's not forget about sex

This chapter has been so highflown and philosophical that there hasn't been nearly enough smut in it; but really, everything we've written here goes right back to the idea of sex and fucking and SM. If one day, we heal our society of all the fear and loathing about sex, if we open our society up, sex will still not be ordinary, not something you would take for granted, like eating and shitting.

Sex would not lose its mystery, because sex is far more than a hunger or a thirst. Sex is a way to connect to ourselves, to others, to our tribe, to everybody, to nature, to the cosmos. A truly holy communion — open to everything.

Openness is the theory, but for us, sex is the practice — it's the infinitely fascinating, infinitely creative, infinitely passionate field of exploration, growth and connection on which we can play out every single one of the abstract ideas we've put forth here.

Fire Dance With Janet

You said this night would be about pain.

I dress for dinner, the bias silk you gave me for Christmas, the burnt velvet jacket a serendipitous match: stockings and lace, all clean. The mince pie I made for our dinner pleases you: the rendered goose fat from last year made an exquisitely flaky crust, perfect contrast to the dark rummy sweetness of the mincemeat.

After dessert and coffee, we focus in, sitting on your bed. You have covered it with layers of sheets, evidently plotting something messy. You stare into my eyes, and as I look into yours I see you change, becoming adamant, inflexible — ruthless.

As you stare into me, visibly hardening, I feel something move inside me, something familiar, transiting into this other me, the one that fits, the puzzle piece to this other you. You and I, we fit together in many truly amazing ways — as writers, collaborators, teachers, best friends, lovers; and in these roles we play, the ways our shadow personae fit together. The me that responds to you; the you that responds to me. These intimate ways we mirror each other, the paths we walk together.

Whatever our differences, we always seem to be able to connect our energy to make magic. As you put it, the Light is always there.

When we went dancing to the Sufi chants, I was prepared for you not to like it. We often don't like the same things, at least as entertainment. But when I went out trance dancing, you came right along. You found me on the dance floor, your eyes alive and open windows to the soul, forehead to mine, peering like the owl that sees into the night. The ropes of light between our chakras grew palpable as we danced, ecstatic and sexual, grinding pubes together, pulling apart to wave to the snake rhythm, coming back together, chest to chest, to join at the heart. There is some truth in this connection that transcends language and words.

Now, I'm struggling to find words to describe my journey into myself, demanded by the hardness in your eyes, a part of myself that never yields but loves to get conquered anyway.

You start to appear male to me as you reach out, touch my face, my thigh — pulling my stocking down to my knee, one at a time, a sharp vulnerable pinch. I jump, you continue colonizing my body, one part at a time.

In silence you pull off the jacket, feeling my shoulders and arms as if evaluating something, checking for doneness, signs of unwanted tension, strength? Then the bra goes. As you reach around me for the clasp, I can smell you but I know better than to touch. The shoes, then the stockings all the way off, the silk of the skirt on my skin sliding off and carefully put to the side.

You buckle leather cuffs around me, one wrist, the next — an interesting design, a brief digression into tech-

nology until you pass rope, lovely silky bright orange un-
yielding rope, through the rings and pull me down, fas-
tened tight to the head of your bed.

I feel vulnerable, belly up — uncovered, exposed.
No bra, breasts left to gravity.

You step away, find something in your bag — ah,
the blindfold. Eyes covered, somehow I feel less naked,
settling into the darkness. You trail your hand down my
leg to my ankle: another cuff, more rope, one foot, two —
secured, spread-eagle.

You recollect what you have colonized, pass your
hands over my skin as if to evaluate a new purchase, and
satisfy yourself of my responsiveness. I transit, under your
hands, from relaxed to restive, entranced and aroused
simultaneously. I notice my hips begin to rock. I lift my
crotch toward the warmth of your hand — you laugh.

Another silence of rising tension while you are oc-
cupied with some equipment. A match strikes, catches
my breath, a whiff of sulfur. And you are over me again,
one hand breaking trails on my skin as the other waits,
breathless — no, that's me, holding my breath. You had
told me that you had acquired some new and particu-
larly vicious candles from Japan, which hit so hot that
they need to be built up to with more forgiving forms of
hot wax.

The warm-up is literal. When the first wax drips, I
leap. The heat is intense, hard to adapt to. I have to re-
member that I can't look to see if it's burning, but you are
watching, and you are always careful. The candle drips
very hot, and seems to get even hotter on the skin for
quite some time. I wonder if I should tell you that, but then
you grab the outside of my crotch with your free hand,

squeezing and pulling. My clit leaps to life, my cunt contracts, right. This is sex. And you have connected these drops of fire to my cunt, my root, and from there the heat flows up through the rest of me, my belly, my heart, my throat.

I am already writhing, and when it reaches my throat I start growling and hissing. So you up the gain. Fire falls like rain all over me, burning rain on my chest, my belly, my thighs, my breasts. You inch the drops toward my nipples; the sensitivity spikes, and I add fear to my complex of feelings.

It works, in some strange way, to feel afraid of you. After all, you understand my limits, you have known me for years. I know you won't actually attack my nipples because you know I would hate it, but the threat is hot to play with. And you do know how to tease me, ride my edge, leave me to wonder if you really really would.

Fire shoots up into my skull as my vision opens, and I see you outlined in glowing red, myself crowned in fire.

I don't remember a lot of detail for a while. I remember twisting away a few times, trying to flee, but tied down I don't get far and you just keep on raining. I remember wondering about safewording and then forgetting — I know you poured wax on my cunt. I remember screaming.

A break, you move away, reaching for something. I try to collect myself. In the sudden silence, I feel warmth and burning, a coat of wax like a blanket over me. Then a match strikes again, and you push something cold and hard into my crotch: the vibrator. When you turn it on, my cunt instantly reaches for the sensation, pulling it in as deep as I can. I can feel my womb swelling, my body

arches, and blazing hot drops of fire fall on my naked skin. Hot, hot, hot.

You explore, for a while, this polarizing experience of pleasure and pain: the vibrator, harder and softer, the approach to orgasm, the retreat, all punctuated by exquisite flashes of burning hot wax. Distinct sensations, so different as to seem to tremendously distant from each other, take my consciousness out further and further, as if I were suspended in outer space hanging between orgasm and agony.

You turn the vibrator up, and empty the second candle into my crotch. We hover on the brink of too much: too much pleasure, too much pain, no room for any other awareness, you hold me hovering, you

push the vibrator harder into me, still raining fire, until,

howling,

I come.

In and out of conclusion

Between us, we have over a century of time on the planet, and well over half a century of experience doing slutty sex and greedy SM and heavenly ecstasy; and that is such a tiny fraction of how much there is to explore that we feel like we could live for a millennium each and not begin to run out of ideas.

So the field is infinite, and there are really are no conclusions to any of this. Writing, we tend to choose the stories and events that have expressible conclusions: I learned this, I said that, my life changed. It's harder to write about the episodes of going into the flow and functioning in ecstasy for a while and then... and then... we come back down and go on living our lives: informed, perhaps, or maybe just reminded. We have visited a fountain where the water is always sweet, and it is never the same water.

We are not the same people that we were two years ago when we began writing this book. Putting these words on these pages has invoked laughter, love, terror, embarrassment — "are we really going to tell them *that?*" — frustration, humiliation, pride and joy. We have leapt so high we scared ourselves, and fallen so fast we crashed. It has been two years of ecstasy as radical as any either of us has ever known, and we thank you, dear reader, for inspiring us to undertake it.

After two years, we still have neither definition nor explanation for our spiritual horniness that drives us to seek out pathways to bliss. Yet we go on seeking. We risk hubris to put names to the unnamable, trying to map our journey as our footprints dissolve behind us.

We returned from these journeys with new insights. The borderlines that we used to define our consciousness have opened briefly, tantalizing us. For a few wonderful moments, minutes, hours, we have lost the distinctions between thoughts and fantasies, perceptions and dreams: fact or fiction, myth or life, role or reality, you or me. The boundaries dissolved and we made new connections, grasped new understandings. Having pulled the puzzle apart, we could put the pieces back together in a new way, to show us a new picture, another part of the eternal puzzle that is never finished because it won't, can't, hold still.

The book is finished, for now. Our learning is not. We will go on to new ecstasies, and we hope you will too. Because every time we open ourselves to ecstasy, we come back changed. For the better, we think. More open. More clear. More divine. More human. Just... more.

May you always and ever discover new territories in your never-ending journey into ecstasy.

*— **Dossie Easton & Janet Hardy***
August 2004

OTHER BOOKS FROM GREENERY PRESS

BDSM/LEATHER

The Compleat Spanker
Lady Green $12.95

Erotic Tickling
Michael Moran $13.95

Family Jewels: A Guide to Male Genital Play and Torment
Hardy Haberman $12.95

Flogging
Joseph W. Bean $12.95

Intimate Invasions: The Erotic Ins and Outs of Enema Play
M.R. Strict $13.95

Jay Wiseman's Erotic Bondage Handbook
Jay Wiseman $16.95

The Kinky Girl's Guide to Dating
Luna Grey $16.95

The Loving Dominant
John Warren $16.95

Miss Abernathy's Concise Slave Training Manual
Christina Abernathy $12.95

The Mistress Manual
Mistress Lorelei $16.95

The Sexually Dominant Woman: A Workbook for Nervous Beginners
Lady Green $11.95

SM 101: A Realistic Introduction
Jay Wiseman $24.95

Training With Miss Abernathy: A Workbook for Erotic Slaves and Their Owners
Christina Abernathy $13.95

GENERAL SEXUALITY

Big Big Love: A Sourcebook on Sex for People of Size and Those Who Love Them
Hanne Blank $15.95

The Bride Wore Black Leather... And He Looked Fabulous!: An Etiquette Guide for the Rest of Us
Andrew Campbell $11.95

The Ethical Slut: A Guide to Infinite Sexual Possibilities
Dossie Easton & Catherine A. Liszt $16.95

A Hand in the Bush: The Fine Art of Vaginal Fisting
Deborah Addington $13.95

Health Care Without Shame: A Handbook for the Sexually Diverse and Their Caregivers
Charles Moser, Ph.D., M.D. $11.95

Look Into My Eyes: How to Use Hypnosis to Bring Out the Best in Your Sex Life
Peter Masters $16.95

Paying For It: A Guide By Sex Workers for Their Clients
edited by Greta Christina $13.95

Phone Sex: Oral Thrills and Aural Skills
Miranda Austin $15.95

Photography for Perverts
Charles Gatewood $27.95

Sex Disasters... And How to Survive Them
Charles Moser, Ph.D., M.D. and Janet W. Hardy $16.95

Tricks... To Please a Man
Tricks... To Please a Woman
both by Jay Wiseman $14.95 ea.

Turning Pro: A Guide to Sex Work for the Ambitious and the Intrigued
Magdalene Meretrix $16.95

When Someone You Love Is Kinky
Dossie Easton & Catherine A. Liszt $15.95

TOYBAG GUIDES: A Workshop In A Book
$9.95 each

Canes and Caning, by Janet Hardy

Clips and Clamps, by Jack Rinella

Hot Wax and Temperature Play, by Spectrum

Dungeon Emergencies & Supplies, by Jay Wiseman

FICTION

... But I Know What You Want: 25 Sex Tales for the Different
James Williams $13.95

Love, Sal: letters from a boy in The City
Sal Iacopelli, ill. Phil Foglio $13.95

Murder At Roissy
John Warren $15.95

Haughty Spirit
The Warrior Within
The Warrior Enchained
all by Sharon Green $11.95 ea.

Please include $3 for first book and $1 for each additional book with your order to cover shipping and handling costs, plus $10 for overseas orders. VISA/MC accepted. Order from Greenery Press, 4200 Park Blvd. pmb 240, Oakland, CA 510/530-1281.